Navigating in the dark

KALLIOPI LEMOS

**black dog
publishing**

london uk

For my father with whom I learned to navigate in the light and the dark

Contents

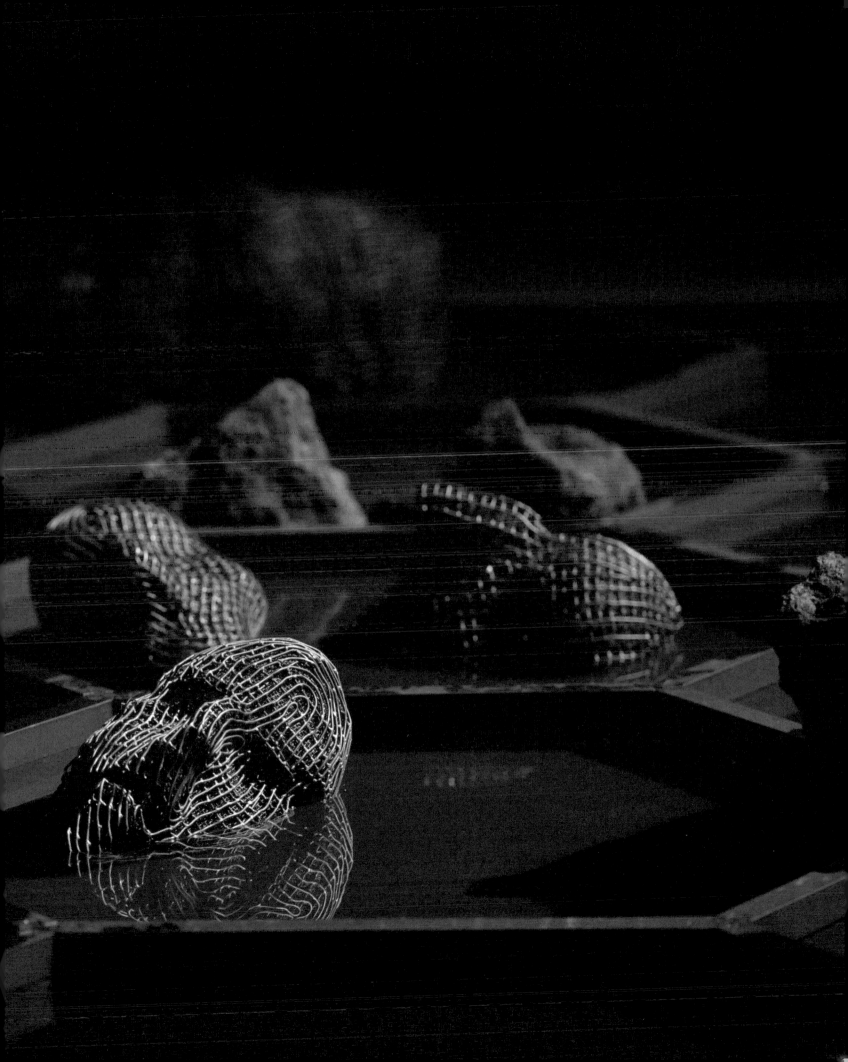

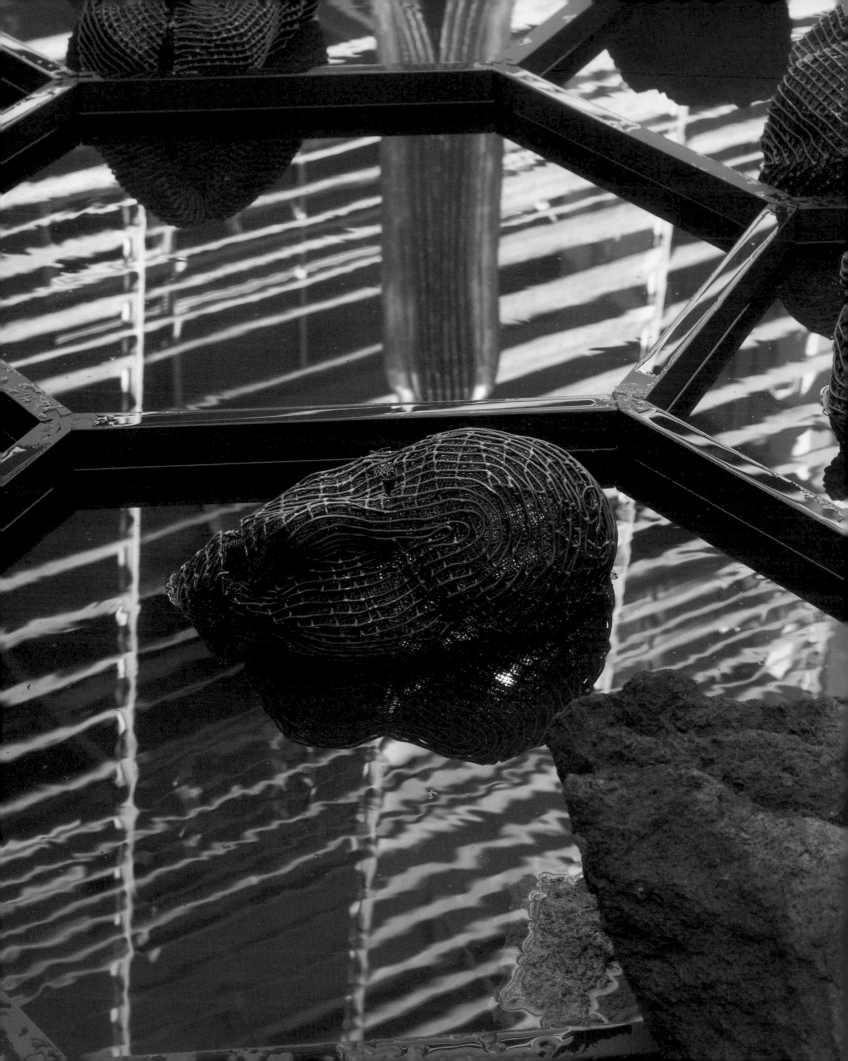

The Descent
MARIA MARANGOU

The project Navigating in the dark represents a great and significant journey that Kalliopi Lemos realised in 2011. This was a journey staged in three different stations, where discoveries and revelations happened; and where startling issues, liberating experiences and initiation rituals intertwined.

It could be argued that the 'journey' is an opus, a central and undivided shell that risks the glory of life for the sake of the grandeur of descent. The three stations (Athens, Crete, London) incorporate the diversity of the whole that constitutes the journey itself, as it evolves towards a desire for the descent.

The first installation was located in the courtyard of the Benaki Museum, in the heart of Athens, located in the Kerameikos area and so having a notional link with the *Dēmósion Sēma* (*δημόσιον σῆμα*, 'public graveyard') (winter 2011).

The second was presented at the Ibrahim Khan Mosque (summer 2011) within the archaeological area of Rethymnon, where the ancient city of Crete, the settlement of Rytimna, was established and later further developed by the Venetians and the Turks.

The third exhibition was installed in the Crypt Gallery of St Pancras Church in London (autumn 2011), an underground burial complex in the centre of the city.

The three exhibitions were autonomous but at the same time connected with a semantic continuity towards darkness, through the process of opening to a world of pain, imagination, exile and reconnection of the lost bonds of the womb with the universe.

The choice of the spaces, signifying the 'journey' itself, defined the development of the narrative and contained fragments of a collective memory, personal experiences and knowledge—both pre-existent and acquired. Simultaneously, each of those spaces carried the weight of its meaningful history. With Lemos' works they relived the continuity of an evolving civilisation that pursues the identity of the 'source'.

Ever since Kalliopi Lemos started her artistic practice, the destined journey has been an overriding preoccupation. The means of the journey have always been many: Japanese paper, wood, mild steel, Perspex, wire, colour. And they have resulted in drawings, sculptures, constructions, and site installations.

The history of art with its different regressions, from the touch of the human hand in the cave paintings and the primitive animistic incantations to the most complex quests of conceptual art in the late twentieth century and the start of the twenty-first, has endowed the artist with infinite freedom

of expression. In a way, it would be superfluous to discuss and isolate one particular medium in the immense realm of art, where the artist is entitled to access the tools of any particular discipline, as well as to explore symbolic appropriation.

Every period has its own particular aesthetics and semantics. In essence, the prerequisite of each period remains the artwork itself, the one that transcends the unconditional acceptance of academic art and approaches codes that refer to the hereafter, a non-negotiable issue as far as the substantive definition of the artist is concerned.

In her journey, Kalliopi Lemos uses many diverse materials, sometimes simple, sometimes complex, while the creative process is long and methodical. The spectator notices some recurring motives such as the boat, the water, the phallus and the goddesses, phenomena that encompass the transformation and the zoomorphic.

The works are contemporary, but they also have the privilege of being timeless. Through an evolving modernism, they create values based on a plot that does not conform to the soap opera of the grand spectacle of contemporary art.

Understanding how to handle the modern and how to engage with postmodern beliefs does not leave Kalliopi Lemos indifferent. However, her course does not have a specific recipe. While embracing the rules of the contemporary in art, she returns to the memory of the animal form and the selection of transformations that derive from her Greek roots and are inspired by ancient mythology.

What we define as our own truth, we place within the area of our symbols and knowledge that we possess. Kalliopi draws her own truth from the boundaries of the knowledge of our world, progressing towards the 'seed core', towards the voice of things that act underground, towards "the part of darkness that gave birth to light" as Goethe expresses it in *Faust*.

So what we experience is a continuous search, initiated by the artworks, for the essence of beings so as to discover the harmonies between the multiple relationships that signify the notional and the invisible. The route to the 'descent' thus becomes a question, for the artist, of investigating the obvious and the tangible, in order to discover their roots.

Are we to understand that the root is the island—meaning the isolation—or is it our wise unconscious that knows the direction of every shadow it creates?

Often, the shadow in Kalliopi Lemos' work becomes the most important element since it foretells the route of the descent and what it entails.

This is true of the installation of the numerous reeds in the underground burial complex of the Church of St Pancras in London or the totem figures within the large Perspex egg in the mysterious and transcendent Mosque in Rethymnon.

"The long day wanes; the slow moon climbs", the poet Alfred, Lord Tennyson (1809–1892) writes in his *Ulysses*. The artist observes the passing of the day as it fades, giving way to the light of the moon that arises and reveals the glory of life, consciously choosing the progression towards the 'light' of darkness.

The 'descent' is defined by Plutarch in two words: *τελευτᾶν* and *τελεῖσθαι* ('ending' and 'perfecting'). The initiation is the wandering, the journey, the difficult course with the rough ending into the darkness until the initiated meets the final light of his descent.

Navigating in the dark, Kalliopi Lemos' *nekyia*, her 'descent', will have its plot continued on the papyrus of her future works. As Hemingway once said, "If the hero has not died, the writer has left the story unfinished."

And since no one can approach the archetypal depths without a constant descent, the journey to the unknown continues.

Navigating the Dark
JIM FITZGERALD
PART 1

Who can say where the artist begins her voyage, what dark waters she crosses on her journey, and what shores await her as she disembarks? We, who stand in awe at the strange cargo unloaded before our eyes, can only draw hesitant conclusions, and sigh in amazement. Each object, inhabiting its own stark presence, suggests an origin at the far edges of the inhabited world, a margin where all opposites our known, limited world contains, are merged and intertwined.

In this first stage of Kalliopi Lemos' tripartite exhibition, Navigating in the dark, set in a courtyard of the Benaki Museum, Athens, we are confronted with a set of alarming, iconic figures. We are faced with four large, black steel totems on separate corner platforms radiating from what seems like a hexagonal central pool, itself marked out into a honeycomb structure. The eye is drawn first to those objects that reach upwards, ignoring for the moment the horizontal plane. Those minatory shapes, familiar yet unfamiliar, call out, as if in significant warning: a journey is about to begin:

> Build then the ship of death, for you must take
> the longest journey, to oblivion.

> And die the death, the long and painful death
> that lies between the old self and the new....

Already the dark and endless ocean of the end is washing in through the breaches of our wounds, already the flood is upon us.

> O build your ship of death, your little ark
> and furnish it with food, with little cakes, and wine
> for the dark flight down oblivion.

We are surrounded here by images of 'beginning', yet, in this liminal space, an internal courtyard where opposites meet at a symbolic crossroads, the image of 'ending' also finds its place. In this small, enigmatic island we are caught between past and future, between memory and desire, and in this transition we are participants in the greater mysteries, where male and female are not yet, or are no longer, differentiated.

How do we achieve some orientation for the beginning of our voyage? What star do we steer by? Do we have a goal? At the centre of this space, as if drawing these steel beings to it, together with our distracted souls, the honeycombed pool awaits, busy with clues to our journey. Scattered over its regular structure, mirrored in a film of water, lie some haphazard, at first incoherent shapes, only gradually resolving into red rocks, interspersed with grey mesh-steel human heads, distorted as if by pain.

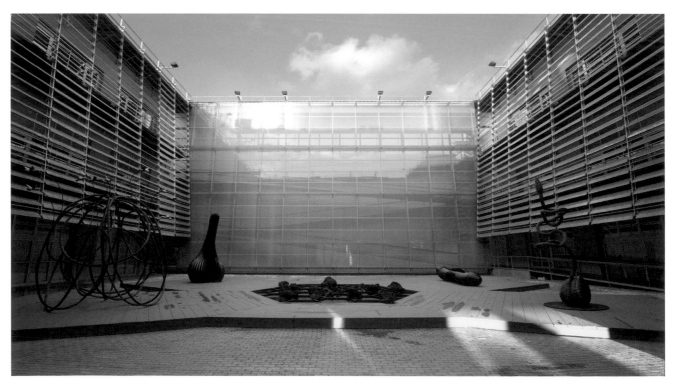

In the cellular structure of the honeycomb, nature presents us with an image of conservation, sweetness and new life. The hive is to be our North Star for this leg of the journey, and its freight of volcanic rocks and suffering-moulded heads indicates what we are to undergo on the way. These are the stores for our crossing. Such heads seem to have been washed up on an abandoned beach, the remains of sailors, like the pilot Palinurus perhaps, lost at sea. Here they have been gathered in and conserved, in order to make their voyage into oblivion and to become the seeds of new life. This is the beach between worlds, where the souls of the ancestors hover and wait to incarnate again in the cycle of life. It is not without pain that this transition takes place, however, and the distorted heads and the volcanic rocks bear testimony to a deep, anguished transformation.

The clues here in the central pool reveal to us that we are indeed in the middle of the mysteries of birth and death. The artist's first idea or image denotes a conception, and there follows a navigation in the dark until its final realisation. As we look around, the pointers for this underworld voyage are provided by the four attendant sculptures. This is to be a night-sea journey, a nekyia, an Amduat. These are the four sentinels of the dark crossing-place. We cannot but remember

Odysseus, whose journey brought him to the land of the dead, where "abominable night is for ever spread over those unhappy mortals". It is here he meets the soul of his dead mother, and tries three times to embrace her. With this heart-piercing failure, he learns the truth of life after death.

Like the Egyptian *Amduat*, or underworld night-time journey of the sun to its rebirth in the East, which took place in measured stages, Odysseus too had his episodic voyage, from island to island, longing for home. His encounters and adventures portray the archetypal journey of the soul, through all the stages of its incarnation, from the otherworld of its pre-birth condition, until its return again through the portal of death.

In the giant egg, surrounded by its flock of winged phalluses, we can observe the dance of conception. The phalluses represent the spermatic spirit, which inseminates this material world, much as the spirit of inspiration fertilises the soul of the artist. The combination of male and female elements, which is repeated throughout the exhibition, accentuates the duality that underlies the universe, the inherent polarity of creativity. "This", it says, "is the moment of conception, which for you, Persephone the Maiden, will send you out on the long voyage into knowledge." This

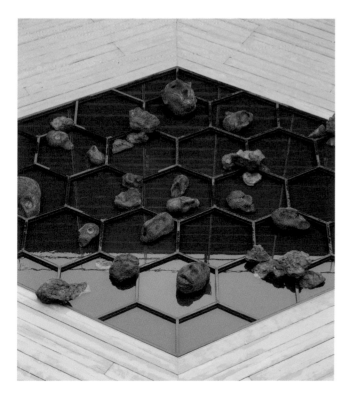

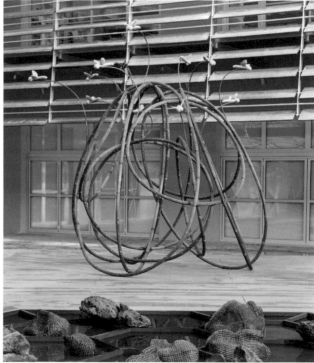

is the secret knowledge at the heart of the universe, which enters the soul of the artist at the germination of each new work. This is the dynamic movement at the core of every human soul.

The steel rods here, coiled and shaped into ovals, compose a rather diaphanous image, as if matter itself had become transparent at this incarnational moment. "Look", it says, "the beginning of life is nothing solid and opaque. It is a dance of the contrary energies, illuminating all." What normally takes place in a dark, private, secret place of nature, has been exposed and exhibited as a cosmic dance. These pale phalluses are attendant angels, encircling the world, nudging it into being, protecting the faint stirrings of new life.

The dark, standing sculpture near to the egg presents a contrast in every way: texture, colour, tone, presence. Its name is *Space Within*. Encompassing the essence of both male and female, it conveys a totemic energy. Figurines with such a shape, dating from the sixth millennium, have been found in south-east Europe, and are interpreted as representations of the Great Goddess. Both phallus and womb are hers, as she is the great genetrix of life itself. It is she, in the time before the patriarchal gods arrived, who presided over the mysteries of birth, death and regeneration. There is a mystery laid before us here, as the figure, dark, serene and secret, has been pulled apart, to expose an interior flesh-like, sensuous, acutely sensitive. The Goddess even so opens herself up, to insemination, to birth, and to recollect all again at death. Dare we enter that gash in the ordered universe? Will we re-emerge again, and be who we are in ordinary life?

As we turn away again, sun-wise, we encounter the earth-hugging, crawling, partly eviscerated *Bear All Crawl*. Here, the contrast between the cool, bluish, polished exterior, and the flesh-coloured, coiled interior, valve-like and tubular, but opened up to view, is startling, intense. What great power can open up this sealed cool being so precisely, so inevitably? Even so might a god like Zeus strike with his lightning-bolt and lay us bare. So, we gather, from this humbly-lying figure, is the soul of the artist opened up, with force and with love, through the exercise of her intuition, so that the innermost parts of the soul can be traced and read?

The nature of this figure is organic, strangely human, so that it arouses the strongest sense of pathos—poor blind worm, biblical in its significance. At this fateful crossroads, we are met with an image of our prostrate, abandoned, wounded self, awaiting redemption, and further voyaging.

The final figure, *Reaching Up High*, raises up the spirit once more, encourages our onward journey, and

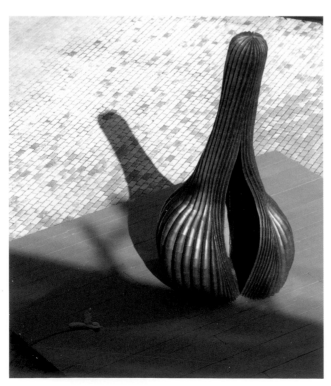

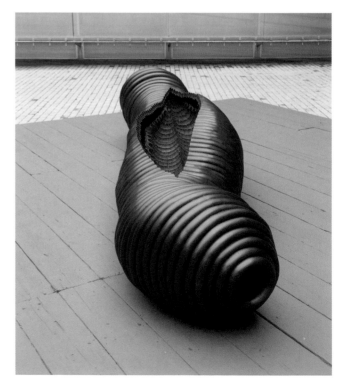

conveys the blessing of new life. Fulfilling the promise of the great egg, a coiling, flexing tentacle of growth emerges from a ribbed seed, whose shell has broken open to reveal the kernel. This is the artist's vision in *statu nascendi*. We are allowed a glimpse of that sacred moment when the questing intuitive *gestalt* breaks through into consciousness and strives inevitably towards the firmament and light. Above and below are joined, dark and light unite in the birth of the new, the artist's creation.

> Wait, wait, the little ship
> drifting, beneath the deathly ashy grey
> of a flood-dawn. Wait, wait! even so, a flush of yellow
> and strangely, O chilled wan soul, a flush of rose.
> A flush of rose, and the whole thing starts again.

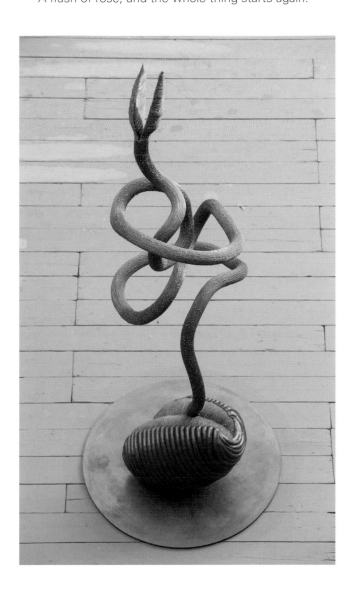

PART 2

As you climb the dusty slope through the scattering of wild flowers in the early summer heat, gradually the promontory levels off to reveal the cerulean Mediterranean ahead, and to one side, a low, dome-shaped building. It seems as if a great, pinkish egg has fallen from the sky, or perhaps been washed up by the blue waters around this *locus amoenus*. Approaching the simple and unadorned building, it comes to mind that this is Crete, where, in a distant mountain cave, the king of the Gods was born, hidden away in safety. This island, too, contains the astonishing ruins of the fabled Knossos, immeasurably old, where the monstrous Minotaur lurked in its labyrinthine depths. What revelation then might await beyond the dark doorway of this now unused mosque—originally a Christian church—where we disembark for the second lap of our voyage with Kalliopi Lemos, in her tripartite exhibition, Navigating in the dark?

To enter, from the intense heat and light of the Cretan sun, is at first to be sightless and disorientated. Rounding what seems like a plain, unadorned templon or rood screen, we emerge in the concave space of the old mosque. This *temenos*, a place of worship and mystery, a space to meditate and pray in, immediately astounds the senses, as it presents what can only be a theophany. This great egg is also a womb, in which

a divinity is in process of being born. Conceived in the artist's imagination at the honeycombed pool of the previous exhibition, the divine being has been carried in the ever-pregnant sea, to this mystery-imbued isle. The navigation has been across the dark waters of the artist's unconscious psyche. We stand in awe, brought to a standstill by the sight that meets us.

Even so must Odysseus have stared, stupefied, dispossessed of ship and shipmates, when he was thrown up on the island of Ogygia. It was there that the goddess Calypso, "that goddess so beautiful and so terrible, who can speak the language of man", rescued him, so that he should become her immortal lover. (For Odysseus however, the longing for his faithful Penelope filled him over the course of the seven years of his confinement on the island.) Even so might Calypso have appeared, in a vessel of light and reflection, multiple images shifting and re-arranging themselves as we stare, dumbfounded. A pointed egg-shape, sparkling, translucent, dazzles the eye. Panels of clear glass allow a vision of a manifold, polymorphous interior. As we approach this mysterious epiphany, the eye is startled to discover that the inner surfaces of the panels that tile this diaphanous egg are mirrored on the inside, to multiply beyond reckoning the figures within. We are being allowed an insight into the heart of some

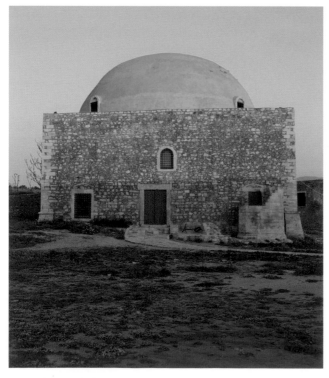

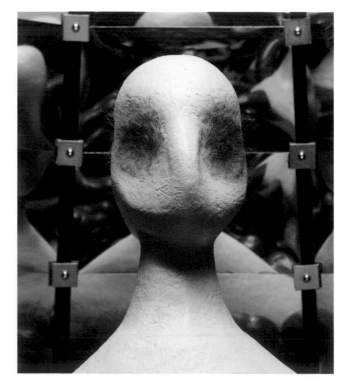

divine mysterium. When we remember back to the beginning of our voyage, at the Benaki Museum, it is clear that some significant psychological shift has taken place. There, those portentous icons were situated in an inner courtyard, open to the sky. Here, however, we are directed inwards on our journey, peering and gazing, mystified. There, the forms were largely opaque, the steely forms occluding sight. Here, matter has gained transparency, allowing inner vision.

To see within is to see into the depths of the unconscious. And what appears here to our inward sight? The *Hairy Goddesses*, three-in-one, one-in-three, resting in their egg-cocoon, on pedestals identical to those supporting the primitive goddess figurines in the nearby museum. Here, however, they are giant sized; they have various mysterious placements of hair, even where we should expect none; and, most perplexing of all, our vision is stunned to see that each figure sprouts, extends and reaches out with dark fleshy appendages, which might be tentacles or transmuted phalluses. But sense is thwarted, as divinity ever thwarts the rational intellect, by the multiple, fragmented, repeating images, receding into infinite distances. It is a dance, of the eye and the mind. Within this egg, what life is being hatched, to break into our ordered universe? The appendages of

the goddesses, wispy hair and tentative feelers alike, reach out as if to entreat us, asking to be welcomed into our hitherto indifferent world. They wait here as yet unborn, patient and enduring, until we release them and plead with them to rescue us from the hostile waters. Render us immortal, we pray, even as the artist renders her material into everlasting image, imbuing matter with living myth. Our prayer is the eternal one, raised to the Queen of the Great Waters:

> Hail, Queen of Heaven, the Ocean Star,
> Guide of the wanderer here below!
> Thrown on life's surge, we claim thy care,
> Save us from peril and from woe.

To either side of this imposing otherworldly capsule, as if acting as sentinels for the presiding divinity, are two arrays of boats. But these vessels have been transmuted in the waters of the artist's imagination, to emerge in this place, as if drawn by the goddesses into an altered shape and purpose. On one side stands a crescent of tall black, burnished boat shapes, upended, so slender as to provoke the realisation that these are boats of the imagination, installed for climbing to the heavens, to cross the waters of eternity.

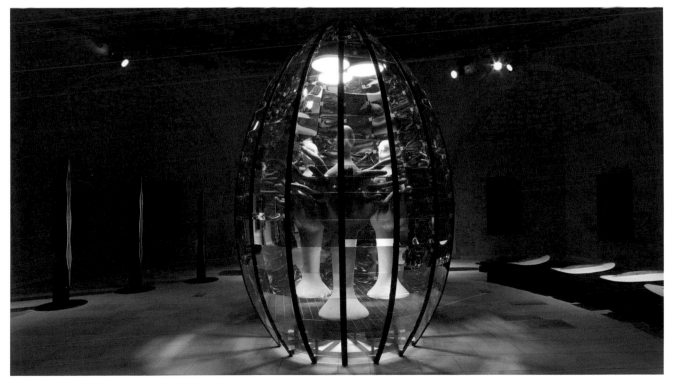

The number of the boats is seven, a number long identified with initiation and transformation. These are the seven sung about in the old song "Seven for the seven stars in the sky", or alternatively, "Seven for the seven that went to Heaven". We find the seven in the constellations—the Pleiades, or the seven stars of the Plough or Great Bear. These boats are pointing upwards, towards heaven, taking the psyche that contemplates them on a skyward journey. The goddesses attempt to teach us that they also belong to, or are taking their journey towards, the zenith of the human universe. In the same way, Zeus, the god that rules the high heavens, had his origin in the earthly caverns of Crete, before his ascension.

These are the *Boats Full of Secrets*. What secrets are stored in their holds, being transported from Earth to heaven? Human longing and desire, freed by the apparition of the *Hairy Goddesses*, stand in readiness for their otherworldly voyage. The *Boats Full of Secrets* are the prayers of the human race, as they face their contradictory place between the fixed and the volatile. This island is the place of change and permanent transformation; the upper world where these boats aim towards harbour, is that of the eternal forms, the archetypes. If we listen, we may hear the words of Yeats emanating from their still shapes:

Consume my heart away; sick with desire
And fastened to a dying animal
It knows not what it is; and gather me
Into the artifice of eternity...
Once out of nature I shall never take
My bodily form from any natural thing,
But such a form as Grecian goldsmiths make
Of hammered gold and gold enamelling...

Opposite the black *Boats Full of Secrets*, arrayed on a horizontal platform, are splayed the white forms of the *Blade Boats*. Their journey is that across the flat plane of this world, their keen edges slipping at ease across the world of matter, towards the far horizon, where descent awaits. The vertical and horizontal planes of this world, crossing at the numinous centre where the *Hairy Goddesses* lie in wait in their transparent shell, are patrolled and observed by these small silent fleets, carrying their messages to the worlds of matter and spirit. The *Blade Boats* are lipped along their centre with twined reeds, those chattering, whispering multitudes, enveloped now in the white garments of initiation. They are the seven again, the seven watchers and servers, plying the waters of the imagination, distributing the artist's visionary wares to the world.

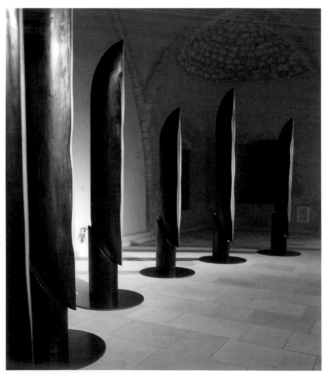

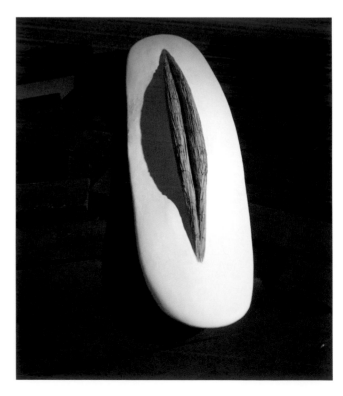

As we view these white shapes on their low platform, our eyes are drawn inevitably to the floor beneath, and to the structure of this material world that sustains the artist's vision. The flat tiles mirror the voyage of the boats, and lead our viewpoint towards the walls and ceilings of the building around us. See now how the arches inherent in the walls, and the high arched dome reflect back the shapes of the coruscating egg at the centre, and the tapering tops of the black *Boats Full of Secrets*. The harmony of the artist's creations and the space in which they are fortuitously displayed delight and thrill the eye.

Moving on from the contemplation of the attendant boats, caught in their eternal present, we arrive at a position which, in a church, would be the place of the altar. Here the altar is a whole tree trunk, peeled of its bark to show a smoothed and whorled boat shape, its pale wood reflecting the colour of reeds and of the surrounding building, its spiral patterns those of the sea itself. This great organic presence seems a living altar, holding on its surface 12 brilliantly white shapes, as if in offering to the enshrouded goddesses. In a startling reminiscence of the steel heads in the first part of the exhibition, these human heads are distorted, as if in pain or regret. This is *Odysseus's Boat*, and these are what remain of the hero and his companions, after their long sea voyage, following a receding vision, pursued by the anger of the heavens. 12 is their number, the sacred number of completion, and of the primal band or crew. There is here a secret reference to the passage of the sun in its solar barque across the sky. Set each one in its own

small scoop in the flesh-coloured wood, the white heads murmur, as they attend the glittering theophany:

> Put out to sea, ignoble comrades,
> Whose record shall be noble yet;
> Butting through scarps of moving marble
> The narwhal dares us to be free;
> By a high star our course is set,
> Our end is Life. Put out to Sea.

It is in this moment of long-suffering stasis that they are now transformed into memorial heads of salt, the essence of the sea itself. Both fragile and permanent, these heads portray the degradation worked by the sea and the long voyage and by life itself. They offer themselves here, at the end of this stage of our voyage, as the residue of grief and pain, a simulacrum of the feeling soul of the artist. There is something noble in those remains, evidence of one who dares to face the great sea of the unknown, and to persist until the farther shore is reached. Whither now? This is our prayer at the altar, this is our question to the artist. Where will she now lead us on our dark navigation? With the poet, we offer a final prayer here, in this sacred temenos:

> Also pray for those who were in ships, and
> Ended their voyage on the sand, in the sea's lips
> Or in the dark throat which will not reject them
> Or wherever cannot reach them the sound of the sea bell's
> Perpetual angelus.

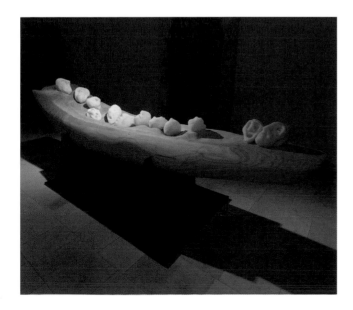

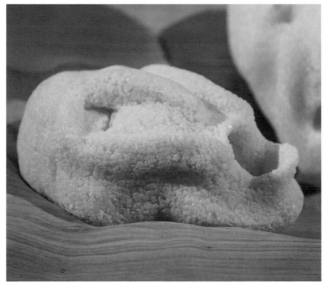

PART 3

If you turn aside from the loud clamour of the busy London thoroughfare, where traffic and pedestrians throng, and enter a short side street, you skirt the east end of what must be the most unlikely church in this city of many churches. Two porches stand out from the main body of the building, in imitation of the Erechtheum on the acropolis of Athens. Where we might expect statues of Christian saints we find instead the forms of caryatids, four to each portico. They stand as if in guard over doorways at either end of the church's crypt. For one who has some knowledge of the significance of the Erechtheum, the possibility of what lies beneath is startling and somehow unsettling. It was that ancient building that contained the holy relics of the Athenians, the icons of its founding deities and ancestors. Furthermore, in its foundations dwelt a sacred snake, representing Cecrops, founder and first king of Athens, which was fed on honey cakes. What we go to meet then, through the red doorway of the crypt, on the final stage of our voyage with Kalliopi Lemos, promises to be of some fundamental significance. What lies beneath the Christian church, the pagan temple? What lies underneath the tumult of the congested street? Do we dare enter and go down?

> Descend lower, descend only
> Into the world of perpetual solitude,
> World not world, but that which is not world,
> Internal darkness, deprivation
> And destitution of all property....

Is this the end of our long journey, or a staging-post, as we set out anew?

The doorway itself, a muted red, pierced as if with sunbursts, or abstract mandala-like patterns, poses a message or a question: "What is it that you seek?"—the very question posed to all initiates. And if we are not well prepared, will that voice resound from within, as it did to Tamino in *The Magic Flute*: "Go Back!" Already it is decisive for our destiny if we enter or turn away!

We enter and go down. A short but steep flight of stone steps takes us down to the crypt itself, and opens up to our view a rather dark passage ahead. A vaulted tunnel, roughly floored, reveals itself in a varied pattern of light and shadow, so that we are obliged to pause and orient ourselves in this underworld dimension. At the same time, a sound-scape, very different from the loud bustle of city traffic, emanates from the surroundings, striking our ears with a strange but familiar sense. There is a soothing quality to the sound of lapping water, the swirl and murmur of the sea, which belies the immediate sight of the wooden boat at the start of the passage. Darting and scouting ahead, our eyes recognise another boat in the shadowy light half-way down the crypt, and at the end another boat is rounding a corner, on its way to somewhere unknown. Carried along on the invisible waters of an underworld river, Styx or Lethe perhaps, these boats are in suspense here at their moment of transformation.

What startles the senses, however, on our first station here, is what occupies the boat before us: a coiled mass of grey steel-mesh snakes, as if nested but somewhat restless in their pale wood vessel. They are being transported, but as yet we cannot be sure if they are the leading vessel of this little fleet, or the last to make land, if land is indeed our journey's end.

Here in truth are the founding-spirits, the primal ancestral deities, a cargo the artist has carried, from the first launching of her vision in distant Athens, seeds now gathered here, to be sown in London soil. The word 'crypt' itself comes from Greece, derived from the word 'to hide' or 'conceal', and applied to a vault or hidden cave. With the knowledge we have gained on the previous stages of our voyage, we draw to mind the hidden spaces opened up in the sculptures called *Space Within* and *Bear All Crawl*. We remember too the epiphanies revealed in the sacred cavernous space of Crete, and Zeus hidden there in his own mountain cave. These seeds are the intuitive founding visions of the artist, which need to be concealed and then planted in the dark underground, in order to renew the life of the collective, and bring about the birth of a healing image.

We have entered here into a dream, such as the supplicant dreamt in the temple of Aesculapius, and wonder if or when we will emerge. These powerful serpents writhe and coil with primal energy. Are they content to be carried over the lapping waves, through whose sound we now hear the knocking of oars against wooden hulls, or does at least one reach over the side, seeking to escape, or to touch us with its alien spirit? But the seven remain, as if to convey the

essential mystery of the number, that which from the earliest times was associated with initiation and rebirth. We have met this number before, in sunny Crete, in the guardian boats accompanying the *Hairy Goddesses*. Those boats, of black and white, have metamorphosed in their voyage, and here precipitate their living cargo.

We are uneasy with this strange encounter, here in the nether world, and squirm ourselves, aware that an extraordinary riddle has been spelled out. Half-turning, we are met by the low tunnel of *The Field of Reeds*. Silent now, these beds of vegetation stretch away into the dark distance, prescient, enigmatic, unspeaking. The unearthly quality of this place is perfectly underlined by these silent reeds, which, in the unimaginable, noisy world above, would never cease in their whispering and chattering, their questioning, their constant motion. All the more, the stillness of this place enters us, the only movement the quiet stream of sound, rising and falling, carrying now, along with the voices of the waters, the calls of distant crows, the buzzing of invisible bees.

Reeds stand for the impermanence of the world, as they rise and fall, burgeon and decay, with the shifting waters. "All flesh is grass", as the prophet declares, underlining the fragility and transience of human life.

However, the reeds also symbolise the primordial creativity of humanity, functioning from the earliest times as agents of civilisation, that which survives the natural decay of life.

In the Egyptian *Book of the Dead*, the domain of Osiris is called the "Field of Reeds", and the dead were believed to work and live in those fields, harvesting the bountiful crops. We have truly been transported beyond the borders of the ordinary everyday world, to enter the realm of the ancestors, where we may consult the departed spirits, like Odysseus at the farthest reach of his unfortunate voyage. Is this our journey's end, the immortal world of the dead? Our quest must move on to interrogate the occupants of the other boats, for our search is urgent, and will not let us pause.

Moving along the shadowy crypt, while casting a glance down a side passage to glimpse with mild alarm some white mystery beyond, we are troubled and intrigued by the human shapes, half concealed in shadow, that sit in silent huddle in the second boat. The low sound of human voices whispering together meets us as we halt by the small craft, a murmuring interwoven in the liquid voices of the sea. Is it a trick of the light, or of our imagination, or do these shapes

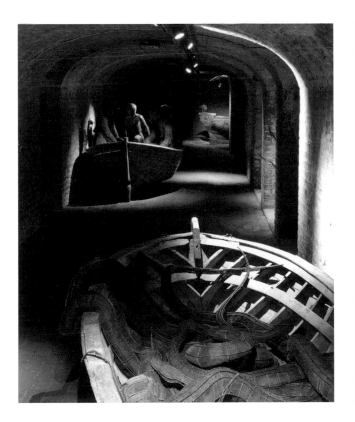

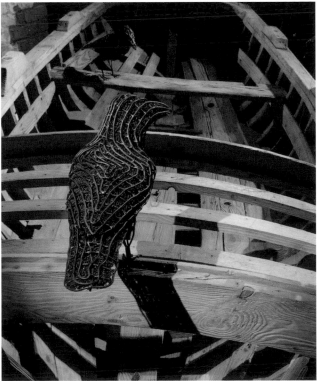

stir and turn to watch our approach, as the dead in the underworld watched Orpheus pass by, too vitally human for their dim world? It seems that these shapes welcome our arrival as it interrupts their endless, patient attending on the mystery. In their shadowy conclave, leaning forward, as if in secret conversation, a graceful cast to the slope of head and shoulder, their utterly human form conveys something tentative, something vulnerable. This look we recognise, the form of universal human pain, of those uprooted and migrant millions, who face their destiny with deep acceptance and resignation, and are transformed into monuments of dignity. At the sight we can speak with the poet:

> I am moved by fancies that are curled
> Around these images, and cling:
> The notion of some infinitely gentle
> Infinitely suffering thing.

As the bell of an underground buoy tolls, we are faced by these forms with the realisation: these figures are the whole of humanity, arrested here in witness to the secret at the core of the human heart and spirit. Here is motion stilled, the heart-beat paused, in that eternal moment "between two waves of the sea". We are close companions to this little crew on their revelatory descent into the heart of matter. It is here, "at the still point of the turning world", that the throb and drone that runs within the atom is clearly heard. The sound, as of water as it purls and ripples, is that of the serpent energies that run through the fabric of the universe.

The legend of the Seven Sleepers recounts an ancient tale of a cave near Ephesus, where seven Christian youths miraculously survived persecution for hundreds of years. This motif is repeated again in the story of King Arthur and his knights, who sleep underground until the need of England summons them to life once more. This state we encounter here is that of dormancy, the life before birth and after death, the inchoate state of the embryo as it develops. It is the state too, of the one who is being initiated into the mysteries of life and death. Standing here, by this motionless boat, yearning to eavesdrop on some private sharing of secret lore, we are held suspended in a deep tranquillity. These Seven Sleepers retain an ancient wisdom, recalling a time of harmony among all living things, the *Unus Mundus* of the alchemists, that state of psychic wholeness so prized by Jung.

Breaking in to our deep reverie, the cries of ravens recall us to our path, to head on to the end of the underground passage, following the underground stream, where a third boat awaits us, half-turned, as if

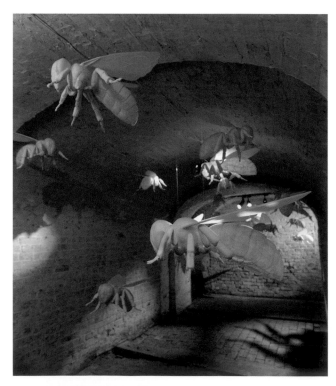

drawing in to some unseen dock. Reluctantly, we turn away, surprised and bemused to see a small flock of ravens, in a flurry around this last boat. It seems that the boat is their serious concern, whether landing, perching, or suspended above it in flight. There is no surprise that their number is seven, but with this count, a thrill of realisation, an epiphany, reveals itself. What we have travelled through from our entrance, is no less than an evolution of being, from snake to human to bird, and ascent of being, from earth to air. The exultant calls of the crows and ravens, those cleverest of birds, announce this transcendence, a transformation performed by our underground voyage. More, we now realise what was conceived in Athens, and born into the light of Crete, has reached here its own rebirth.

The raven is the agent of transformation, stripping and cleaning the ephemeral from the eternal, exposing the hidden structures of life itself. What speaks to us here, in the raucous calling of the ravens, is the voice of Nature herself, prophetic words of encouragement:

Away O soul! Hoist instantly the anchor! ...
Sail forth, steer for the deep waters only,
Reckless O soul, exploring, I with thee, and thou with me,
For we are bound where mariner has not yet dared to go...
O my brave soul!
O farther, farther sail!

It is borne in on us as we view these busy creatures of transformation, that the stream that has carried our frail vessels along, this river that flows through the underworld, is one of the mysterious waters of darkness that animate our human form. Its snaky course, helix-shaped, spirals through the dark hinterland of matter, ferrying the initial fires of creation from that unimaginable forge, into the fabric of life. This is the Promethean task of the artist, her artefacts, the fennel stalks, which harbour the divine sparks that light up and warm our dark terrestrial abode.

But we are called to move beyond this epiphany, as the voices of bees, and a brief recollection of white shapes glimpsed on our journey urge us to explore further. Leaving the main passage where the boats rest, we enter a kind of labyrinth, at whose end white forms almost flare in the dim surroundings. As we turn into yet another vault, we are met, suddenly and unexpectedly, with a swarm of pure white

bees, suspended in flight, scattered awry. Their susurration calms the spirit, as it conjures up green landscapes, colourful blossoms and warm sunshine. We have here a considerable contrast to the gloomy, mysterious passage we have left, and yet it presents its complement and fulfilment.

If the busy ravens have properly completed their transforming task, the human soul is now released into its bee-like existence, creative, exultant, immortal. Having passed through its difficult initiation into the mysteries of birth and death, we are to become creatures of the imagination, under the sway of the artist's spirit. The revelation here is that our god-given task is to transform.

Transform? Yes, for it is our task to impress this provisional, transient earth upon ourselves so deeply, so agonisingly, and so passionately that its essence rises up again 'invisibly' within us. We are the bees of the invisible. We ceaselessly gather the honey of the visible to store it in the great golden hive of the invisible.

Here all the figures are in the air, and their whiteness emphasises their transcendence of the material dimension. This is the state called by the alchemists 'Sublimatio': "the process of purification and clarification whereby the volatile spirit is extracted from the impure matter or body". The bees represent this natural ascent of the life essence, as they mediate between the temporal and the eternal, earth and sky. In the organised structure of the hive, the bees truly offer an image of the precision at the heart of nature, and of the creative process itself, which orders and nourishes the human soul.

The true destiny of the artist is to penetrate the darkness of this occluded, temporal world, to gather the essence of wisdom, the sweet nectar hidden in the many forms of matter, and to administer it to the waiting world. See, they say, artist and bees alike, we are immaterial essences, hidden in the ephemeral husks of matter. See, we are headed for the immortal shores of eternity.

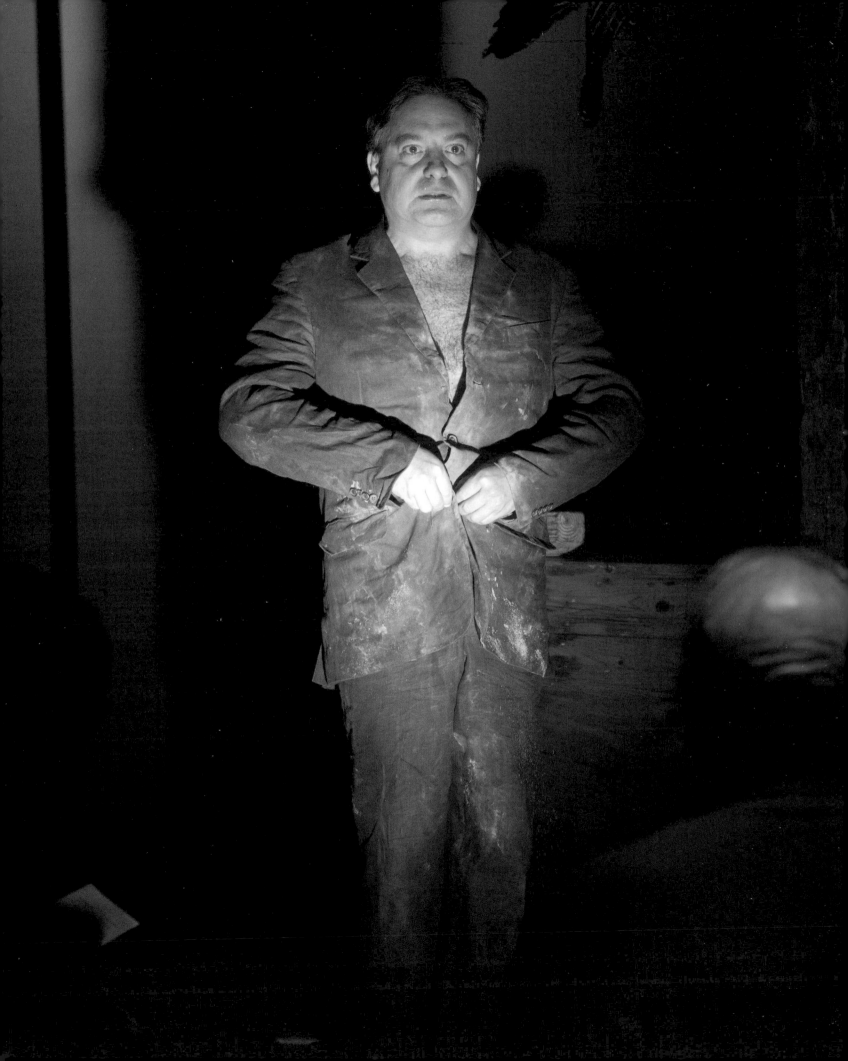

A conversation between Kalliopi Lemos and Theodoros Terzopoulos

In October and November 2011, Kalliopi Lemos collaborated with acclaimed theatre director Theodoros Terzopoulos. Under his direction, actor Paolo Musio performed the play *Il Deserto*, written by Carlo Michelstaedter, that was staged in the context of Lemos' exhibition Navigating in the dark—Part 3 at the Crypt Gallery of St Pancras Church in London.

In January 2013, Lemos and Terzopoulos had the chance to recall and discuss this collaboration:

Kalliopi Lemos: I have been very interested in multidisciplinary projects and I am always looking for collaborations that will stimulate a dialogue. For example, I find great inspiration in theatre, from the ancient Greek tragedies and the Japanese Noh tradition to contemporary body expression theatre, and also in contemporary dance, from Pina Bausch's and Merce Cunningham's performances to the Japanese *butoh* movement. From the first time I saw your work, Aeschylus' tragedy *Prometheus Bound* performed in Eleusis, I believed that there could be a very productive dialogue between my sculptures and your theatrical work. At the same time I find intriguing the stillness of sculpture combined with the expressiveness of the theatrical medium. In your work, Theodoros, you have the element of time and this is very important, whereas, in my practice, time freezes. When the sculpture is completed and out of the studio, it 'freezes'.

Theodoros Terzopoulos: This is inevitable in theatre, as there is always the use of the word, the next word, and the next phrase. There is an event and it moves, warms up and becomes alive.

KL: And every day the theatrical performance becomes something different.

TT: Yes, but I would also say the same about your work. It looks different each day, because you look at it differently. It changes. I believe that everything changes.

KL: For me, the 'live' component of another discipline with my work initiates a dialogue and makes it feel even more communicative.

TT: Changes occur anyhow. And everything that changes, does not die, it remains alive. And even if it 'freezes', "the ice contains heat", as Heiner Muller used to say.

KL: I felt that the Navigating in the dark project was a journey through darkness, decay and death into life again and therefore a continuous change.

TT: Navigating in the dark was a journey in a wet landscape...

KL: An introverted, internal journey.

TT: It was explicitly an introverted journey, the *Acherusia*, the various stages that you have to go through in order to cross over to another time/world. Now, could it be Hades, a personal, ontological or an existential Hades? Unquestionably it was depth; it was a descent into the deeper layers of the psyche. And from this depth comes the energy that fuels our existence and evolution. This energy does not derive from logic, but from the inner core; and Navigating in the dark was the journey to and from the inner core.

KL: In order to get to these forms I delve into a private, dark, inner space searching with my intuition, following it like a dim little light, sometimes approaching it, sometimes losing it, but always pursuing it until I get hold of something solid. This solid thing might be a feeling, an idea or even the feel for a particular material, like mild steel or velvet, reeds, etc.. Then I continue exploring, delving deeper.

TT: In its totality, your work has a very 'earthy' quality and great power. One can see this chthonic, underground, earthy tradition and a depth. And in this sense, you deal with archetypes. When you explore the depths of your psyche, the imagery and your forms become archetypal; they are not realistic or naturalistic, as is the representation of an ephemeral reality. You have an unfamiliar form that comes from within and this is the true meaning of the archetype; it is the expression of structure, the form of depth. It is the opposite of social interpretation and reflection.

KL: This is the reason I am always interested in the earliest forms of artistic expression; whether I find them in the West or East, I am fascinated by how similar all human beings are when we approach the core of our existence.

TT: When I first encountered your work what immediately came to mind was Japan and *butoh*; *butoh* performances, the *butoh* philosophy. The Japanese, in general, are very introverted and internal, their energy enters the depth of their psyche and then it comes out with great economy, very slowly. Time becomes the ritual. In contrast, Mediterranean people take this energy out quickly. But your work has this Japanese energy that comes out slowly. The movement is very esoteric, very deep and within. You seem to be in a constant search for the unseen side of human existence, the unconscious.

KL: It is true that I have been attracted to the Japanese culture and its different creative expressions, whether it is theatre, literature,

architecture, the gardens or *ikebana* ('flower arrangement'). I was drawn to this meditative way of understanding and dealing with life. The Japanese have a greater acceptance and openness in things left undefined; therefore they allow space for the ineffable, and the unpredictable. I believe that all of us can identify with this. My work relates greatly with such a notion.

TT: Yes, it is inexplicable, undefined, unpredictable and unfamiliar. When you move deeper, you meet unfamiliar images, dreams, nightmares, and your unconscious. Then you need to ascend back out slowly and carefully, like a rock climber, otherwise you might get lost within the depths of your own existence. Extroverted art, on the other hand, needs minimum attention, as it is spectacular, commercial and ephemeral. But this is a tendency that has dominated the arts for some time now. Oblivion and non-memory have been systematically cultivated.

KL: Navigating in the dark is all those ideas and feelings you mention. The whole project is about the human effort to reach an inner centre, to find a support foundation, one's inner core. And when we discussed about incorporating a performance in the context of the final exhibition of this trilogy in London, I felt that there could be no better way to express my intentions than through the medium of theatre and your proposed work *Il Deserto* by Carlo Michelstaedter.

TT: In his performance Paolo Musio (the actor) brought something that was 'nested' deeply in your sculptures; and that was fear.

KL: I would rather say pain combined with wonderment and a strange combination of agony and confidence.

TT: An ontological agony. Paolo's performance felt as if he came out of the boat that was taking him to Hades, shared his agonies with the audience and then took his position back inside the boat again. In that sense, the relation was not descriptive but energetic. There were multiple energy levels that brought fear, memory, madness... archetypes. These elements in your work are the reason I see a connection with *butoh*, because *butoh* brings out the inner state of the human condition.

KL: And similarly I feel that all these elements that are my concerns connect our two different disciplines.

TT: If you ask me, I would say that our connecting point is our meeting in the depth [of the psyche] and all its unforeseen, unfamiliar, unpredictable and sometimes dangerous consequences. But all

this is fascinating, because an internal dialogue, a dialogue from within, creates fermentation; whereas a dialogue coming from without is just chatter.

KL: I agree. The expression of the pathos of the psyche on the body that is primarily the point of your practice is exactly what I strive to make my sculptures be. In fact, they are like my body experiencing life. They are the mirror of my psyche.

TT: But it is a distorted and broken mirror and you agonise to find ways to assemble the pieces. Representation does not exist anymore. But I believe very strongly in the moment and the sign. The sign may lead you to a dramatic direction. And you may believe it and follow it. Then, when you enlarge it, it becomes this infinite space where you can swim and struggle. But if you override it, it will seek revenge against you. You need to respect it, because what you create is a living organism, even if it is made of metal, clay or paper. It becomes a living organism because you give it your soul and the material becomes the flesh and the voice.

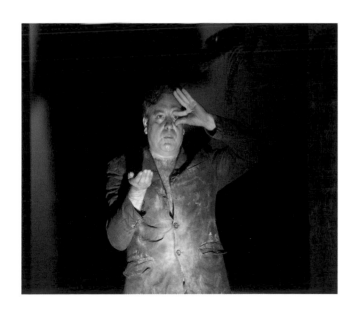
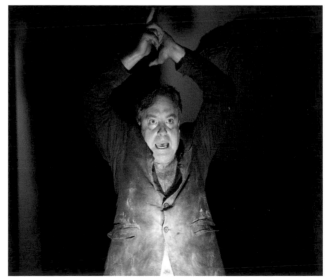

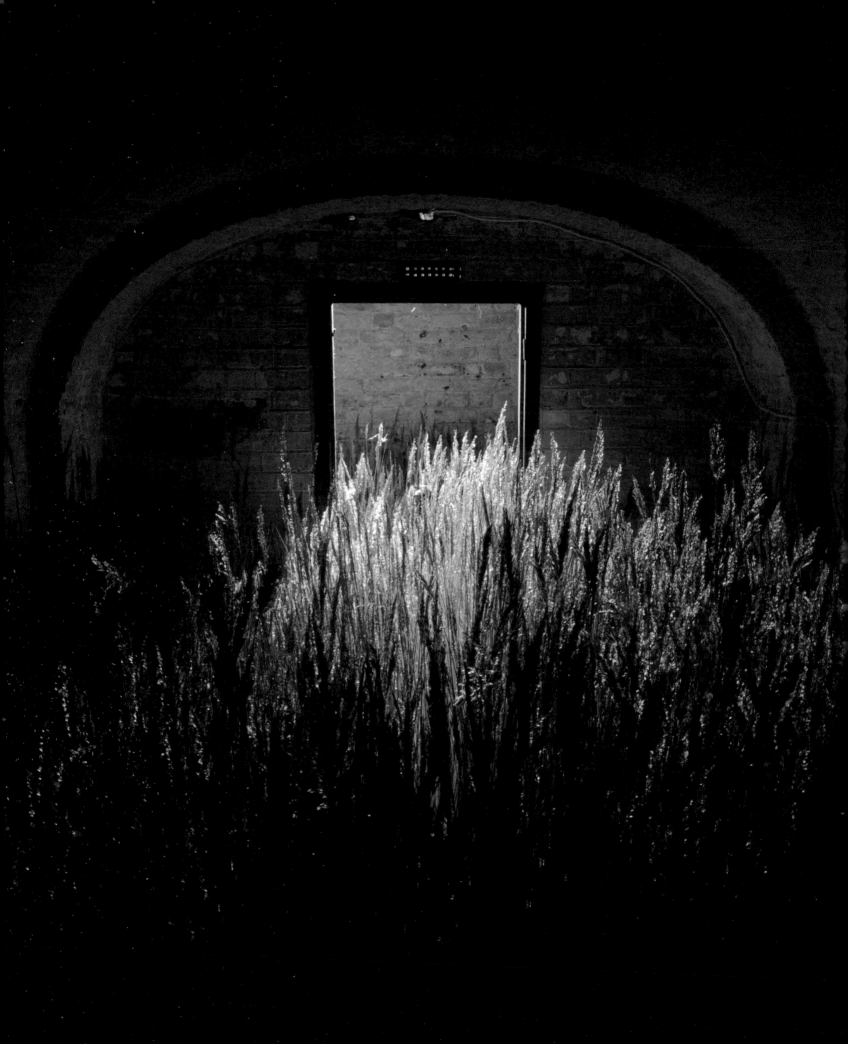

A Sculptural Navigation

ARTHUR C DANTO

I know of no work quite as ambitious as Kalliopi Lemos' Navigating in the dark. A trilogy of linked installations, it represents a journey in three stages, set in three significant buildings in different cities—Athens, Rethymnon and London—and a virtual one, 'The Afterlife'. No one really knows what The Afterlife consists of, or if there even is an Afterlife at all, but in the third installation, in the Crypt of St Pancras Church in London, there is a passageway in which Lemos has placed three wooden boats—one of which could be read as the Vessel of Charon, whose task it was to transport the souls of the dead to The Afterlife, from which no one returns to tell us what it is like.

It required considerable travel to have seen the entire work, from Athens to Crete to London, though I suppose that it would have been possible for all three installations to have been accessible at the same time. In principle that leaves a question of how the work is to be experienced, most likely in a museum in which all three of the installations can be experienced in the course of an afternoon. My view is that the sculptures belonging to the separate installations must be placed in spaces fashioned more or less as we see them in the various architectures that belong to the various buildings that caused Lemos to choose them in the first place. Thus, the first space has to have an hexagonal pool; the third space has to have a passage, etc.. The artist's aim was to construct a pilgrimage that would be evolving and developing, not only in space but also in time. So housing the three installations will require more than just transferring the sculptures into, say, three white cubes.

Each of the three installations has a different theme. The first concerns life as something created though sexual union. The second concerns life as something lived, that is, the narrative that is lived out according to the Three Fates. The third installation is the preparation for The Afterlife. The meanings of the sculptures in each installation are more or less universal, and embodied in natural objects that are easily read. Thus one of the four sculptures in the first installation is a swarm of winged penises buzzing in and around a pubic thicket. There is what could be a boat by cutting away a segment of what looks like a worm which, were it intact, might be a kind of penis. Next to it and diagonally across the garden is a large fig, long seen as a metaphor for a vagina. Occupying the remaining corner of the garden is a pair of leaves, about to flower at the tip of a long eccentric stem surging upward from a seed. These erotic objects surround a hexagonal pool at the centre of the garden, itself made of hexagonal cells as a honeycomb and in it are human heads made of mild steel, formed with facial features that express pain.

The second installation, in my view, deals with a second meaning of 'life', namely the biography of one's birth and death, triumphs and failures. The sculptures here are a glassy egg-shaped shelter in which are three goddesses, possibly the three Fates: Klotho, Lakhesis and Atropos.

Beyond the shelter of the three Fates is a screen of boats in the shape of blades, while opposite are some delicate boats in the shape of ballet slippers. Each soul has, in consequence of the Fates, a kind of biographical DNA. There is a darkness we each have to navigate in the ordeal of birth, but we are prepared to learn upon our entry into the world.

The winged penises and the honey pool of the first exhibition refer us to the third installation, where the penises turn into honey bees. As sculptures the bees are made of paper, brilliantly crafted, signifying art, the same way as the field of reeds signifies the wisdom of nature. Those beings ferried out through the passageway of St Pancras are bloodless souls. In Homer's poems, heroes descend into The Underground and converse with the dead, or afterlifers, who complain of their condition.

One reason that there might be nothing that distinguishes The Afterlife is that it might just consist of a next life, with everything between lives forgotten. This is the gist of a myth, with which Socrates ends Plato's Republic. It concerns a soldier, Er, who seems dead on the battlefield, but is not thrown on the funeral pyre since his body does not give off the stench of putrefaction that marks death. Instead, Er moves with the souls of the dead who undergo a post-life education and as they are instructed in what sort of life to live, he cannot help internalising the curriculum. When it is completed, the souls must choose from an array of different lives, laid out on a meadow. Each chooses his or her next life, and if they choose wisely, it will be a good life. Epeus, a sort of engineer who designed the Trojan Horse, chooses the life of a craftswoman, crossing the boundaries of gender. Others take the lives of animals; Agamemnon, the leader of the Greek forces that won over the Trojans, chooses to be a lion, and the great warrior, Ajax, chooses to be an eagle. Odysseus, by contrast, looks carefully for a simple life. There are plenty of lives to choose from, but once the choice is made, there is no turning back: one has to live the life one has chosen. As the book concludes, the Myth of Er prepares its characters to choose wisely, philosophically speaking. In Hinduism, by contrast, the next life is determined by the karma individuals have accumulated in their lives. When one's karmic account is entirely good, one enters Nirvana, which is bliss. Nirvana leaves all lives behind. The Afterlife of Christianity is caricatured in *The New Yorker*, where the deceased stands on a cloud, wearing a halo and gown, unless sent to Hell, of which Dante has given us the sharpest image. And then of course there is the view that death is the end of life, and nothing exalted succeeds it.

In the third installation, the one performing the passage does so in the dark, but it is only the boatman that navigates in the dark. In the stage of death, it requires genius to depict navigation, as Lampedusa does in the final chapter of *The Prince*. *The Prince* hears the rushing of waters as death overtakes him. Birth and death are unavoidably linked: the instant of birth means that death is inescapable. On the other hand, he heard

the outside sound of dying rather than hearing death itself, which is impossible. Wittgenstein wrote brilliantly that:

> In death, the world does not change but ceases.
> Death is not an event in life. Death is not lived through.
> Our life is endless in the way that our visual field is without limit.

The solution of the riddle of life in space and time lies outside space and time.

But The Afterlife is another matter altogether. The shape of The Afterlife determines what exactly it is that has made the journey from birth to death. Michelangelo's *Last Judgement* could have no meaning for Hindus. The Hindu conception of Karma, is birth, death, birth, death, birth, death… in which the self may be born an animal, a human female, a human male, another animal, perhaps a king, depending upon the karma acquired in the previous stages.

In his masterpiece, *The Phenomenology of Spirit*, Hegel, tracks 'spirit' —what the Germans call *Geist*—through many stages, in each of which spirit is the subject. Only in the final stage does spirit attain self-knowledge of its nature. We do not have a word for the 'x' that journeys from life through death to The Afterlife. We can borrow the term 'spirit' —or even Hegel's term *Geist*. The Greeks considered death to be the separation of spirit or the psyche from the body as a "little breath or puff of wind".

Certainly the Greeks depicted the dead as ghost-like entities—spirits detached from their weightless or almost weightless bodies conducting conversations in the underworld, if given an infusion of blood. It was not much of an existence. Odysseus, still alive, descends into The Underworld where he meets Achilles dead, but able to speak. He complains that he would rather be "a poor serf on earth than lord of all the dead in The Underworld". In life, Achilles liked to make love and fight. He was immortal except for where his mother held him by what is designated "Achilles tendon" leaving him otherwise immortal. Evidently, the tendon renders everything else in his body mortal. He could only speak if splashed with blood, giving him enough substance to talk. In a marvellous aside, Kant writes that "Life without a feeling of bodily organs would be merely a consciousness of existence, without any feeling of well-being or the reverse, i.e., of the furthering or the checking of the vital powers. For the mind is by itself alone in life… in union with its body." (Immanuel Kant, *Critique of Judgement*). The Greek conception of death depends on how much structure the Psyche carries with it— hardly any structure at all if it can be 'a puff of wind'. By comparison The Afterlife—or Afterdeath—is pretty speculative. So, Lemos was prudent to take the viewer only to the entry of the passage that leads to The Afterlife, whatever that is.

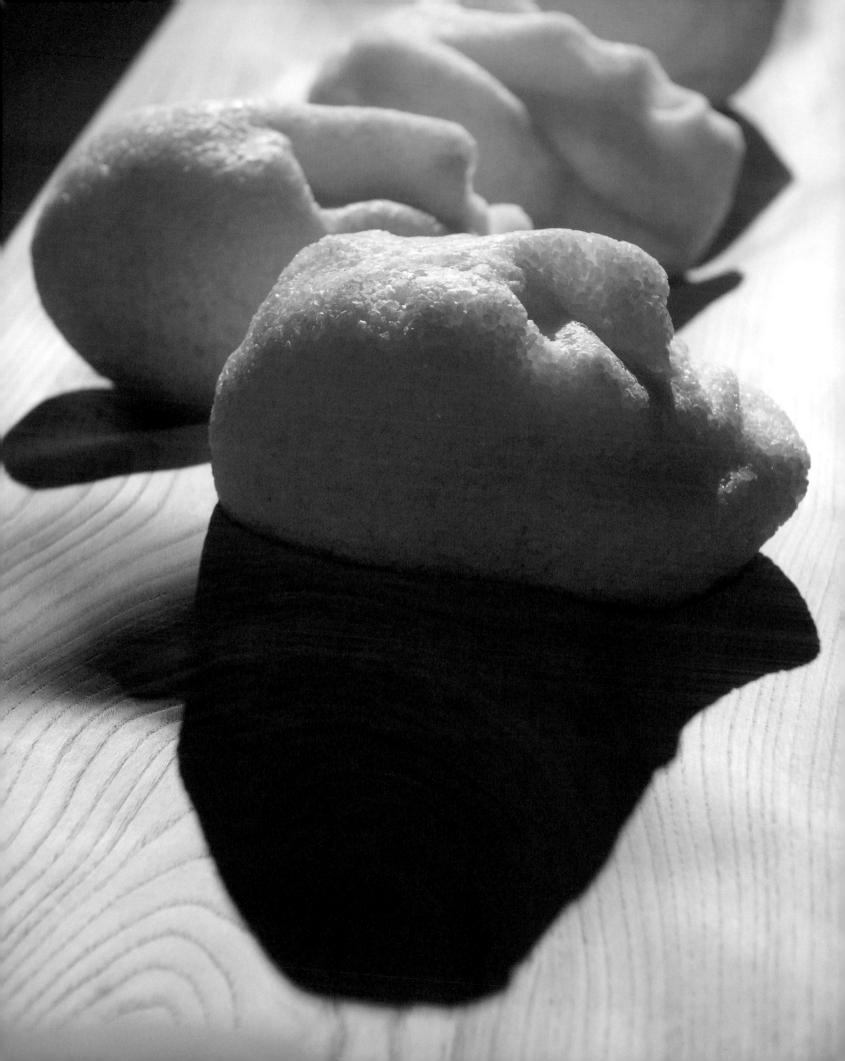

Watergazing with Kalliopi

SIMON CRITCHLEY

There now is your insular city of the Manhattoes, belted round by wharves as Indian isles by coral reefs—commerce surrounds it with her surf. Right and left, the streets take you waterward. Its extreme downtown is the battery, where that noble mole is washed by waves, and cooled by breezes, which a few hours previous were out of sight of land. Look at the crowds of water-gazers there.

Circumambulate the city of a dreamy Sabbath afternoon. Go from Corlears Hook to Coenties Slip, and from thence, by Whitehall northward. What do you see? Posted like silent sentinels all around the town, stand thousands upon thousands of mortal men fixed in ocean reveries. Some leaning against the spiles; some seated upon the pier-heads; some looking over the bulwarks of ships from China; some high aloft in the rigging, as if striving to get a still better seaward peep. But these are all landsmen; of week days pent up in lath and plaster—tied to counters, nailed to benches, clinched to desks. How then is this? Are the green fields gone? What do they here?

But look! Here come more crowds, pacing straight for the water, and seemingly bound for a dive. Strange! Nothing will content them but the extremist limit of the land; loitering under the shady lee of yonder warehouses will not suffice. No. They must get just as nigh the water as they possibly can without falling in. And there they stand—miles of them—leagues. Inlanders all, they come from lanes and alleys, streets and avenues—north, east, south, and west. Yet here they all unite. Tell me, does the magnetic virtue of the needles of the compasses of all those ships attract them thither?

Once more. Say, you are in the country; in some high land of lakes. Take almost any path you please, and ten to one it carries you down in a dale, and leaves you there by a pool in the stream. There is magic in it. Let the most absent-minded of men be plunged in his deepest reveries—stand that man on his legs, set his feet a-going, and he will infallibly lead you to water, if water there be in all that region. Should you ever be athirst in the great American desert, try this experiment, if your caravan happen to be supplied with a metaphysical professor. Yes, as every one knows, meditation and water are wedded for ever.

Herman Melville, *Moby Dick*

HAPPINESS

What is happiness? How does one get a grip on this most elusive, intractable and perhaps unanswerable of questions?

For the Greek philosophers of Antiquity, notably Aristotle, it was assumed that the goal of the philosophical life—the good life, moreover—was happiness and that the latter could be defined as the *bios theoretikos*, the solitary life of contemplation. Today, few people would seem to subscribe to this view.

But is the idea of happiness as an experience of contemplation really so ridiculous? Might there not be something in it? I am reminded of the following extraordinary passage from Rousseau's final book and his third autobiography, *Reveries of a Solitary Walker*:

> If there is a state where the soul can find a resting-place secure enough to establish itself and concentrate its entire being there, with no need to remember the past or reach into the future, where time is nothing to it, where the present runs on indefinitely but this duration goes unnoticed, with no sign of the passing of time, and no other feeling of deprivation or enjoyment, pleasure or pain, desire or fear than the simple feeling of existence, a feeling that fills our soul entirely, as long as this state lasts, we can call ourselves happy, not with a poor, incomplete and relative happiness such as we find in the pleasures of life, but with a sufficient, complete and perfect happiness which leaves no emptiness to be filled in the soul.

This is as close to a description of happiness as I can imagine. Rousseau is describing the experience of floating in a little rowing boat on the Lake of Bienne close to Neuchâtel in his native Switzerland. He particularly loved visiting the Île Saint Pierre, where he used to enjoy going for exploratory walks when the weather was fine and he could indulge in the great passion of his last years: botany. He would walk with a copy of *Linneaus* under his arm, happily identifying plants in areas of the deserted island that he had divided for this purpose into small squares.

On the way to the island, he would pull in the oars and just let the boat drift where it wished, for hours at a time. Rousseau would lie down in the boat and plunge into a deep reverie. How does one describe the experience of reverie: one is awake, but half asleep, thinking, but not in an instrumental, calculative or ordered way, simply letting the thoughts happen, as they will.

Happiness is not quantitative or measurable and it is not the object of any science, old or new. It cannot be gleaned from empirical surveys or programmed into individuals through a combination of behavioural therapy and anti-depressants. If it consists in anything, then I think that happiness is this feeling of existence, this sentiment of momentary self-sufficiency that is bound up with the experience of time. Arguably, at its best, this is what art can do.

Look at what Rousseau writes above: "floating in a boat in fine weather, lying down with one's eyes open to the clouds and birds or closed in reverie, one feels neither the pull of the past nor does one reach into the future. Time is nothing, or rather time is nothing but the experience of the present through which one passes without hurry, but without regret." As Wittgenstein writes in what must be the most intriguing remark in the *Tractatus*, "the eternal life is given to those who live in the present". Or, as Whitman writes in *Leaves of Grass*, "Happiness is not in another place, but in this place... not for another hour... but this hour."

Rousseau asks, "What is the source of our happiness in such a state?" He answers that it is nothing external to us and nothing apart from our own existence. However frenetic our environment, such a feeling of existence can be achieved. He then goes on—amazingly—to conclude, "as long as this state lasts we are self-sufficient like God."

God-like, then. To which one might reply: Who? Me? Us? Like God? Dare we? But think about it: If anyone is happy, then one imagines that God is pretty happy, and to be happy is to be like God. But consider what this means, for it might not be as ludicrous, hybristic or heretical as one might imagine. To be like God is to be without time, or rather in time with no concern for time, free of the passions and troubles of the soul, experiencing something like calm in the face of things and of oneself.

Why should happiness be bound up with the presence and movement of water? This is the case for Rousseau and I must confess that if I think back over those experiences of blissful reverie that are close to what Rousseau is describing then it is often in proximity to water, although usually saltwater rather than fresh. For me, it is not so much the stillness of a lake (I tend to see lakes as decaffeinated seas), but rather the never-ending drone of the surf, sitting by the sea in fair weather or foul and feeling time disappear into tide, into the endless pendulum of the tidal range. At moments like this, one can sink into deep reverie, a motionlessness that is not sleep, but where one is somehow held by the sound of the surf, lulled by the tidal movement

Is all happiness solitary? Of course not. But one can be happy alone and this might even be the key to being happy with others. Wordsworth "wandered lonely as a cloud" when walking with his sister. However, I think that one can also experience this feeling of existence in the experience of love, in being intimate with one's lover, feeling the world close around one and time slips away in its passing. Rousseau's rowing boat becomes the lovers' bed and one bids the world farewell as one slides into the shared selfishness of intimacy.

And then it is over. Time passes, the reverie ends and the feeling for existence fades. The cell phone rings, the email beeps and one is sucked back into the world's relentless hum and our accompanying anxiety.

LIFE

Life is movement. It is the feeling of movement or what the Greeks called "kinesis" whose counter-thrust is lethargy, the slowing down of existence into a lassitude and languor. But life as movement can be the sheer restlessness of anxiety, the shape of a becoming that is too tightly bound to its terminus in death, a death that casts too long a shadow over life. Living in death's shadow grants both individuality and morbidity, individuality as morbidity. The trick, if it is a trick, is to dwell between movement and lethargy, to try and balance at the

mid-point between them. The meaning of life consists in the art of not being lazy without being anxious. This is very difficult. It means learning to become a tightrope walker.

INDIRECTION

What is closer to me than myself? Nothing. Yet, how does one say this? How to express this closeness as closeness, i.e. closely? It is enormously difficult, as when Heidegger says "that what is closest to me in everyday life is furthest from being understood", where he quotes Augustine saying that "I have become to myself a *terra difficultatis*, a land of toil where I labour and sweat". It seems to me that the only way of expressing the closeness of self to itself is indirectly, through other voices and personae, what the great Portuguese poet Fernando Pessoa called "heteronyms". These heteronyms are the names of strangers, they are ways of estranging the self so as to approach it, to approximate it, in closeness. This closeness to self and to world and of self to world is so close that one cannot separate them, divide and sunder them. Self and world are of a piece, they are one piece of a garment that should not be broken down into pieces like mind and reality or subject and object. They are the one piece of which I am made and which I have made. The world is what you make of it. That is to say, self and world are a fiction, a fiction that we take to be true and in which we have faith. The difficulty is making that faith explicit. Art is the attempt to make faith explicit in a fiction, an artifice.

All one can try in one's work is to tell the truth. One can only do this in a fiction, in art, by putting on a mask, by naming oneself with a heteronym. If truth is a fiction, or truth has to be related in a fiction because it cannot be articulated directly, then this raises the question: is there a supreme fiction, a fiction in which we could believe, where it is a question of final faith in final fact? Wallace Stevens insists that "it is possible, possible, possible. It must be possible", where it is at the very least unclear whether the repetition of the word "possible" is a symptom of strength or weakness. It is telling that a poet of the supreme calibre of Stevens only felt that he could write "Notes Towards a Supreme Fiction".

SUICIDE

Have you ever felt your body losing control in the sea, being swept by the swell, pulled powerless, pulled out, pulled under?

When it happened to me it made my loins tingle in the same way as when I am close to the edge of a tall building I desire more than anything else to throw myself off. I see myself flying through the air—joyous in that instant—and then bang!

I stayed in a friend's apartment in Central London for a month one summer. He lived on the thirteenth floor of a tower block on a quasi-council estate with stunning views of a panorama stretching from Highgate in the north to Clapham in the south and taking in everything in between. All I thought about for that month was launching myself from his tiny terrace. It wasn't that I felt unhappy. On the contrary, I simply wanted to feel the fullness of that loin-tingling instant as my body fell to earth out of control.

EMPTINESS

What is it about the experience of emptiness, about turning your back on the world and facing nothing?

For me, this happens in front of the sea, each time I face the brightness over the sea. One looks at the sea and feels an emptiness. Facing the sea is absence regarded. It evokes a feeling that I want to call calm. The body slows and the mind lays by its trouble and adapts itself to the rhythm of the waves, where time is tide, and tide is endless to and fro, coming and going. Time becomes a circle rather than a line, a cycle endlessly renewed rather than a movement of decline or deadlines.

At times like this, I begin to think. To be honest, I don't know what goes on in my head much of the rest of the time, or what to call what goes on in my head, but it is not thinking. Facing the emptiness of the sea, one begins to think, slowly and with a deliberate carelessness.

Cities sometimes slip into the sea, eaten alive by their thoughtfulness, like Dunwich on the Suffolk coast in East Anglia. Or the sea slips away from them, in some act of historical thoughtlessness, where tides' time thickens into silt. Harbours get blocked with silt and clogged with mud, becoming unnavigable. The land seems to rise like the wooden top of an old school desk and the cities slip back into an inkwell of obscurity, like Ephesus and Miletos on the Ionian coast in Turkey or Istria at the mouth of the Danube. Other cities are destroyed by a vindictive violence that is the enemy of thought like Carthage, ravaged brick by brick with godless Roman arrogance. Silt sometimes slows the water, allowing malarial swamps to form, like Torcello in the Venetian lagoon, the proto-Venice with its rubble in the marshes and a few lonely Byzantine mosaics.

I sometimes dream of writing a volume on the role of silt in determining the shape of world history and I imagine whole chapters on lagoons and blocked harbours and subsections on oxbow lakes and alluvial deposits.

I have, for as long as I can remember, been obsessed with cities prior to their settlement or at the moment of settlement. I like to think of what opposed sets of eyes were seeing and minds thinking as white sails were spotted on the horizon at what would become Jamestown or Botany Bay or off the coast of

the treed vastness that would become Brazil. I think of vicious settlers, happily decimating the local populations and of the broken Jesuits who landed in Brazil with the text of a Papal bull declaring that they must save the souls of the natives. I think, repeatedly, of the first European feet to tread on Manhattan, on this hilly, handsome island situated on a huge river beckoning possible passage to the Indies.

I try and think about the places I know at a point approaching emptiness and therefore, I suppose, thoughtfulness.

Emptiness—this is how the earth will be after humans have finished with it, or—more likely—it has finished with them.

MIDDLE SEA

The vast surface of the Mediterranean conceals a depth that is by no means simply aquatic. It is a space of passage, of crossings, of movement, of trade, of peoples, of goods, of languages. Rather than dividing the countries and the three monotheisms that surround it, it unites them in countless points of contact, as crucially superficial as a taste for olives, mezes and hummus. Mediterranean culture is a *mélange*, a *tissage* and *métissage*, a bastard tissue woven from distinct, yet overlapping and interconnecting peoples. The Mediterranean is a sea of communication, not segregation, of inter-mixing and not purification. It is a hybrid space, where peoples mix, match, mate and merge, and where the layering of history comes from contact, crossing and cultural braiding. The division of this common space into national territories is a late and lamentable development. The Mediterranean has no capital city, it has no defining metropolis, least of all Rome and the Roman Empire, which was always more orientated towards land than water. Its defining figure is the port, the place defined by its opening to the sea, the place of meeting and markets, of minds and merchandise, of import and export, of cargo human and inhuman.

> The many boats that cross the middle sea.
> The many that die in those boats
> *Anthropos esti pneuma kai skia monon.*

MELVILLE

Think back to where I began with the opening words of *Moby Dick*, where Melville describes the "insular city of the Manhattoes belted round by wharves as Indian isles by coral reefs—commerce surrounds it with her surf". Even here, in the entirely mercantile, commercial bustle of mid-nineteenth century New York, Melville observes, "Thousands upon thousands of mortal men fixed in ocean reveries". These are what he calls the "water-gazers", inlanders all, desperate to stand close to the water, "They must get as nigh the water as

they possibly can". Melville goes on—as only Melville can—to ponder the connection between human beings and the sea: "Why did the old Persians hold the sea holy? Why did the Greeks give it a separate deity?" He concludes that we witness something mysterious about ourselves and our origins in the contemplation of the sea, something vast, sublime and incomprehensible. He writes, "It is the image of the ungraspable phantom of life."

Try and follow that phantom and observe these quotations from Joseph Conrad:

> What commands the seaman's dogged devotion is not the spirit of the sea, but something that in his eyes has a body, a character, a fascination, and almost a soul—it is his ship.

> It seems to me that no man born and truthful to himself could declare that he ever saw the sea looking young as the earth looks young in spring. But some of us, regarding the ocean with understanding and affection, have seen it looking old, as if the immemorial ages had been stirred up from the undisturbed bottom of ooze. For it is a gale of wind that makes the sea look old.

> If you would know the age of the earth, look upon the sea in a storm. The grayness of the whole immense surface, the wind furrows upon the faces of the waves, the great masses of foam, tossed about and waving, like matted white locks, give to the sea in a gale an appearance of hoary age, lustreless, dull, without gleams, as though it had been created before life itself.

CODA

As night falls in the mountains, the sound of crows screeching and the buzzing of bees slip away to near silence, as the first frogs are heard and their huge broad bass begins to spread across the valley floor. Then, from nowhere in particular, growing like a great slow swell in the ocean, the crickets add their pulsating treble. The all-encompassing twilight vibrates with sound. I can no longer hear myself. I shut my eyes in the hammock and await the appearance of stars. I sleep. I dream of the desert. I dream of God without man.

PART 1

Navigating in the dark

BENAKI MUSEUM, ATHENS

26 January–26 March 2011

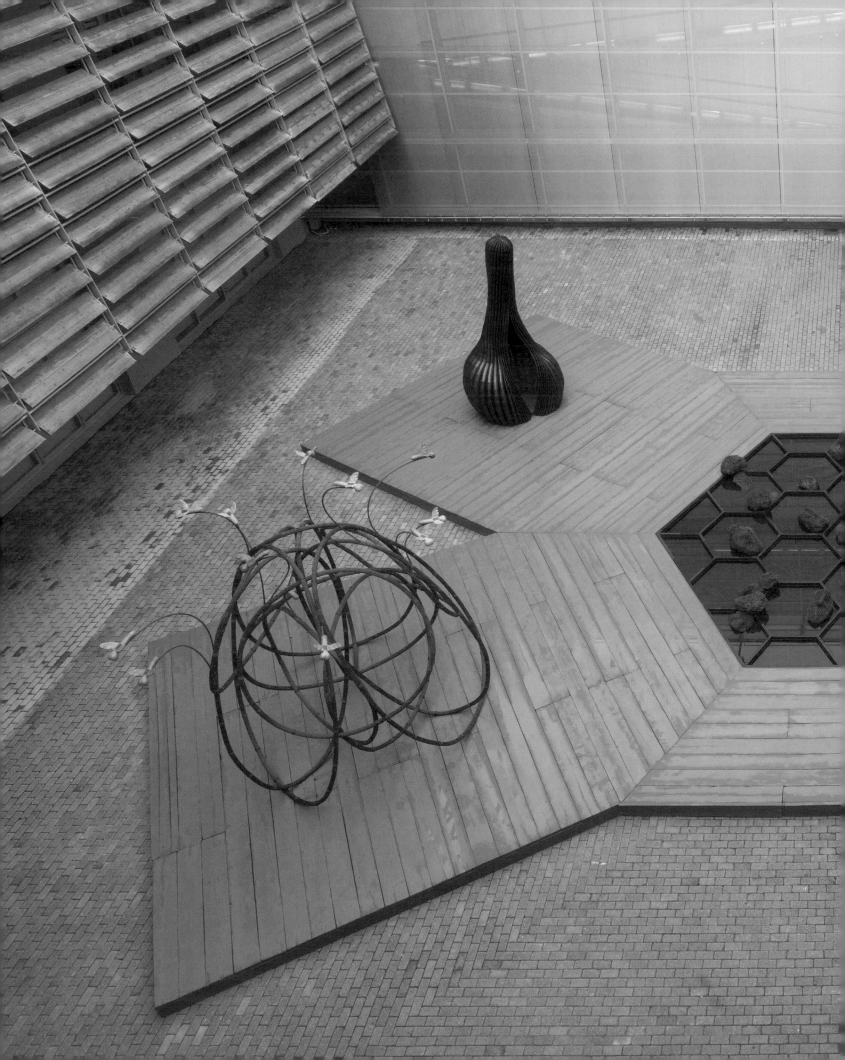

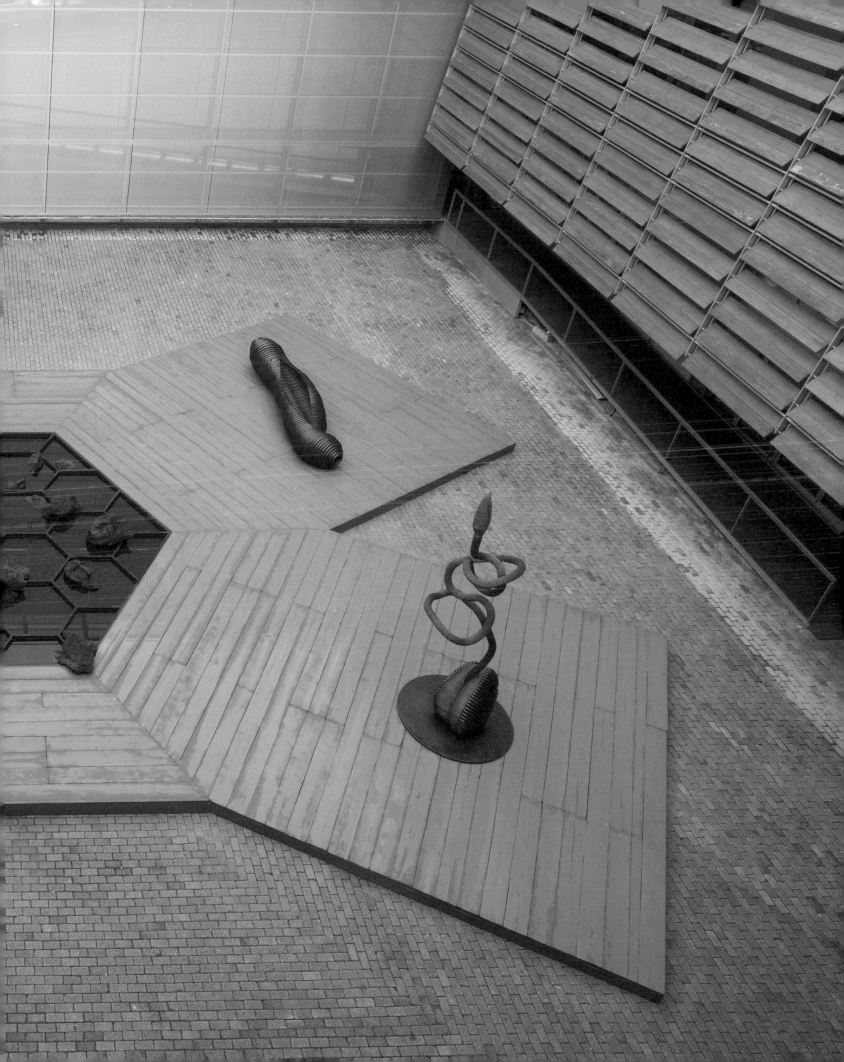

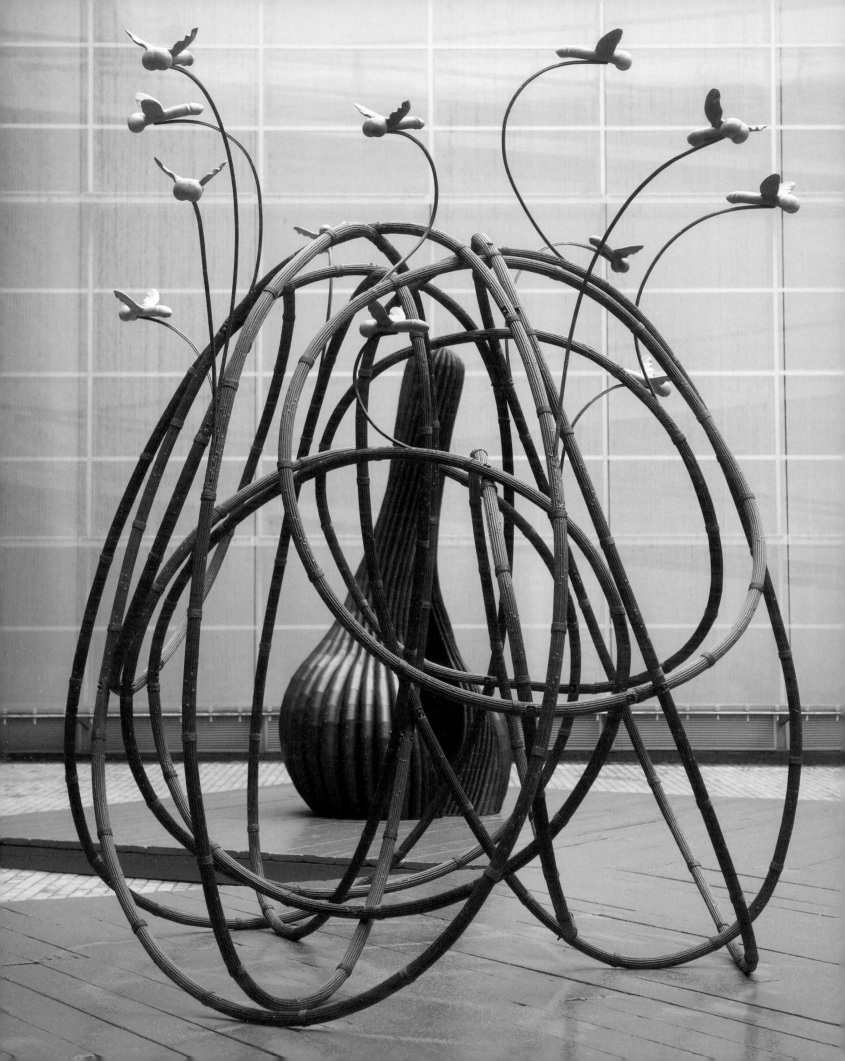

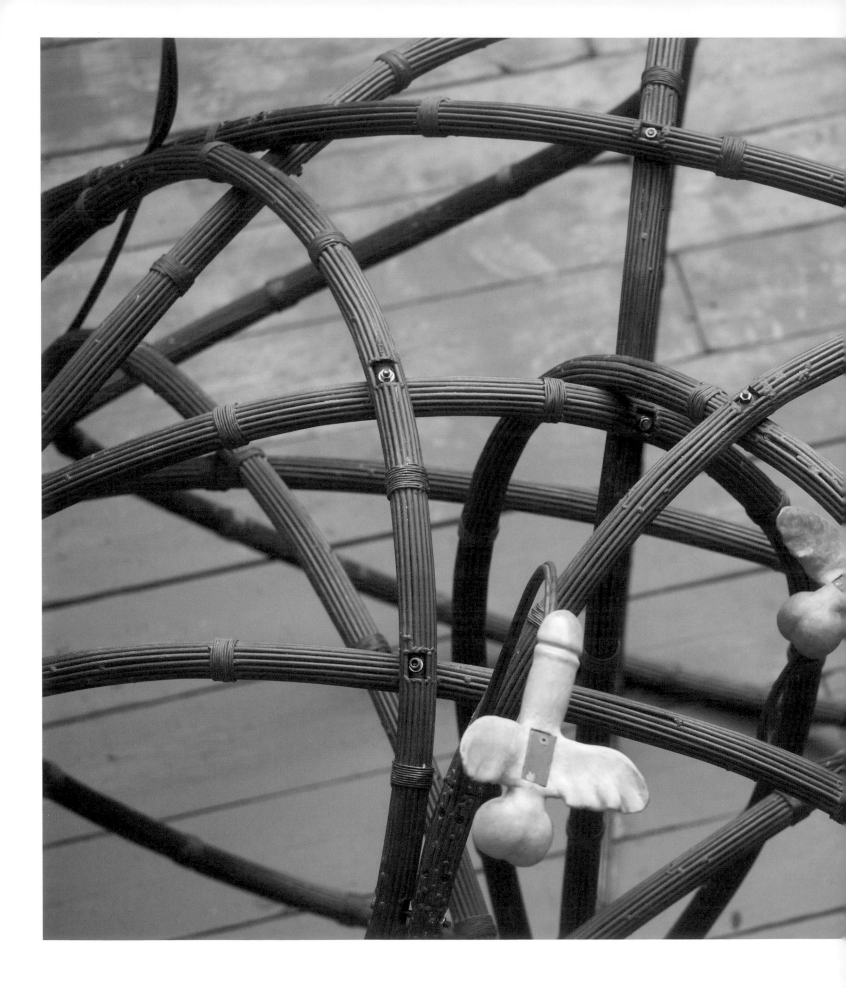

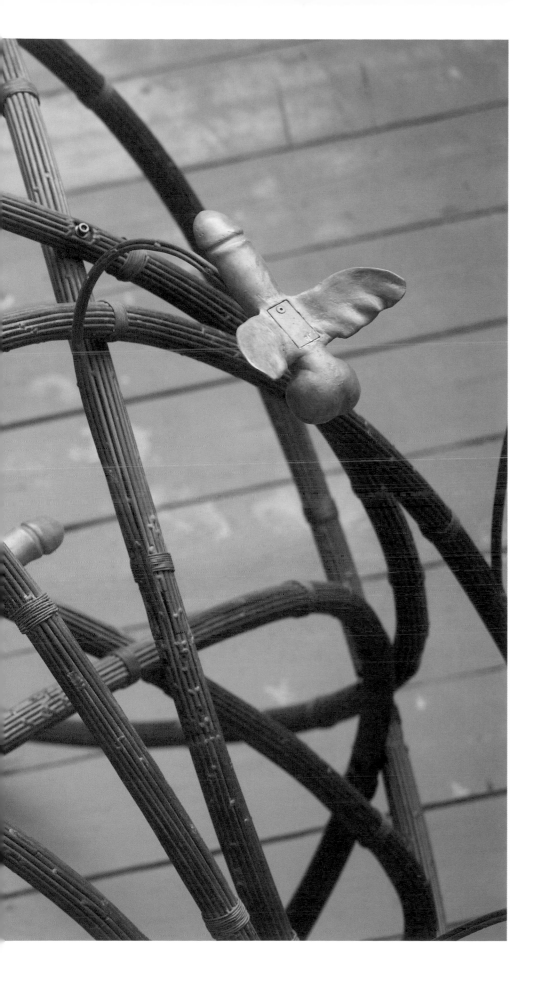

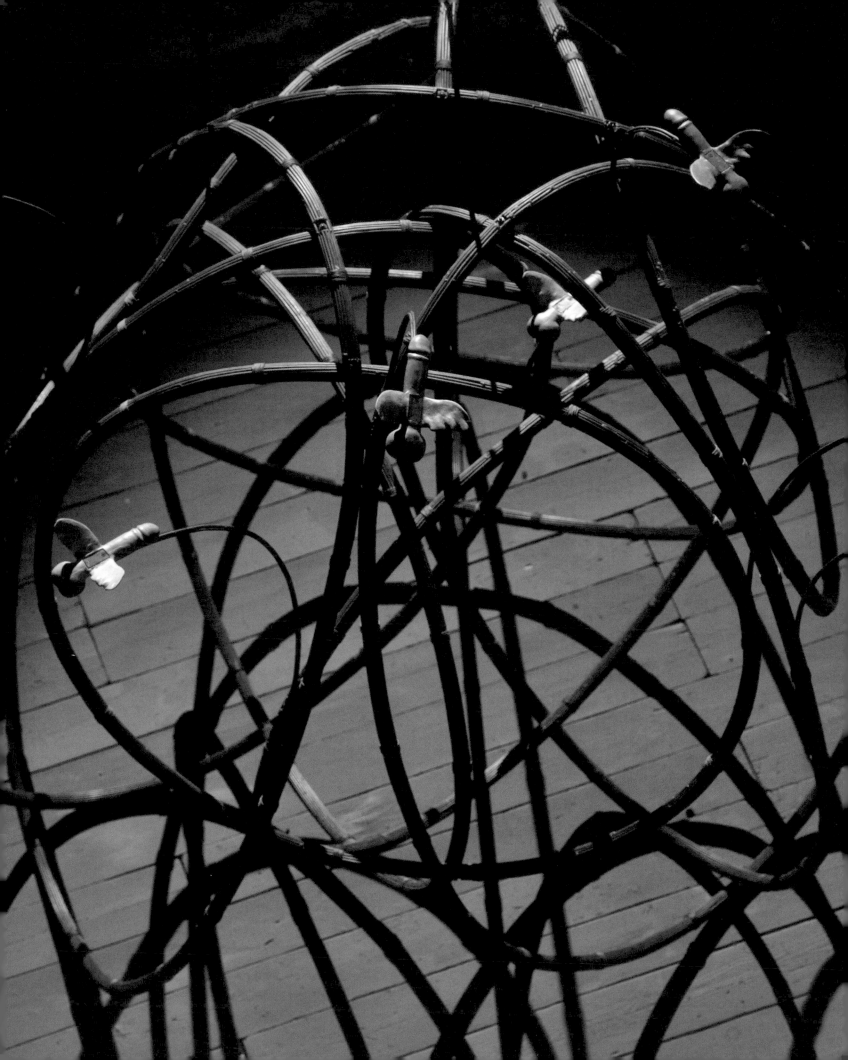

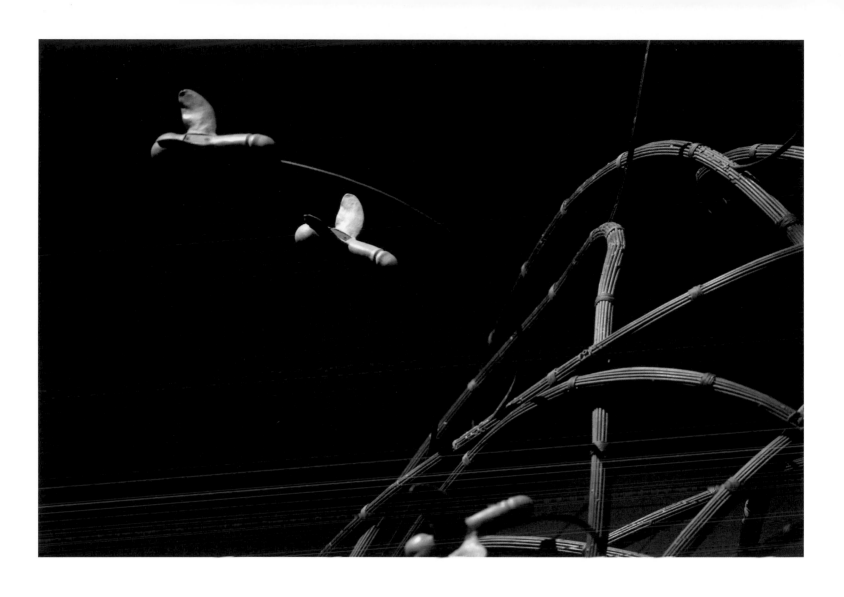

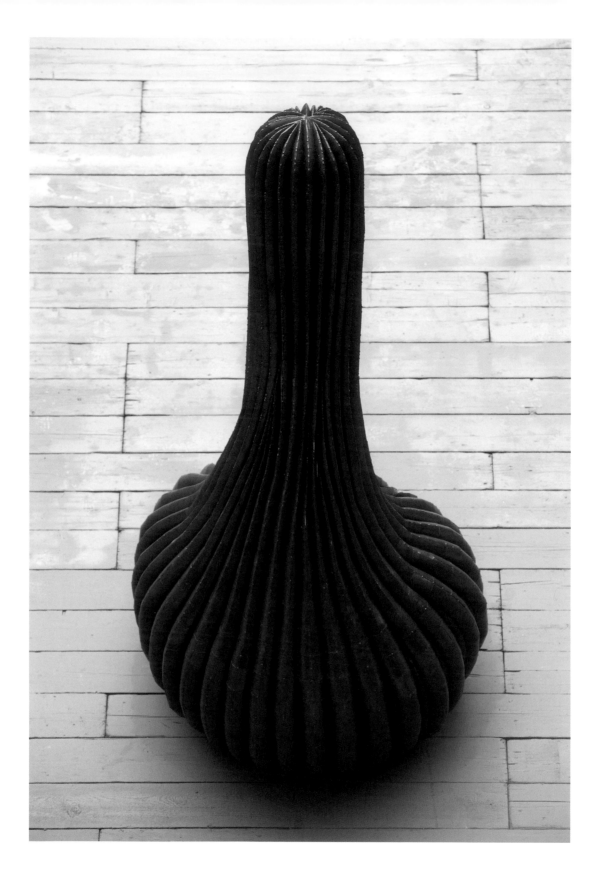

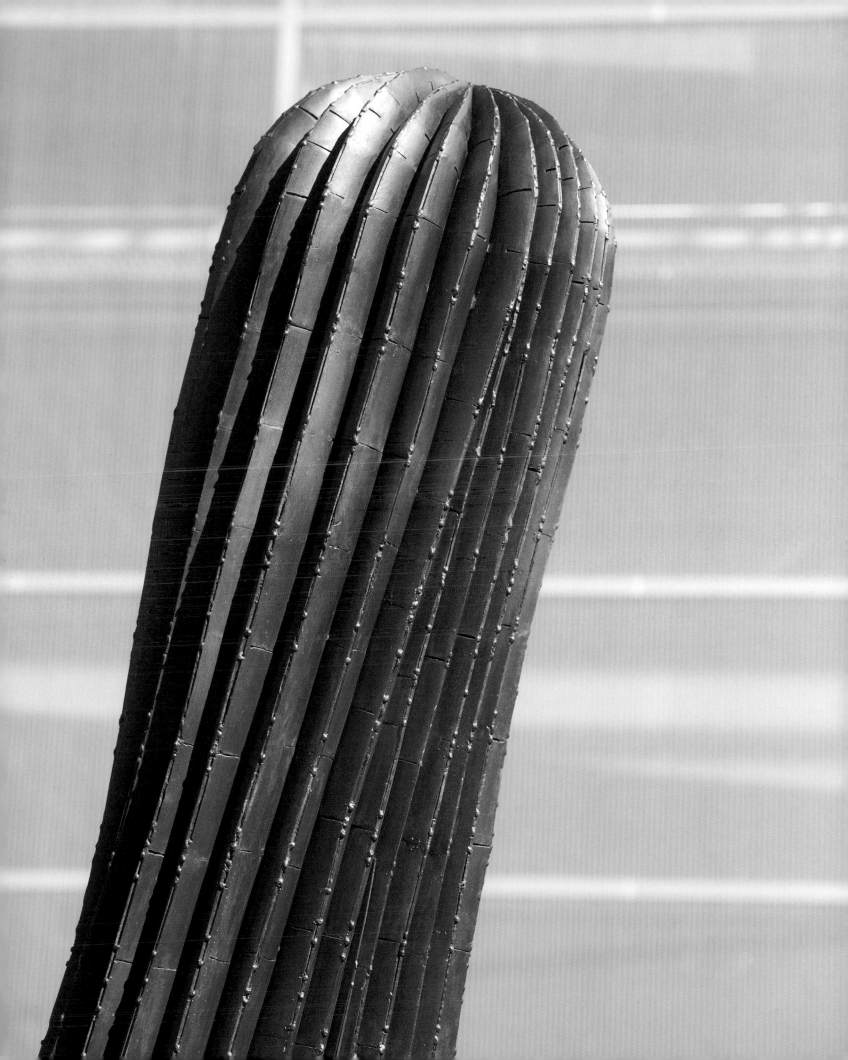

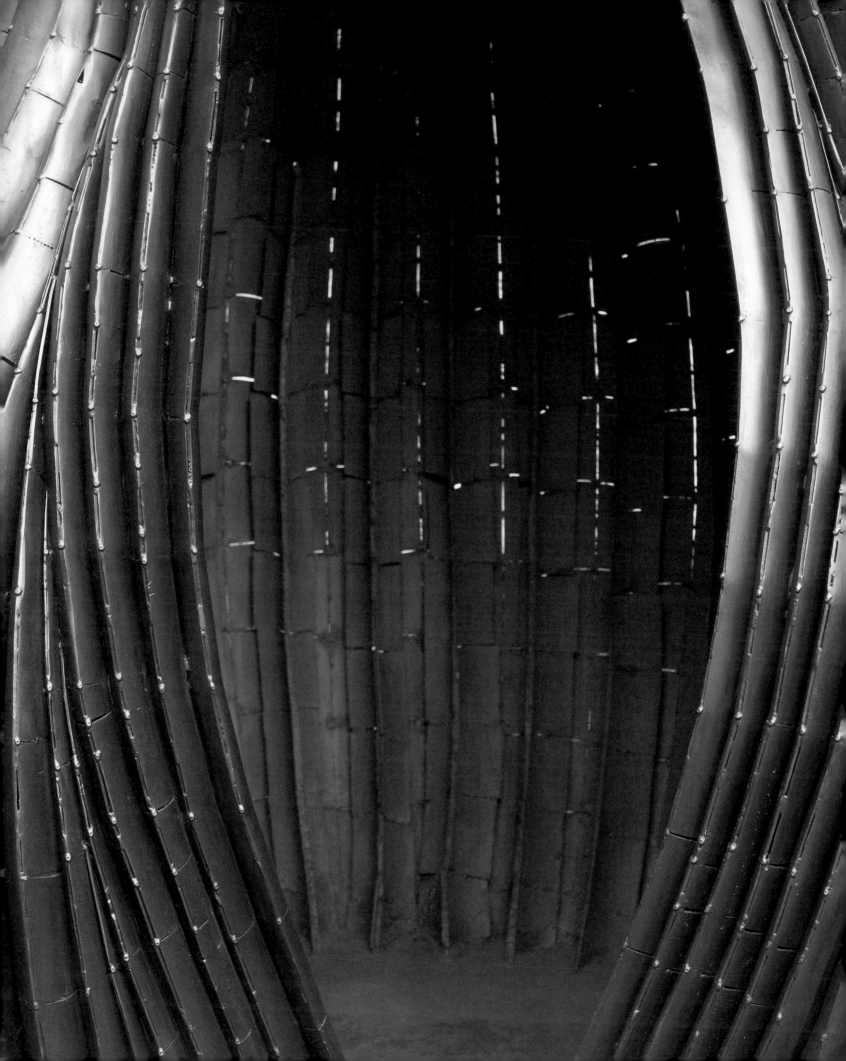

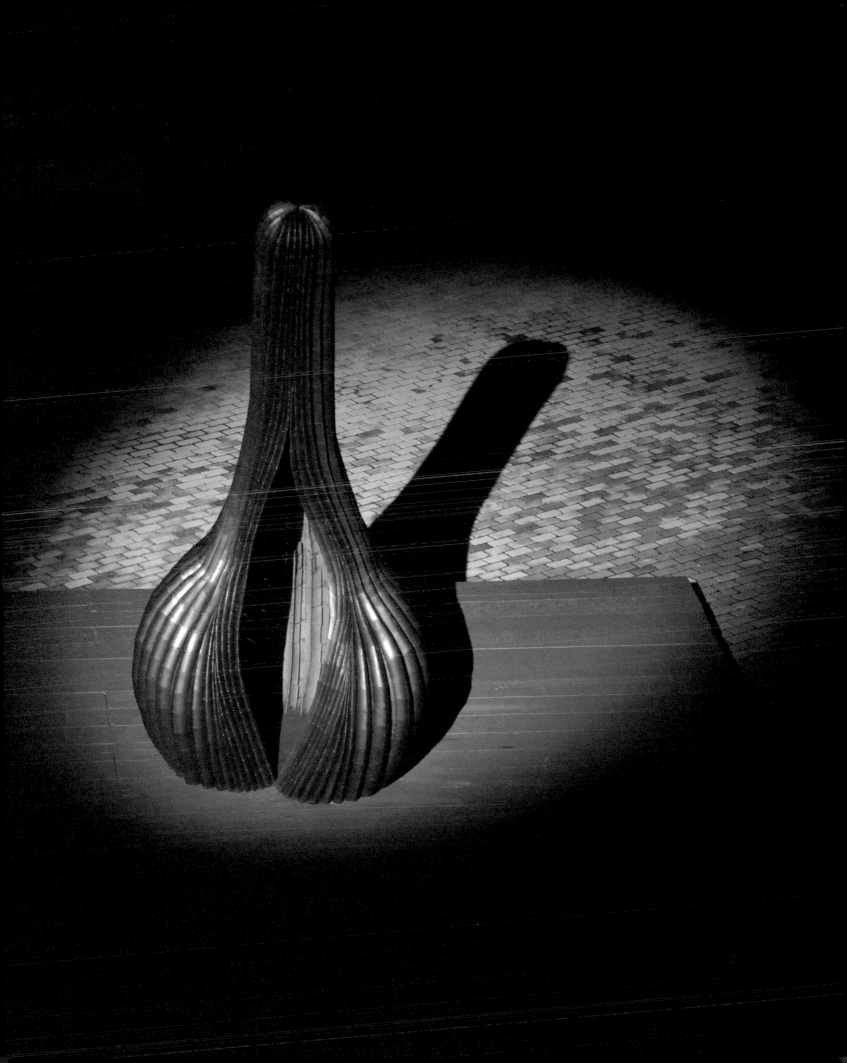

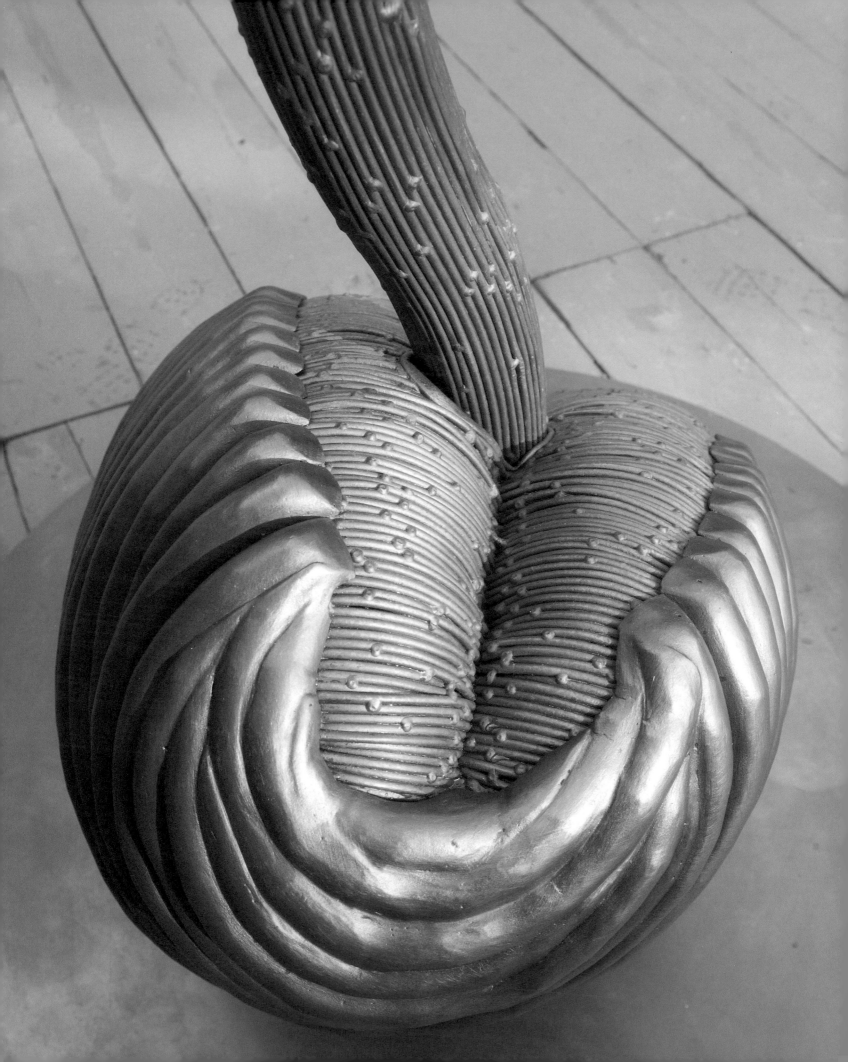

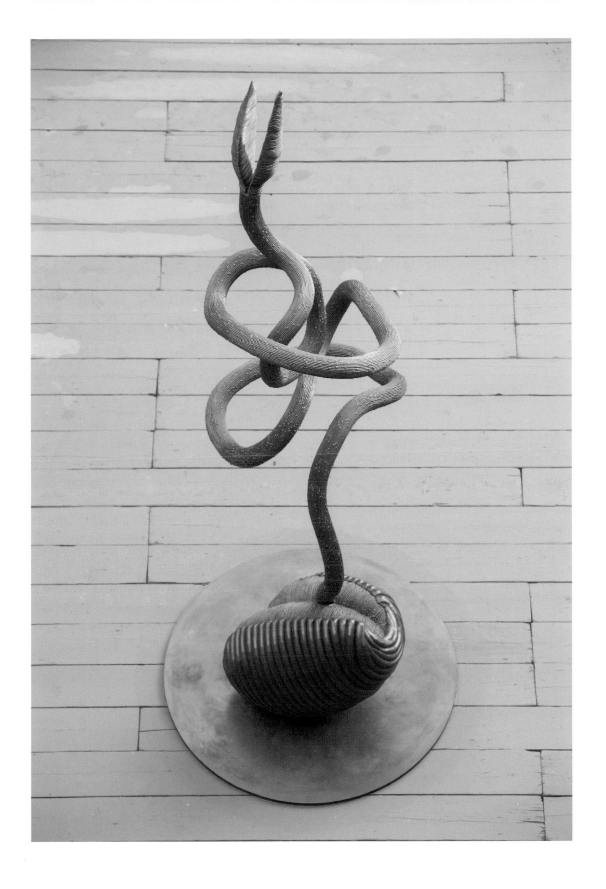

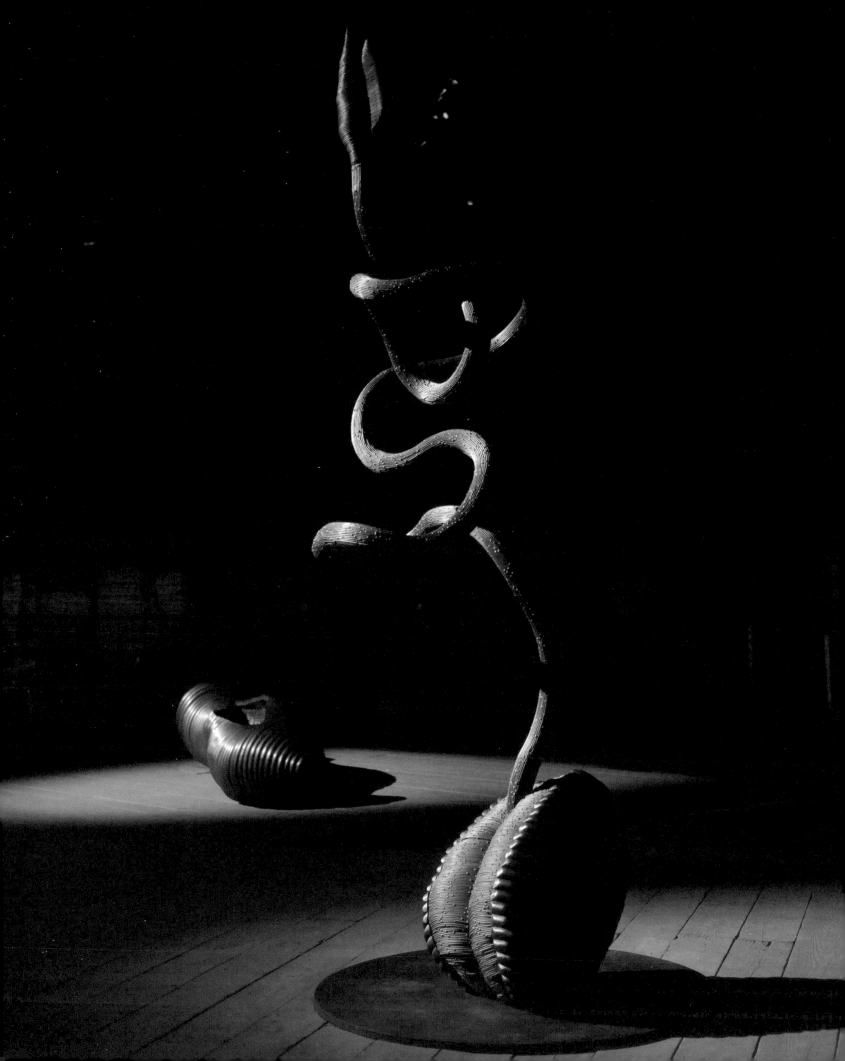

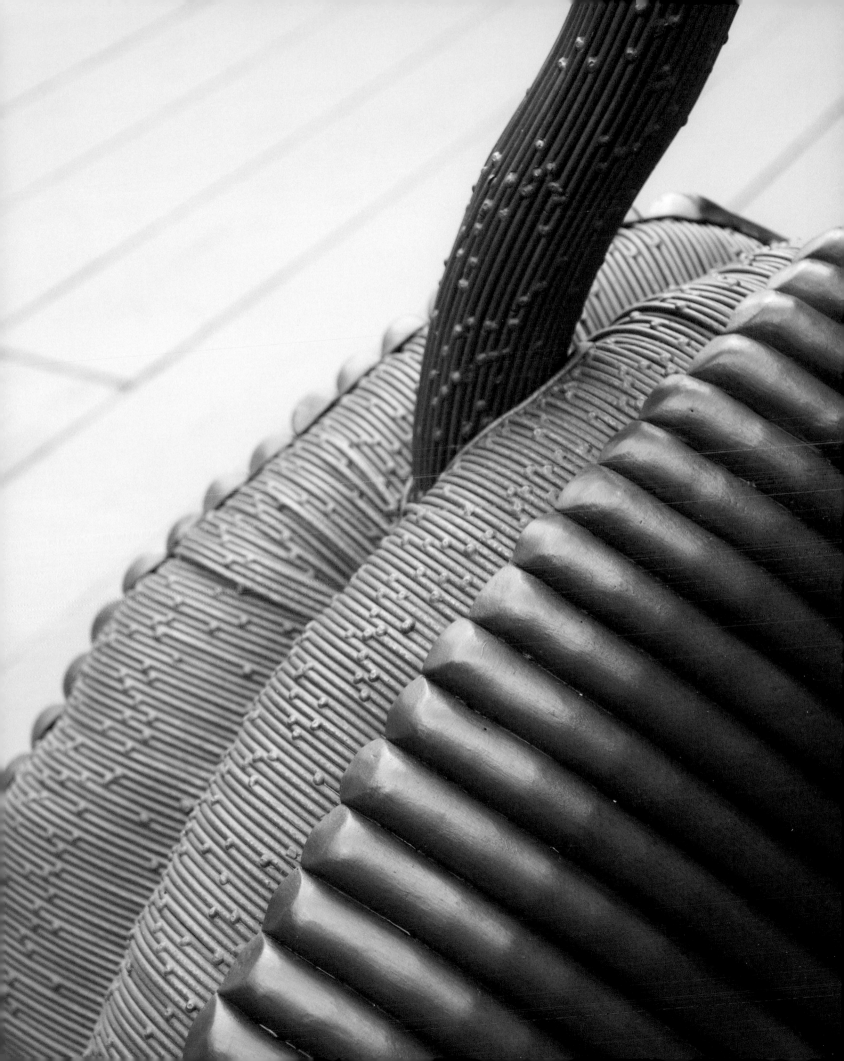

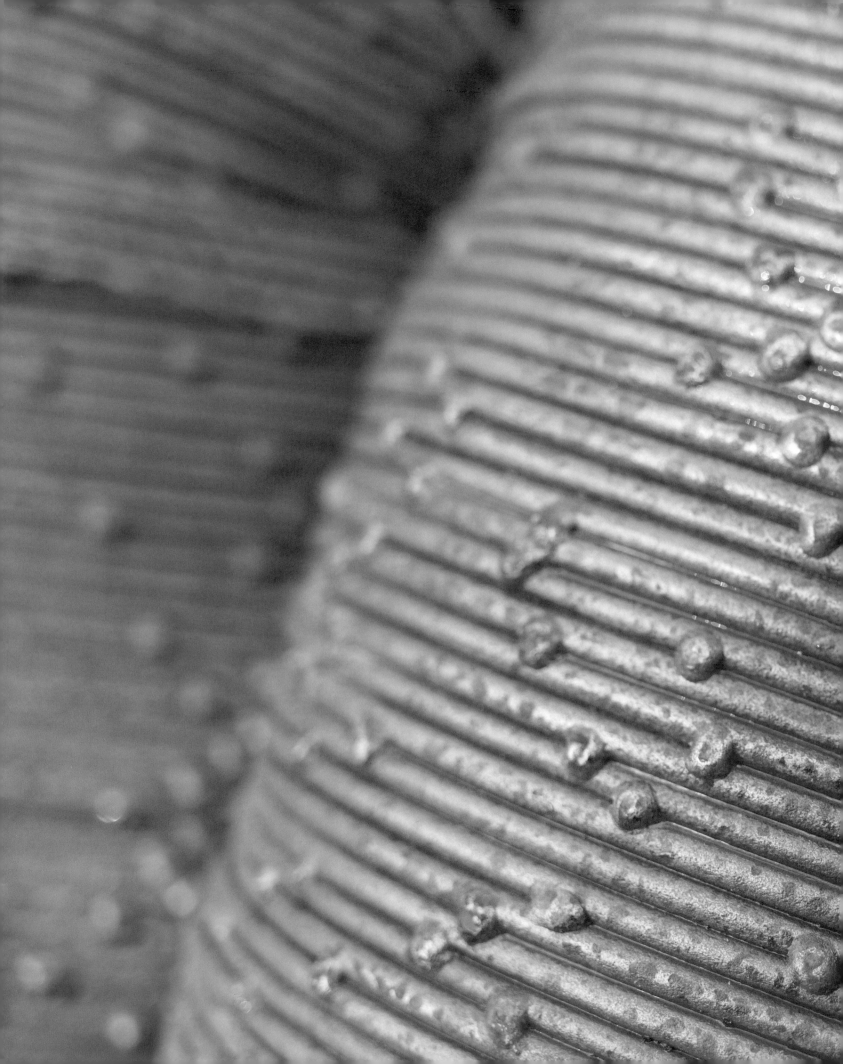

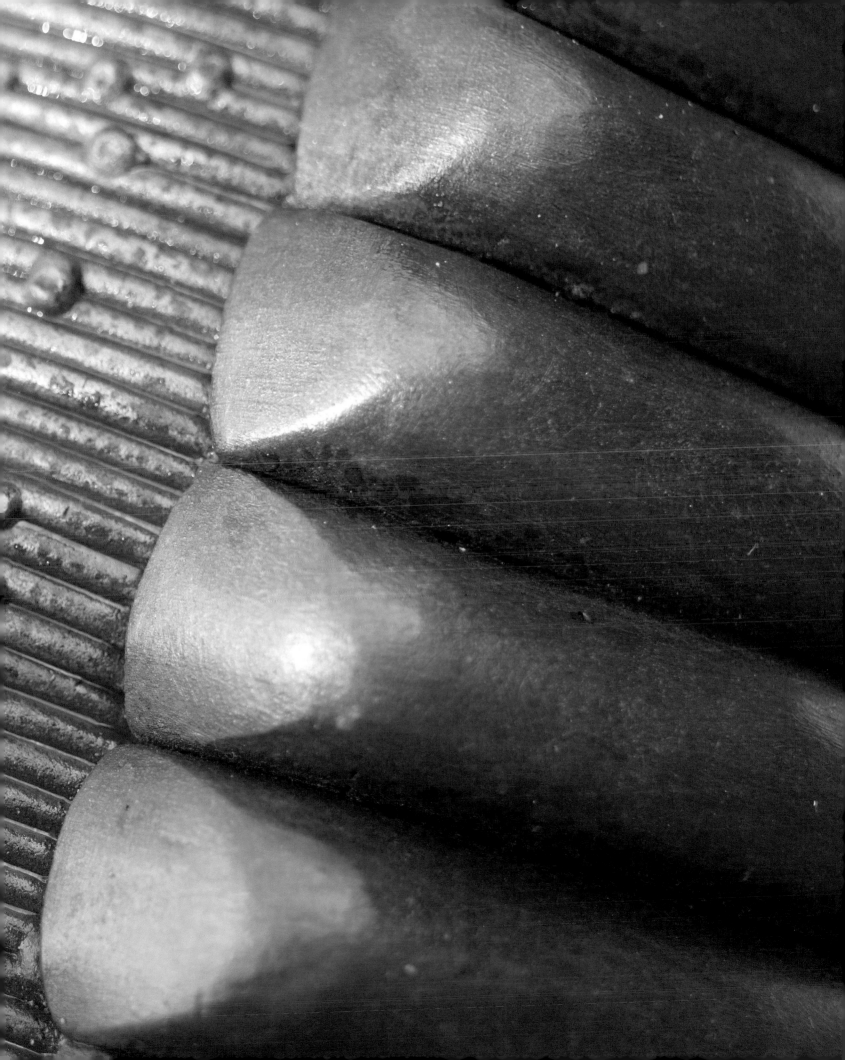

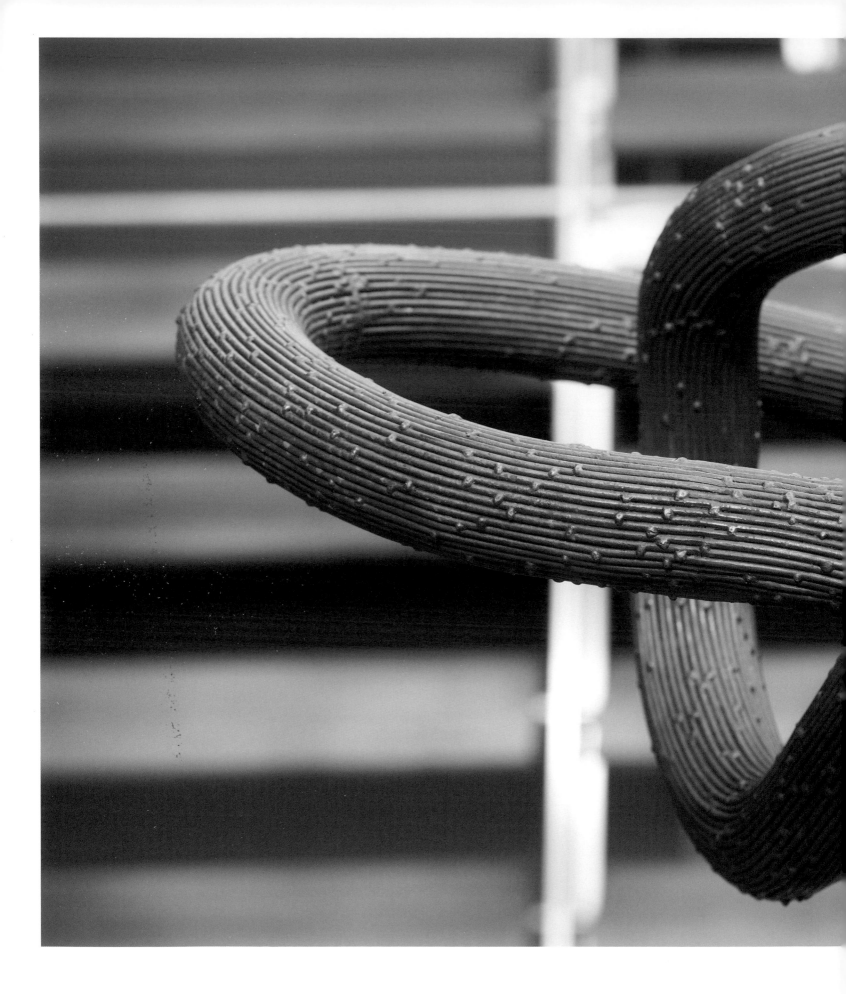

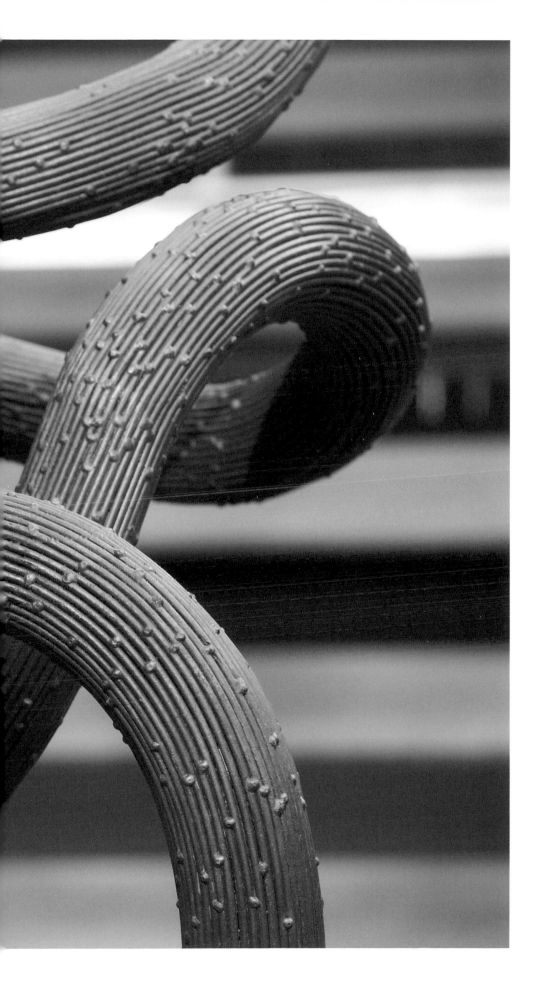

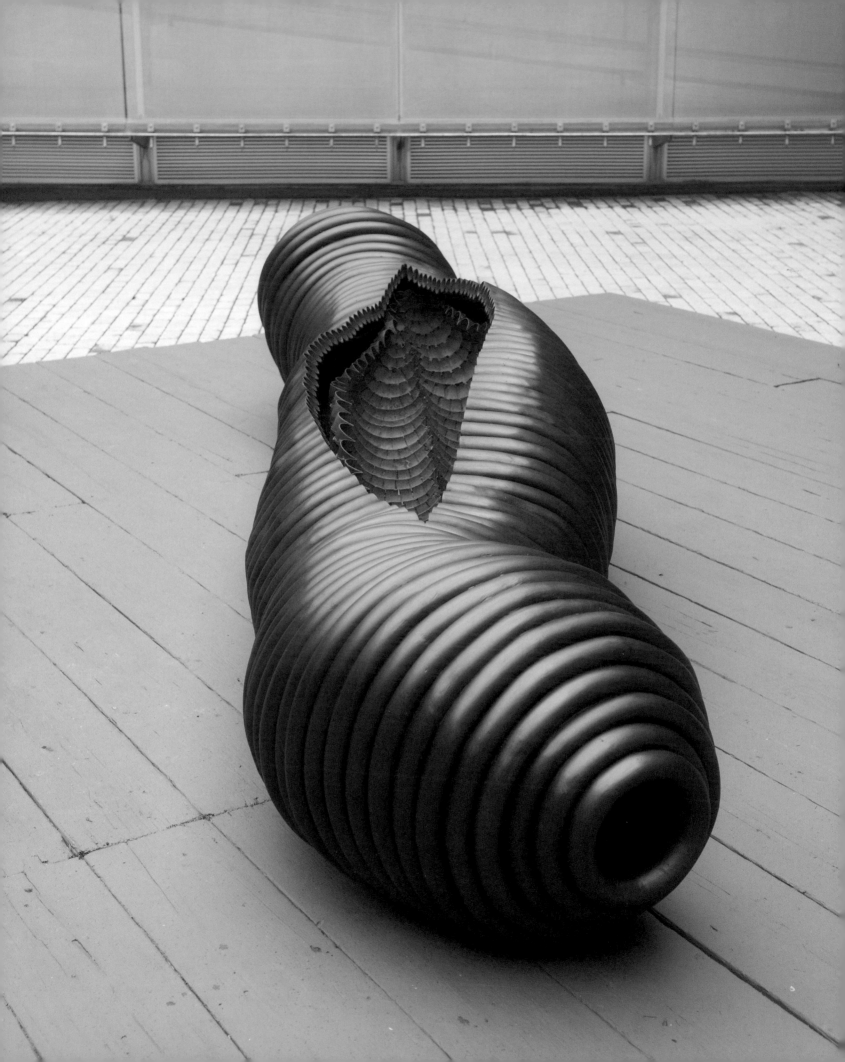

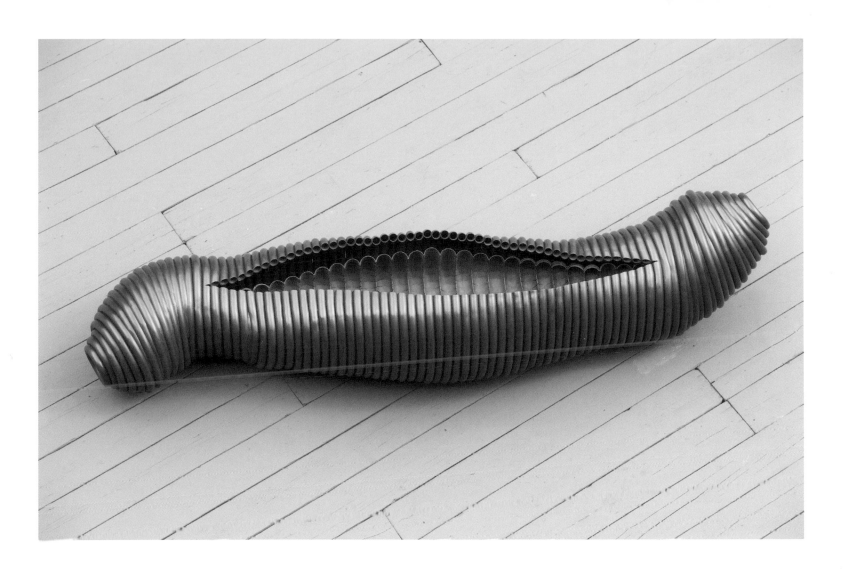

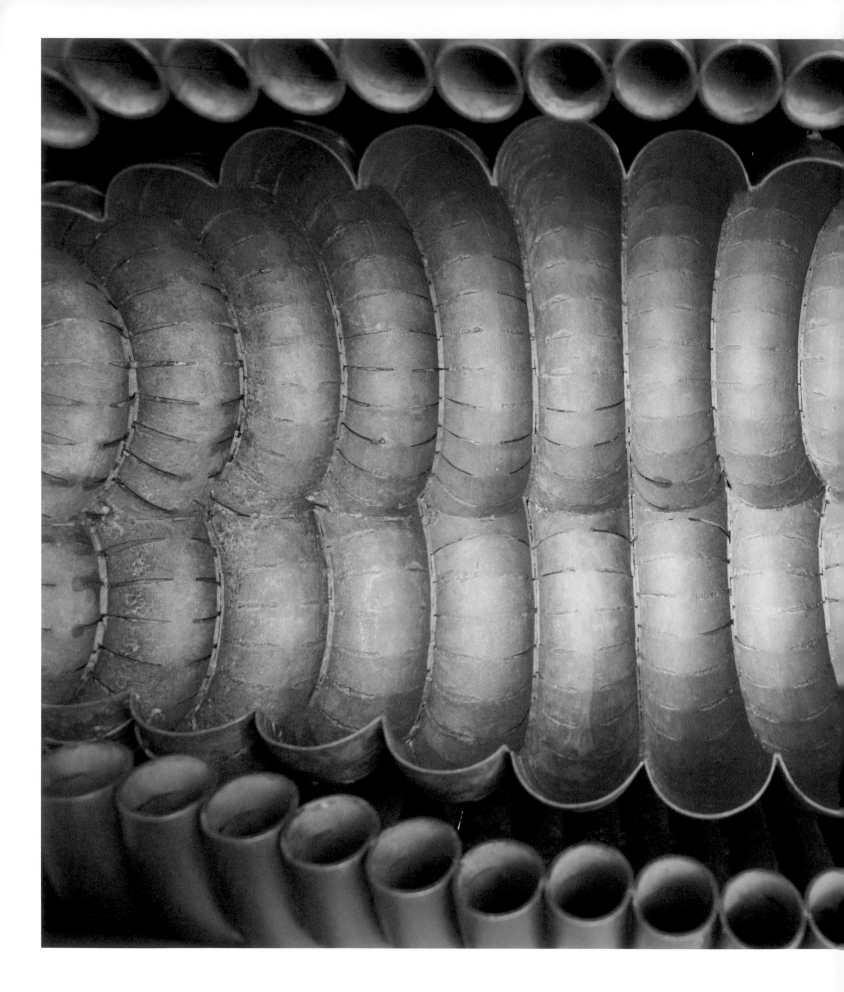

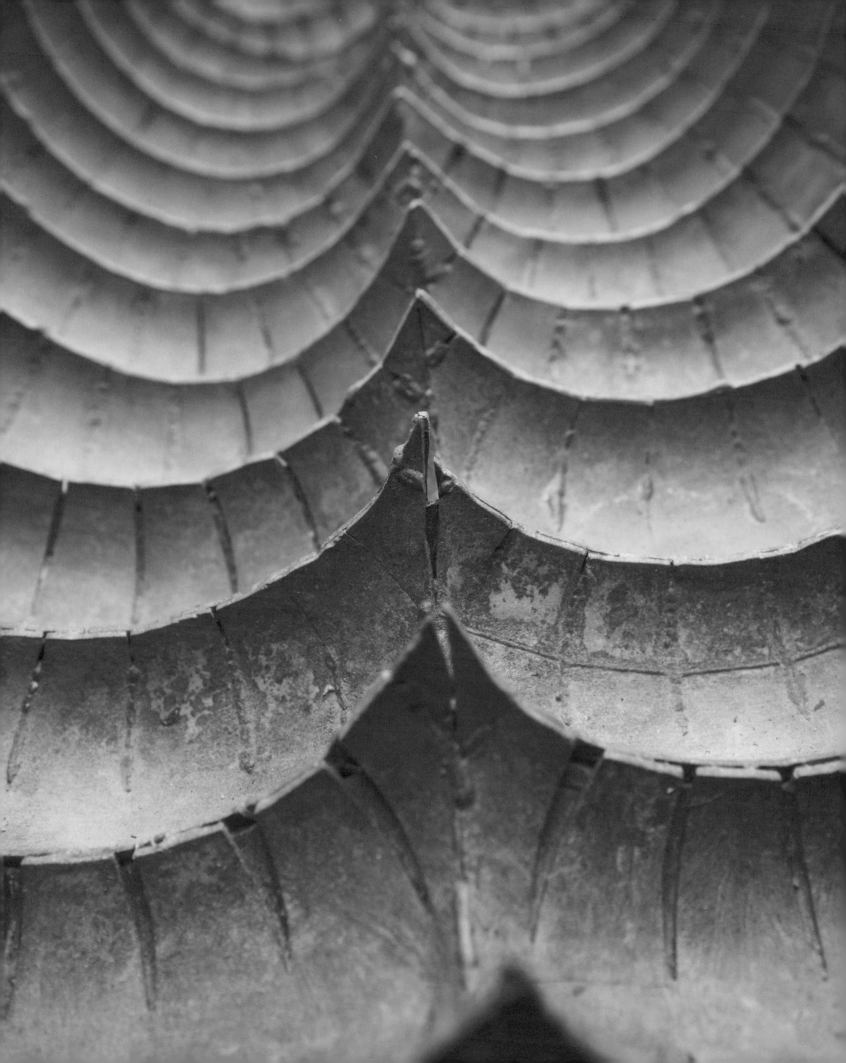

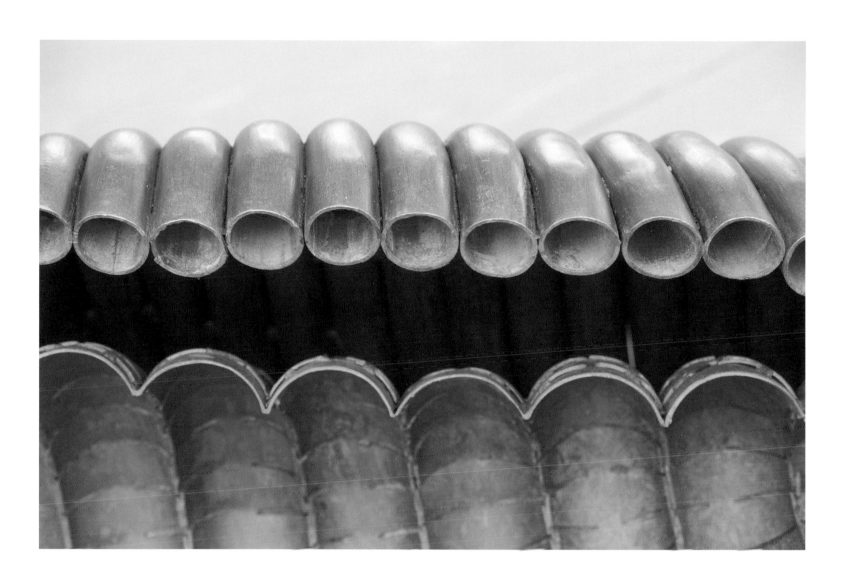

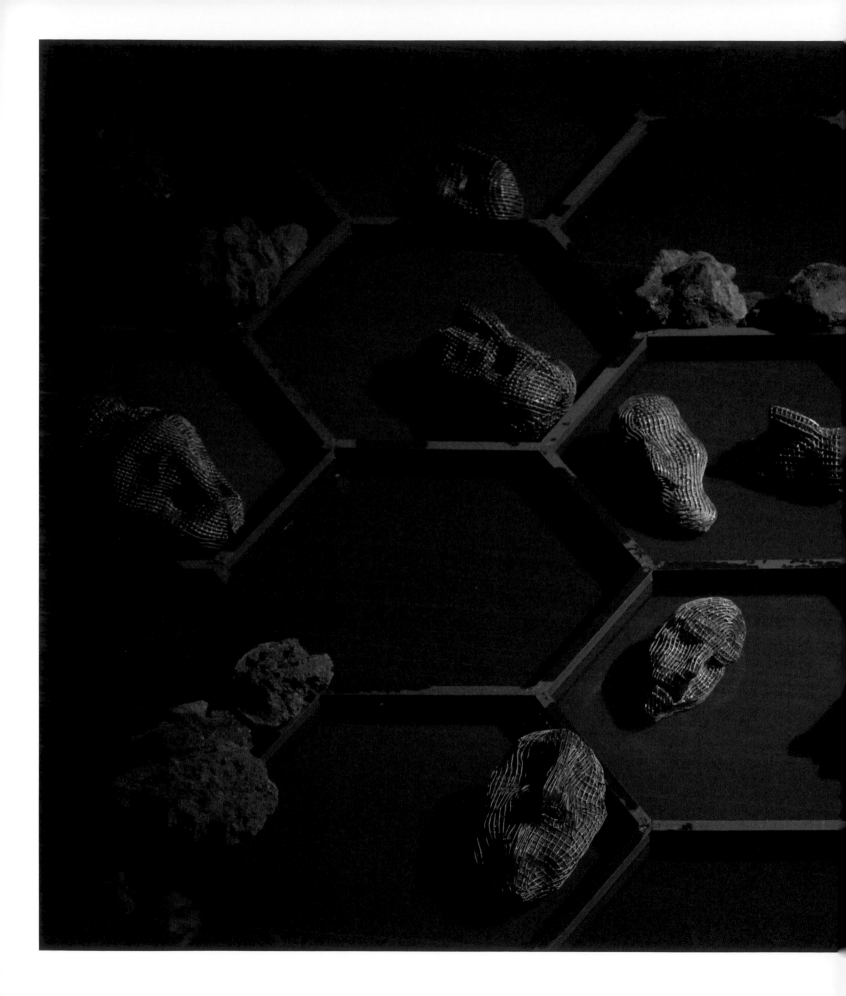

Navigating in the dark

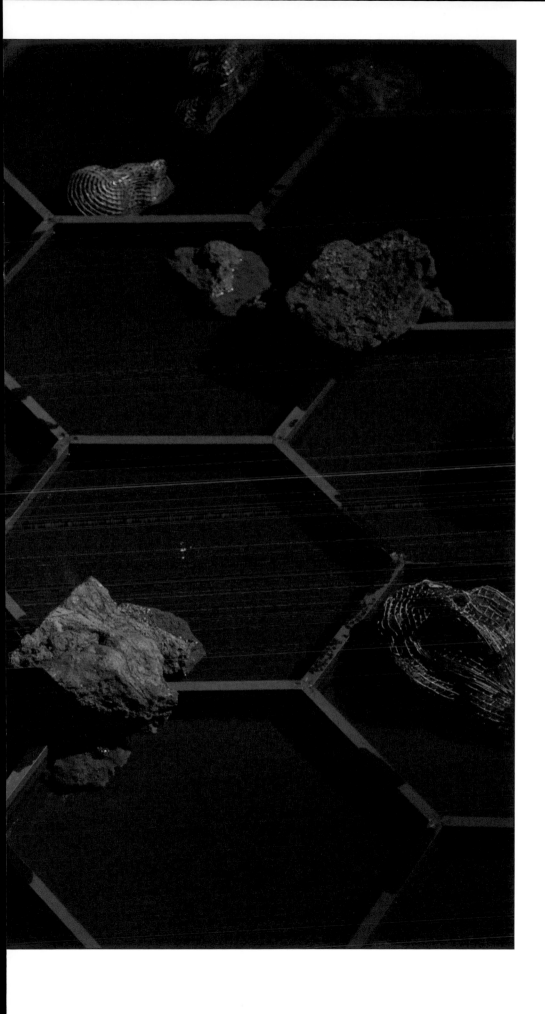

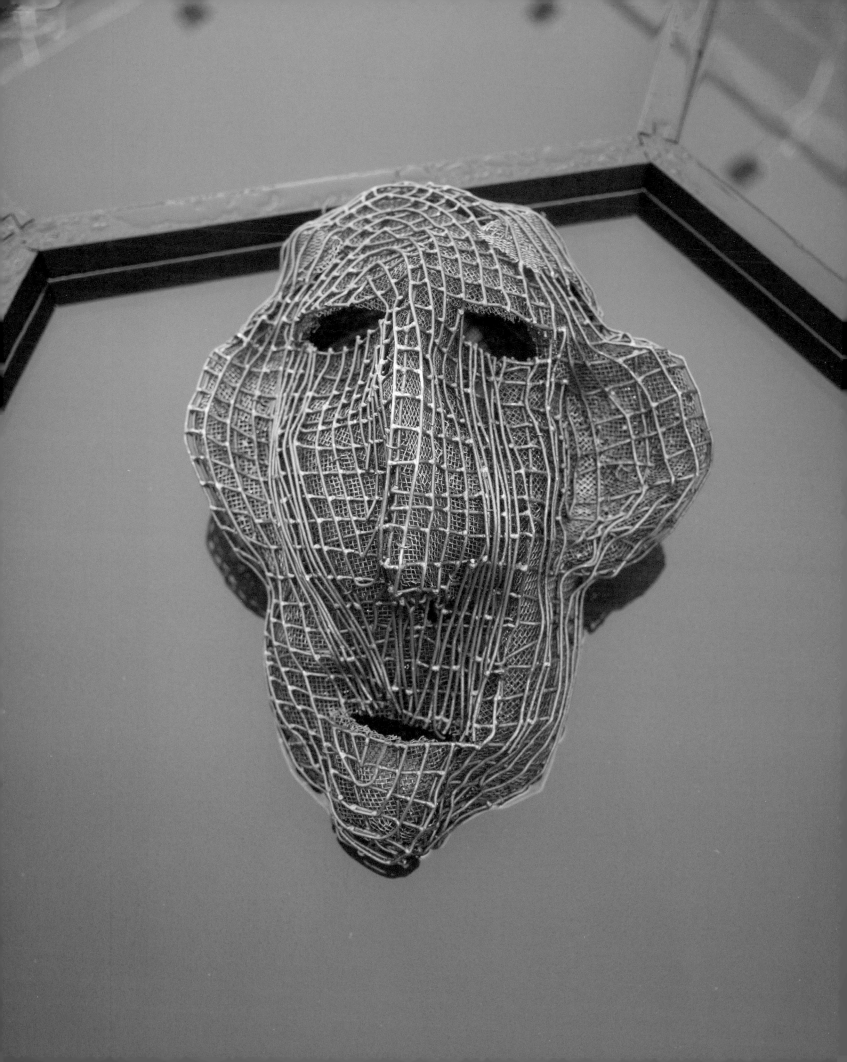

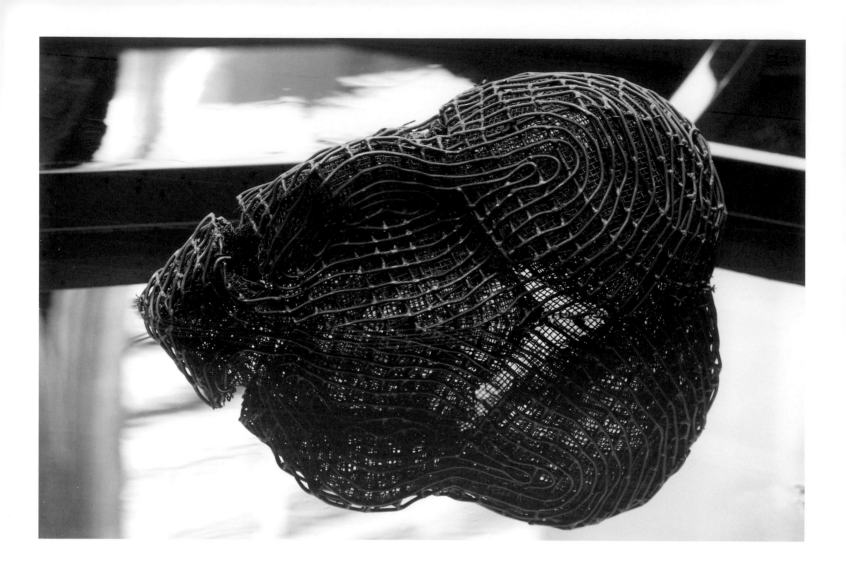

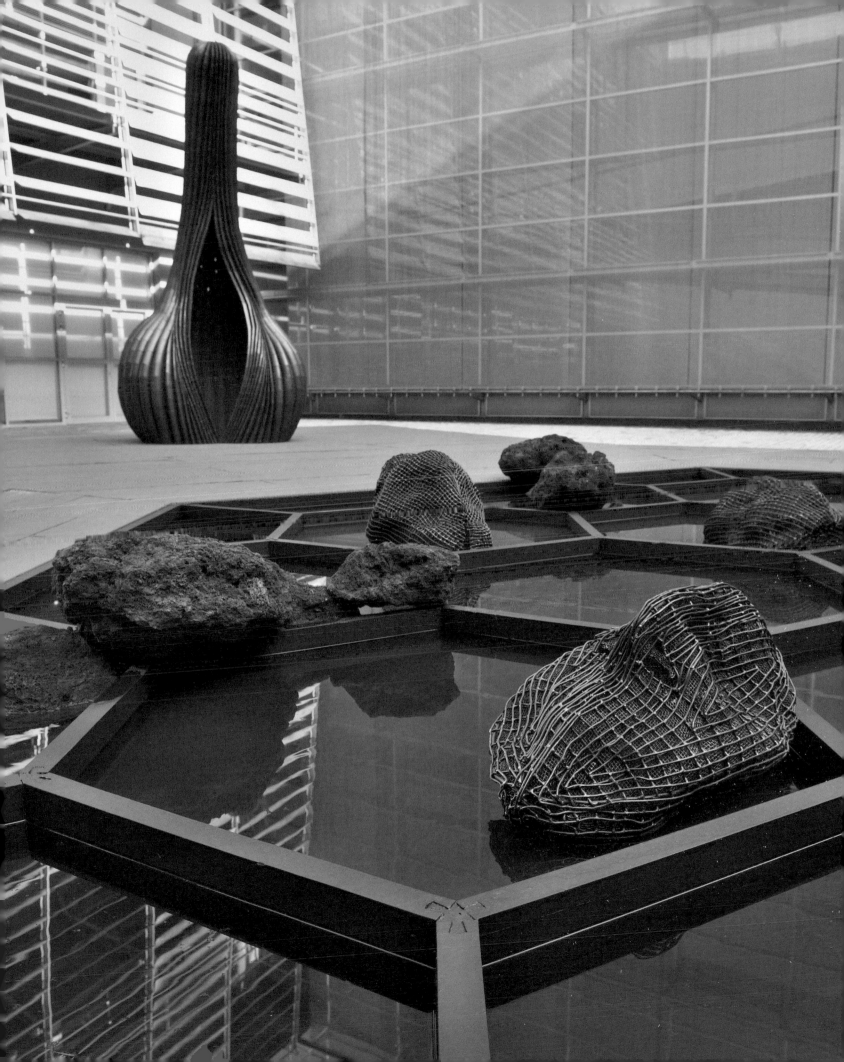

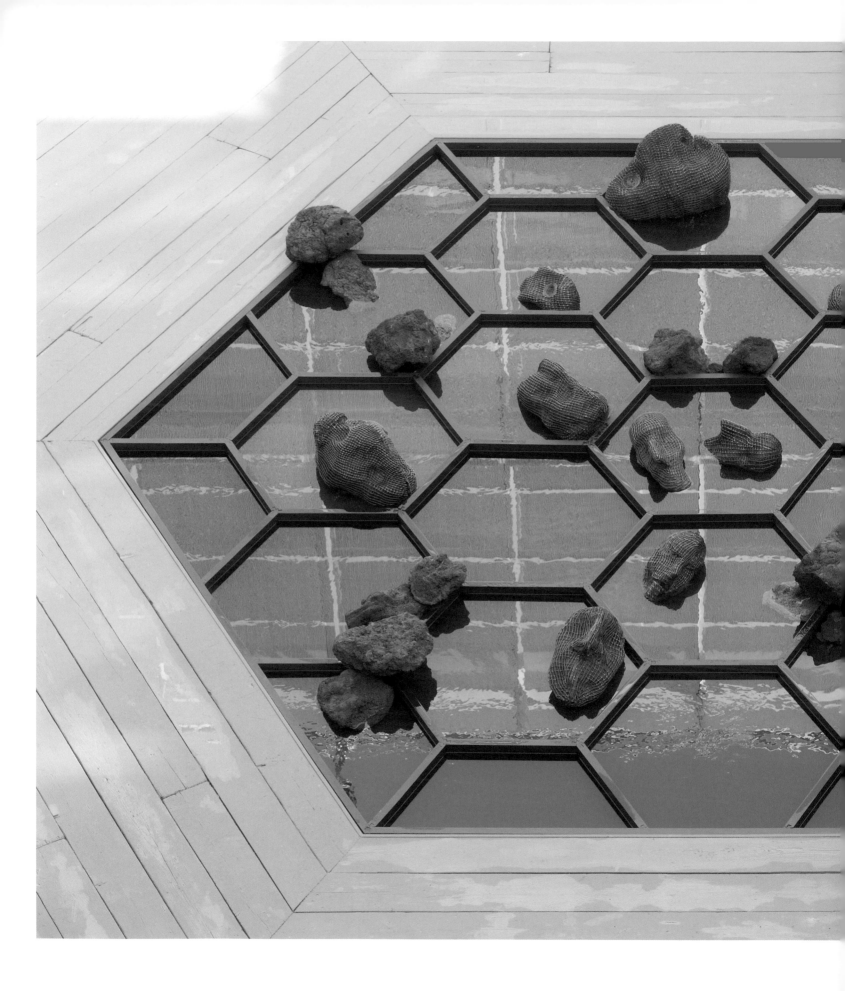

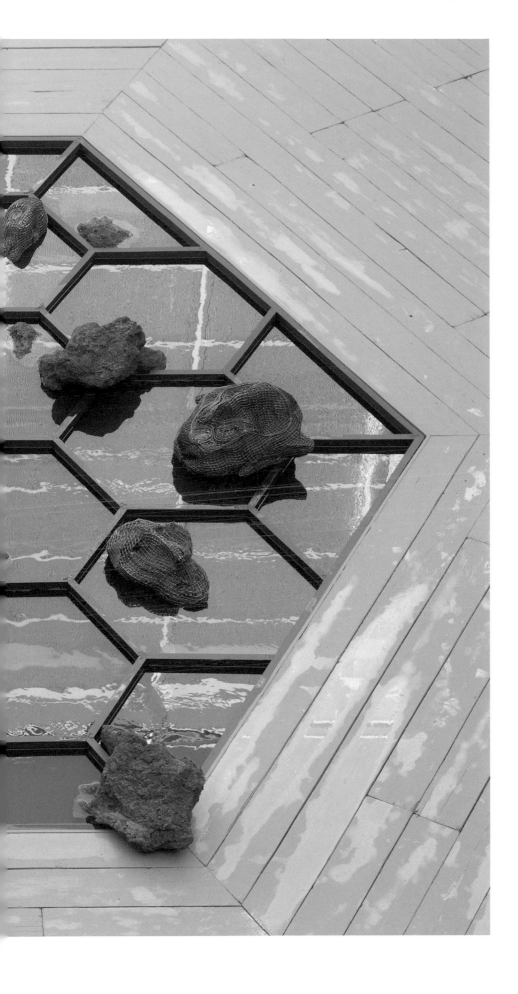

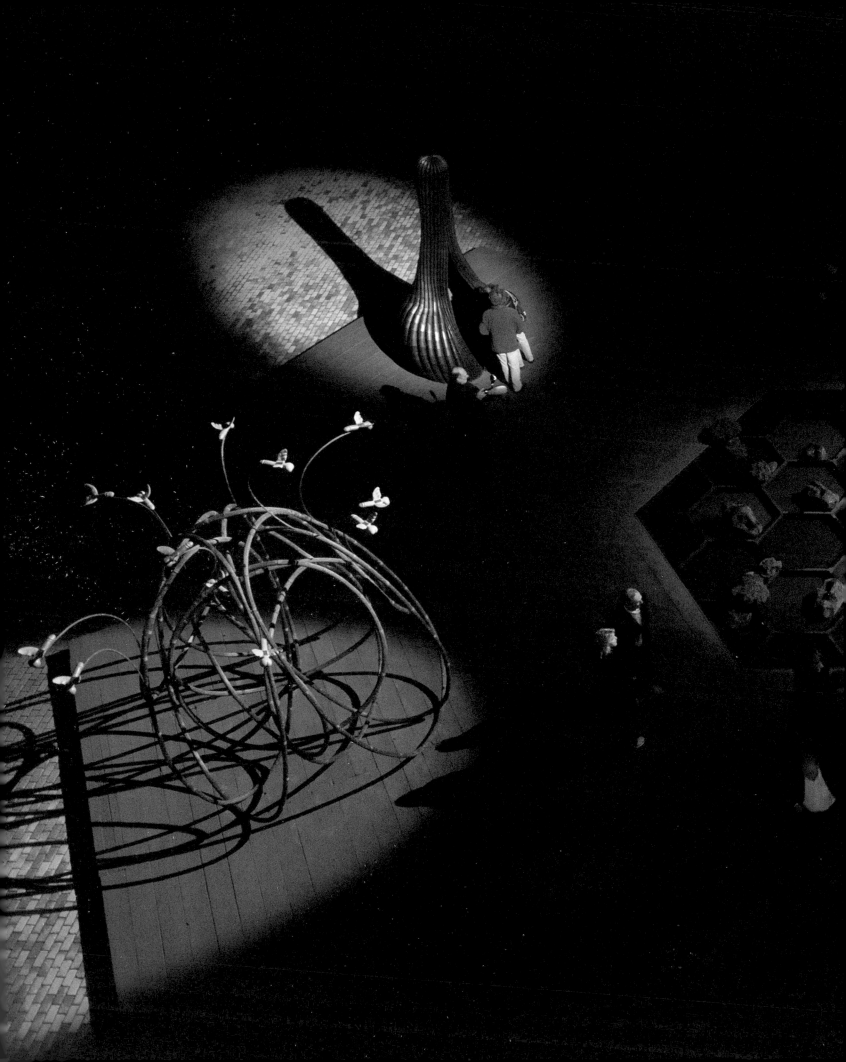

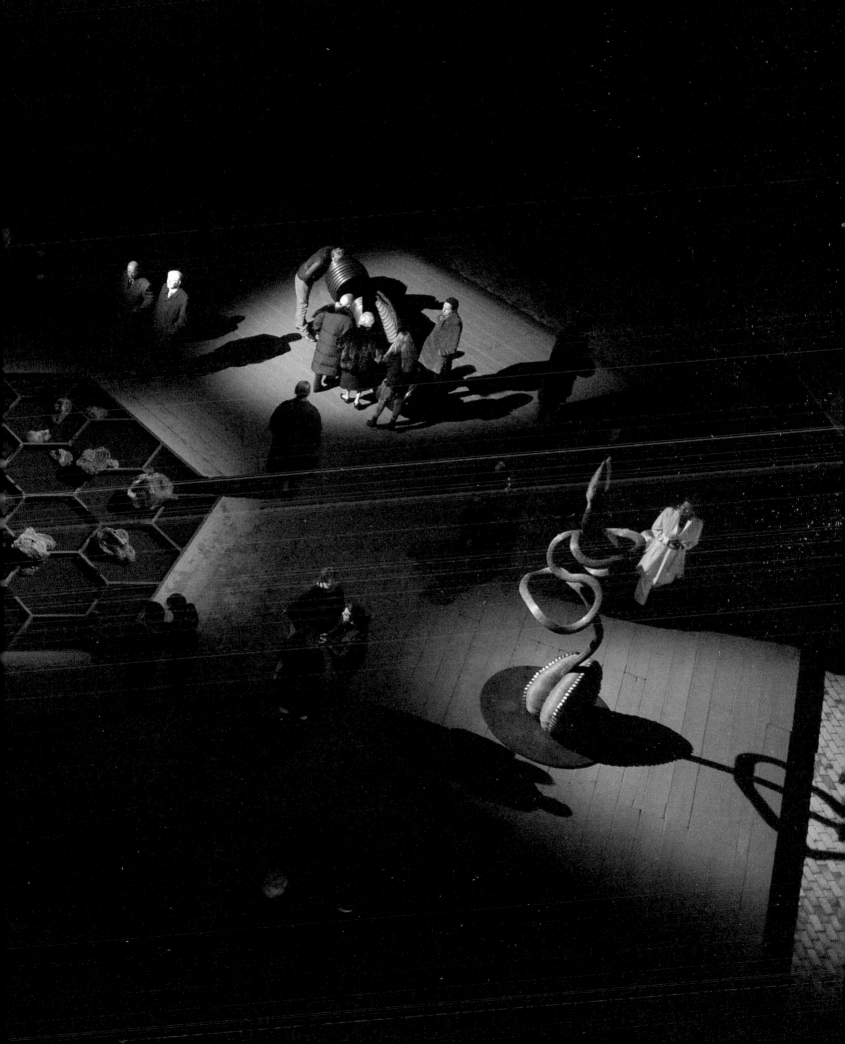

PART 2

Navigating in the dark

IBRAHIM KHAN MOSQUE, RETHYMNON

8 May–27 August 2011

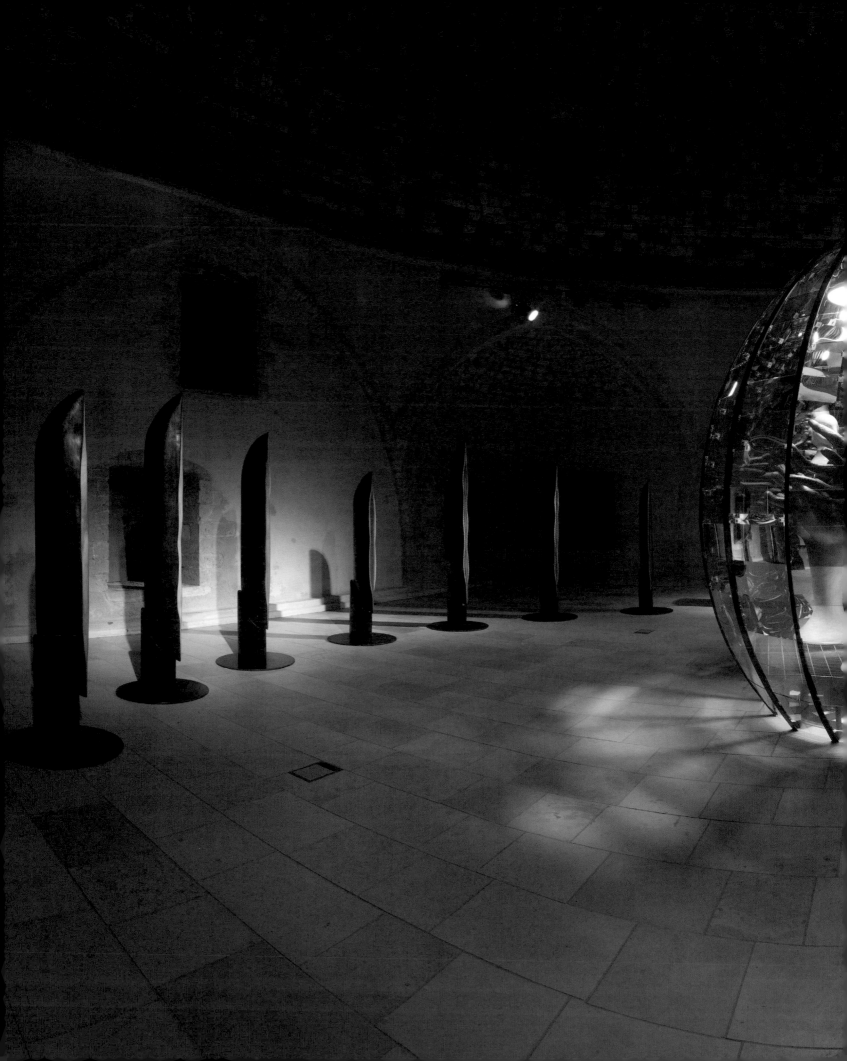

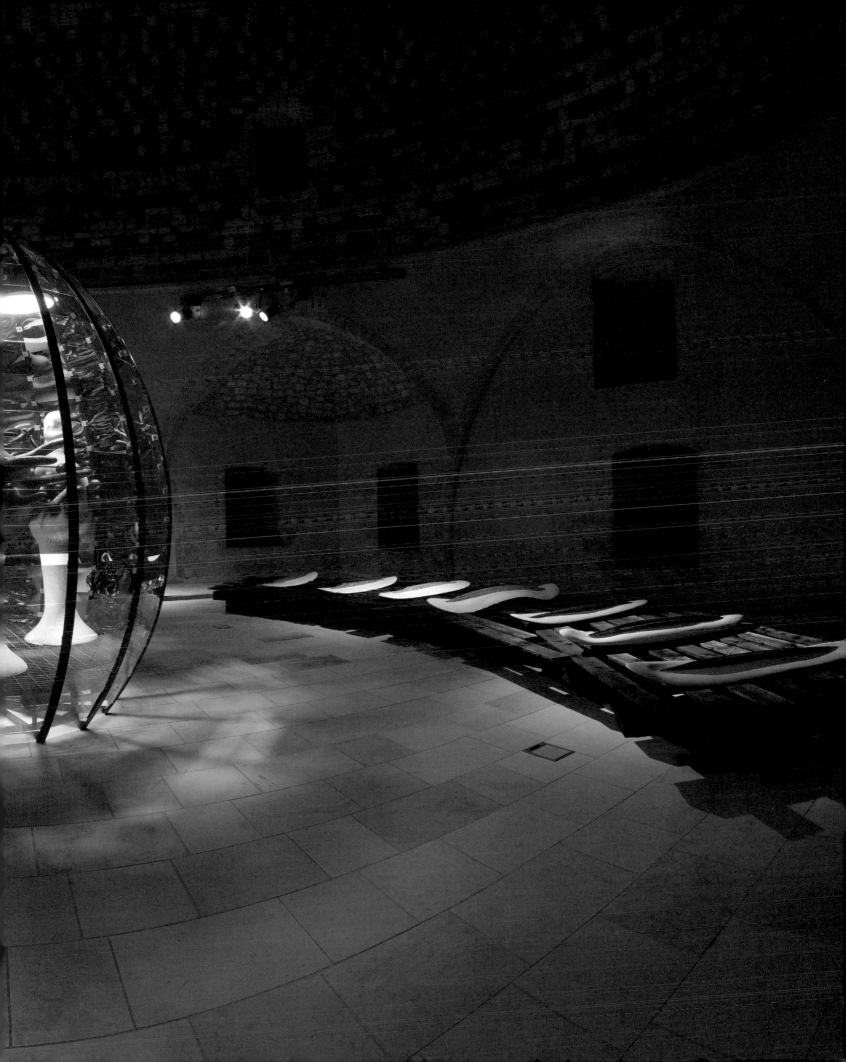

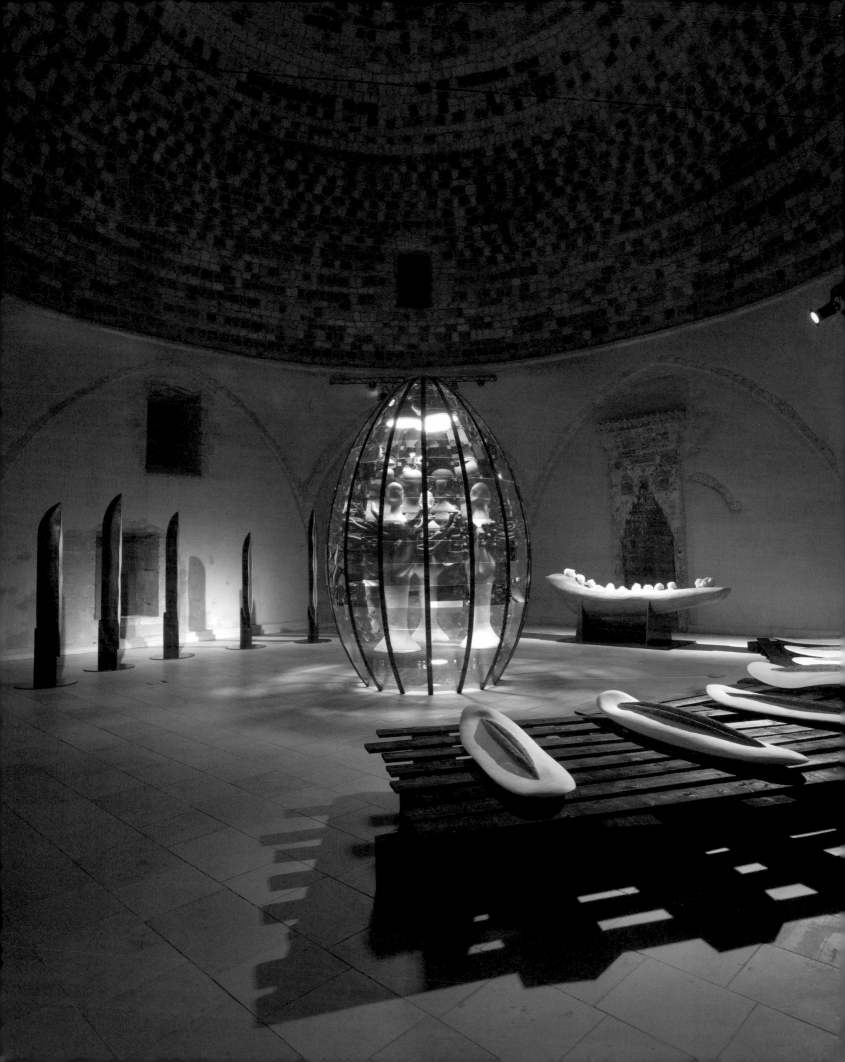

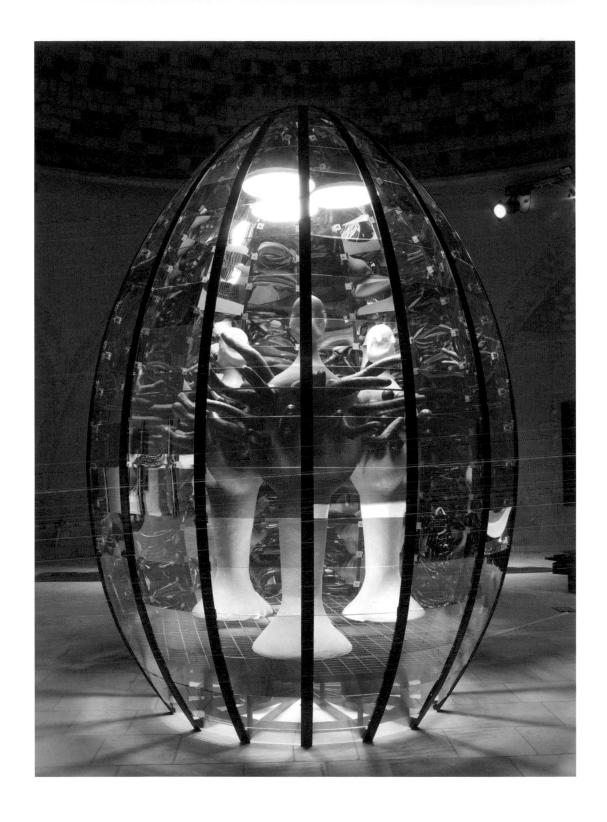

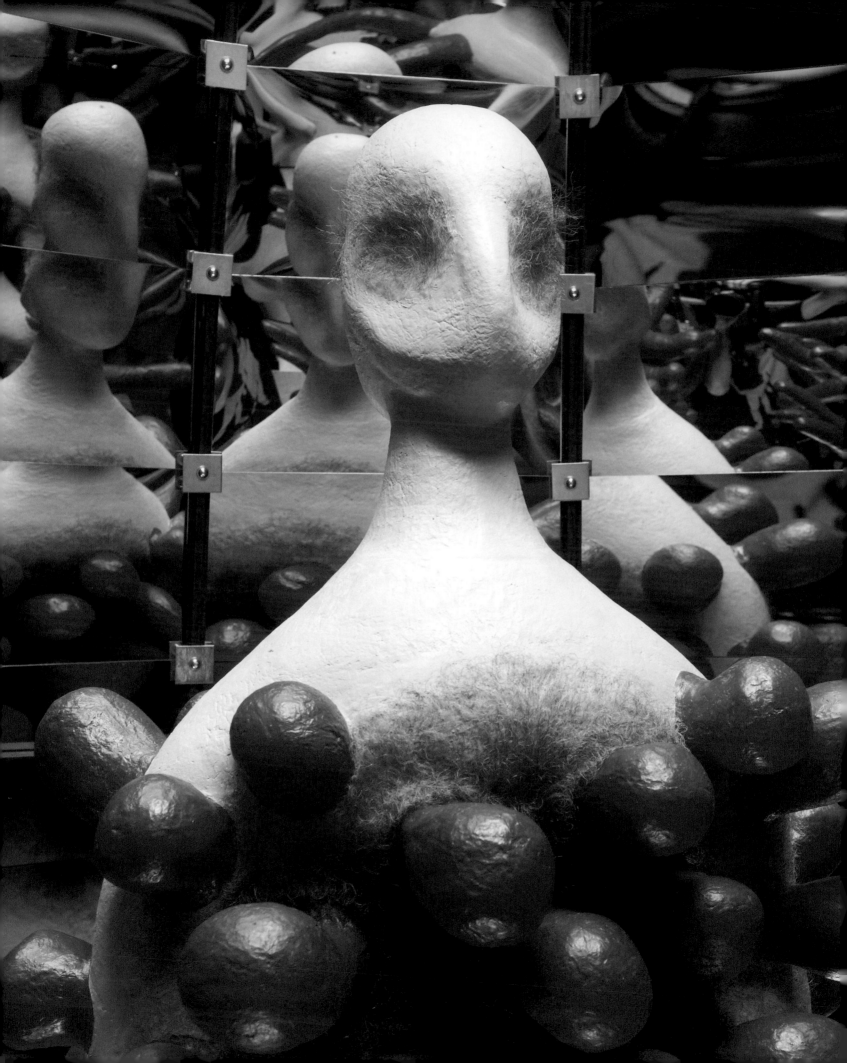

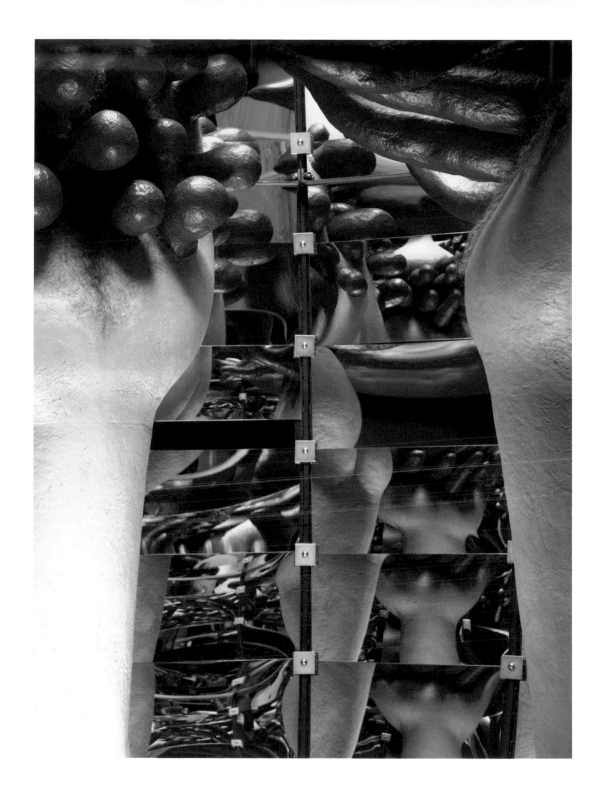

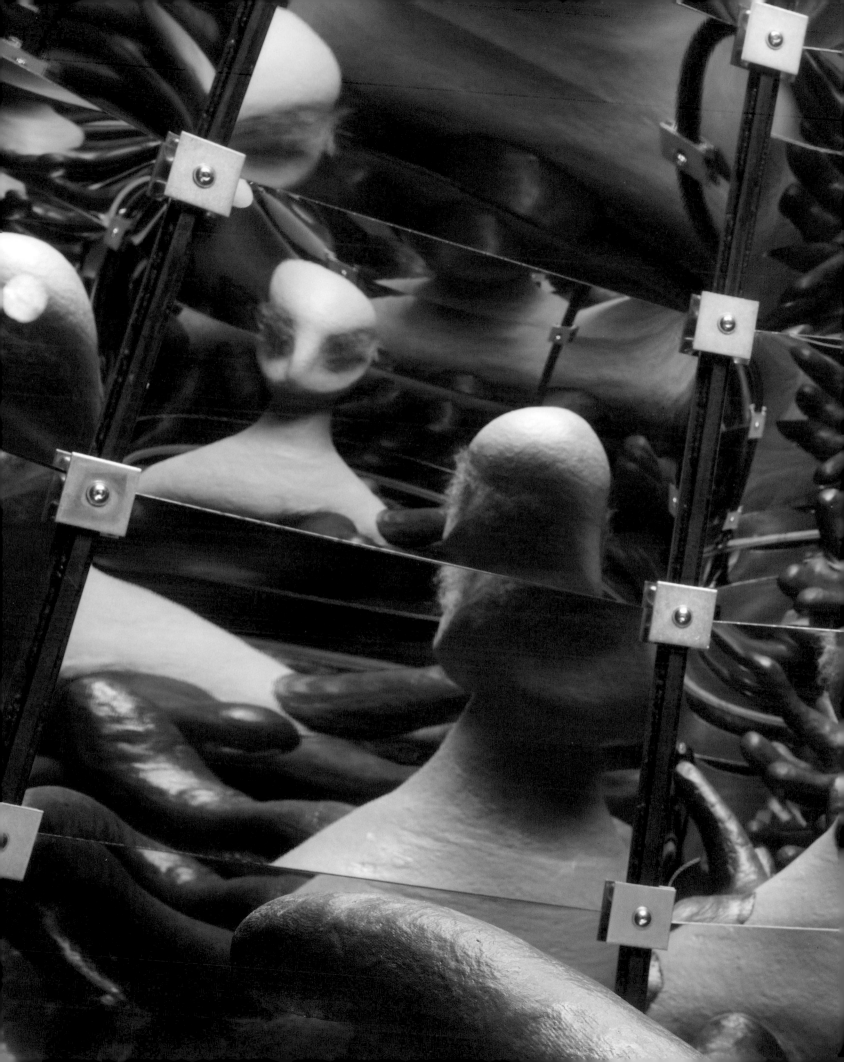

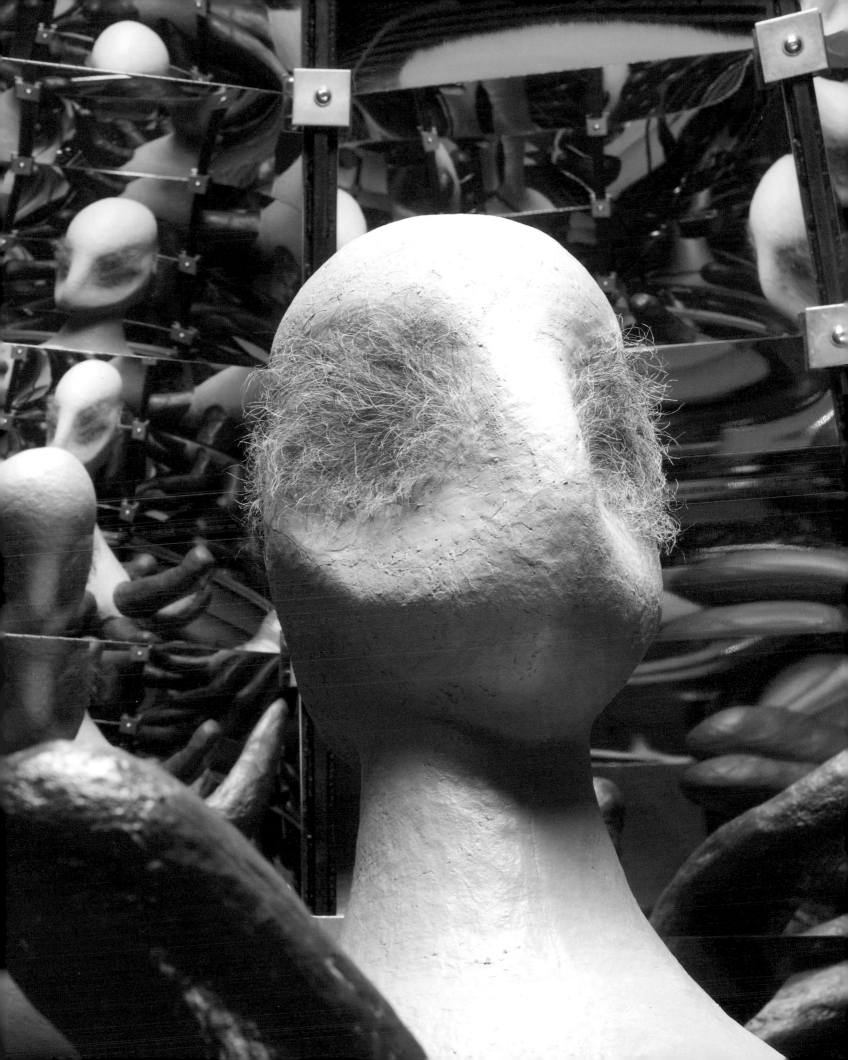

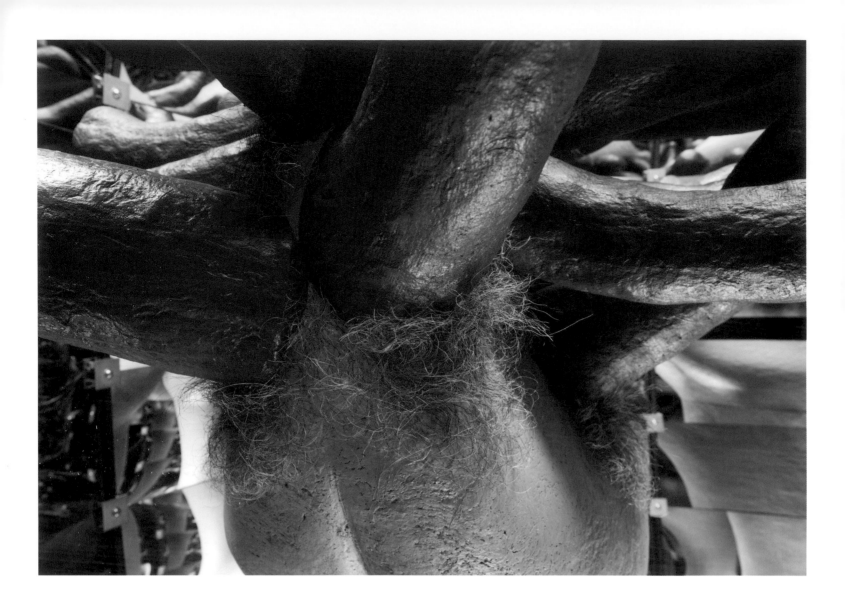

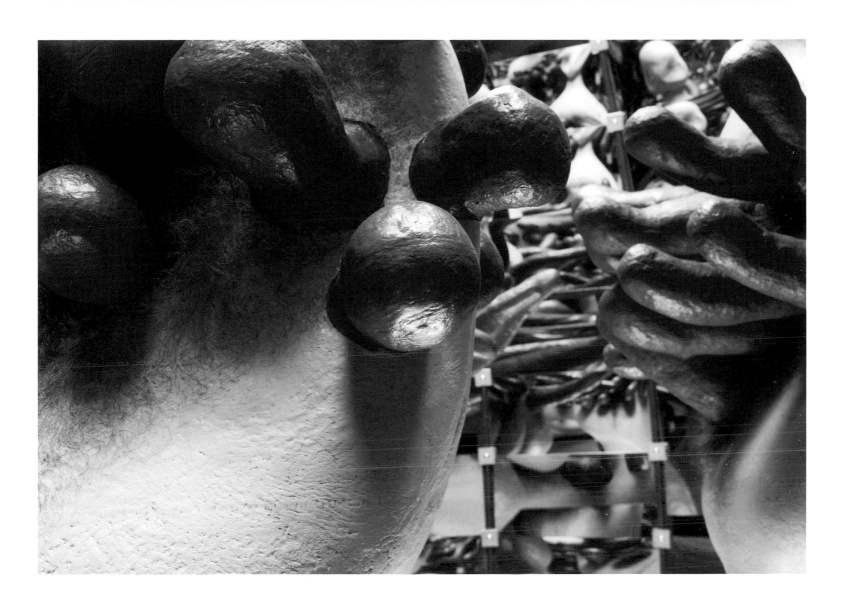

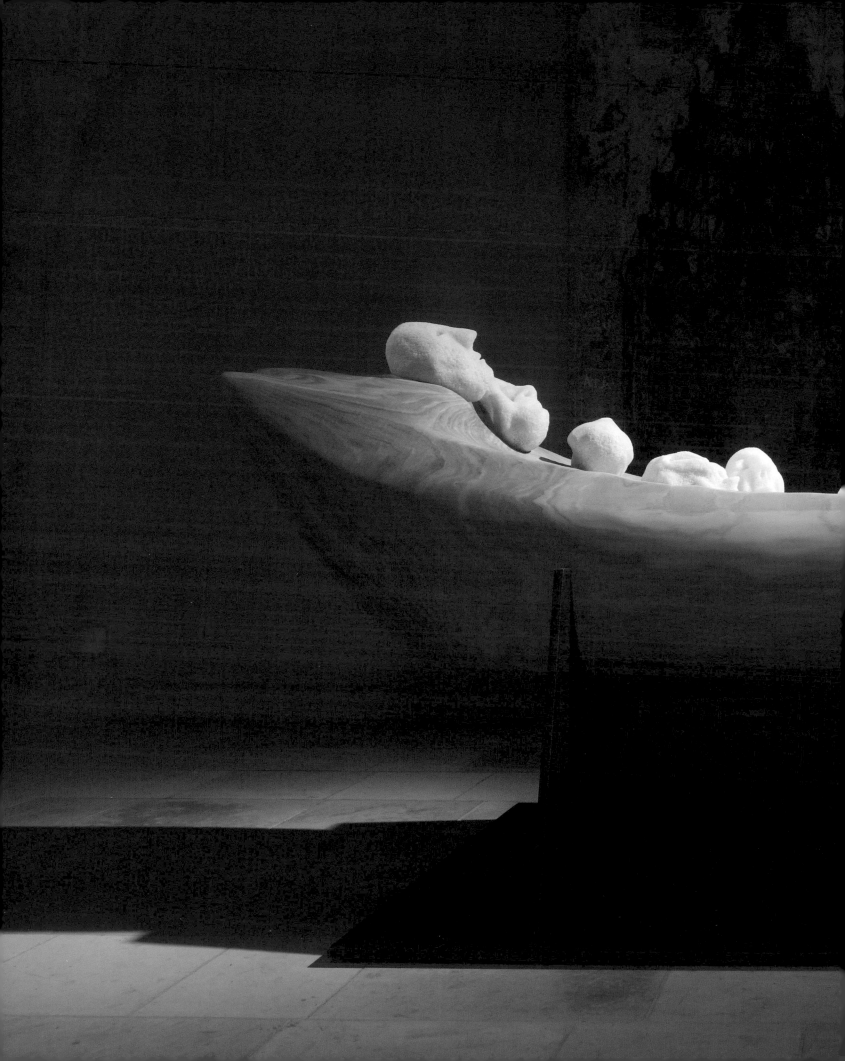

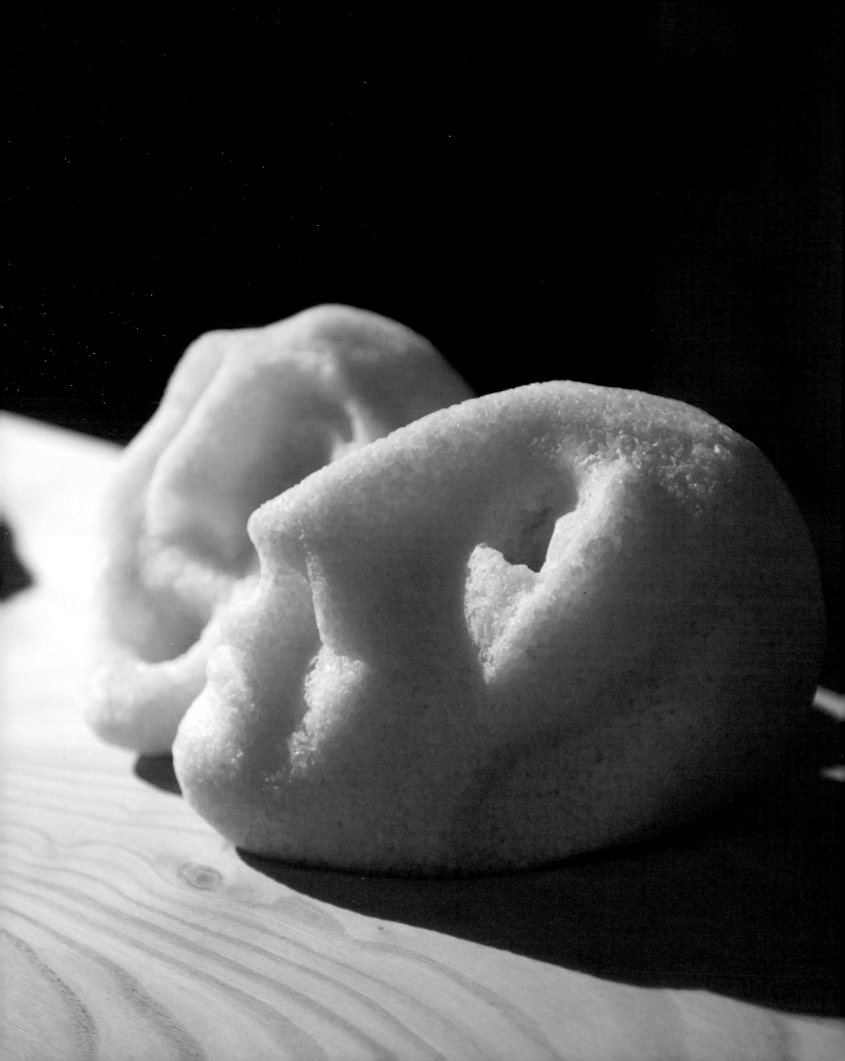

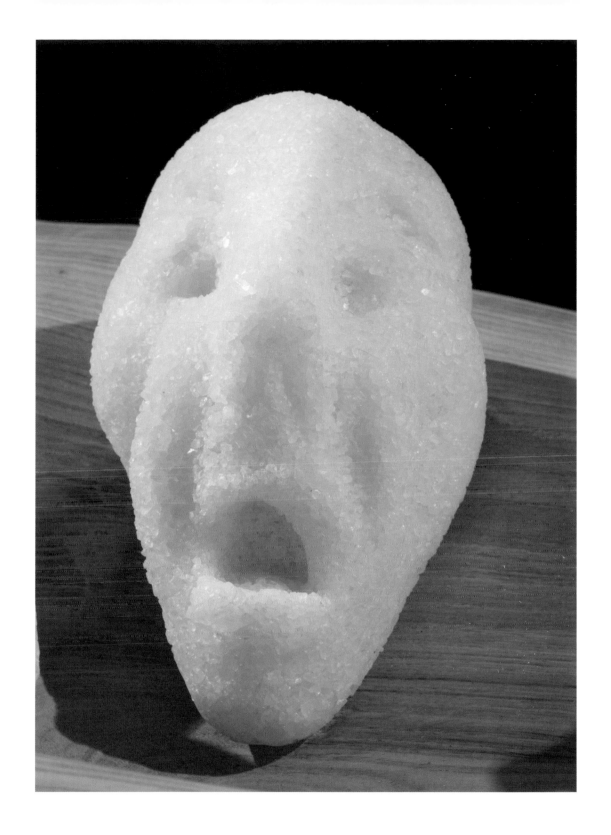

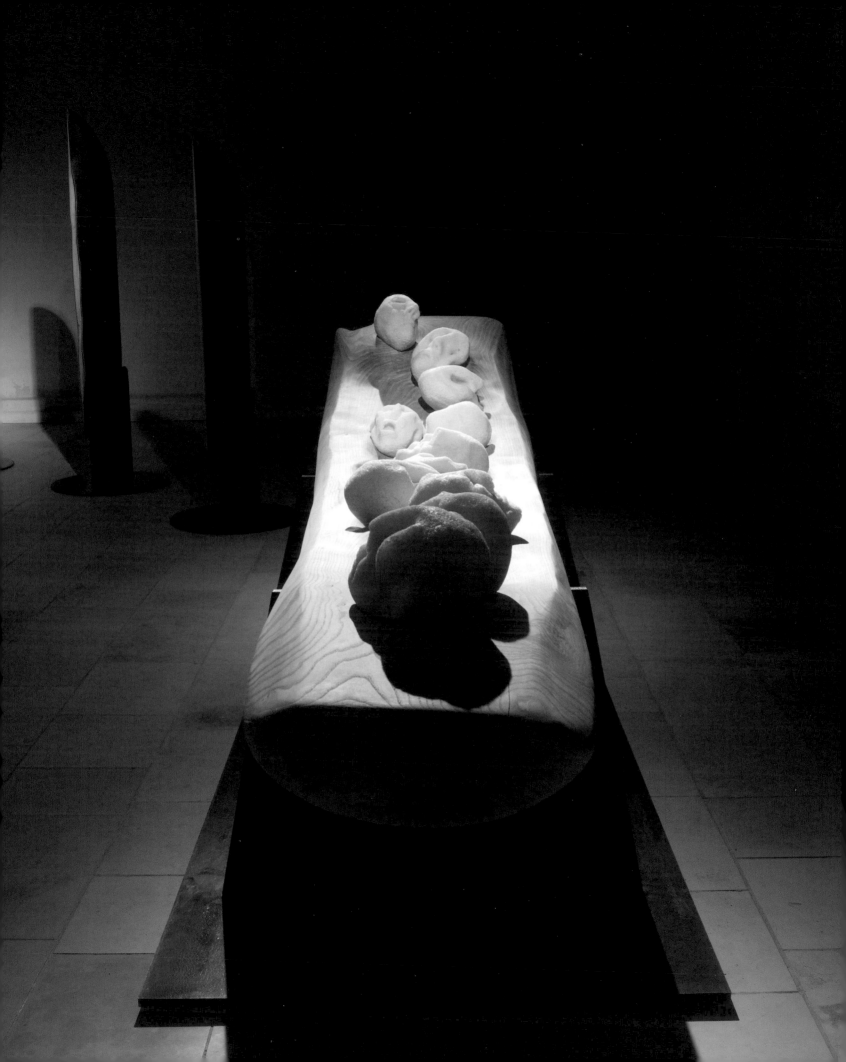

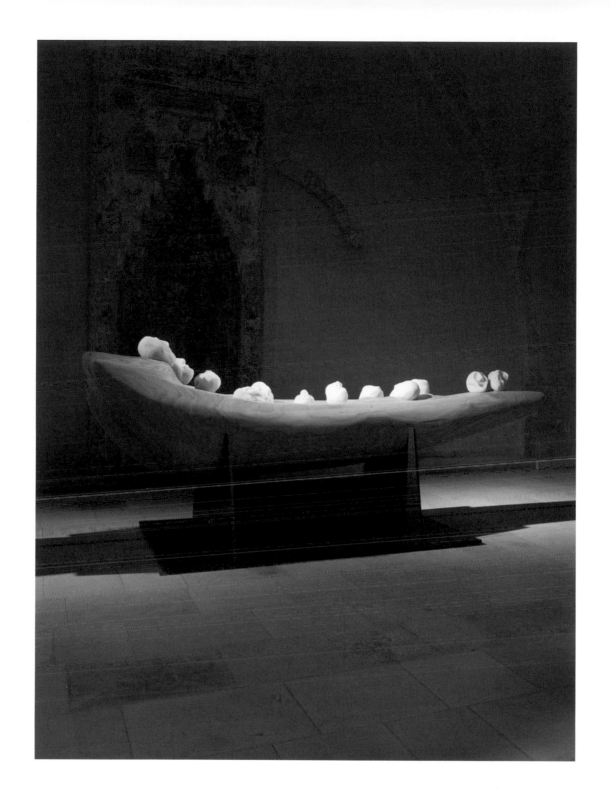

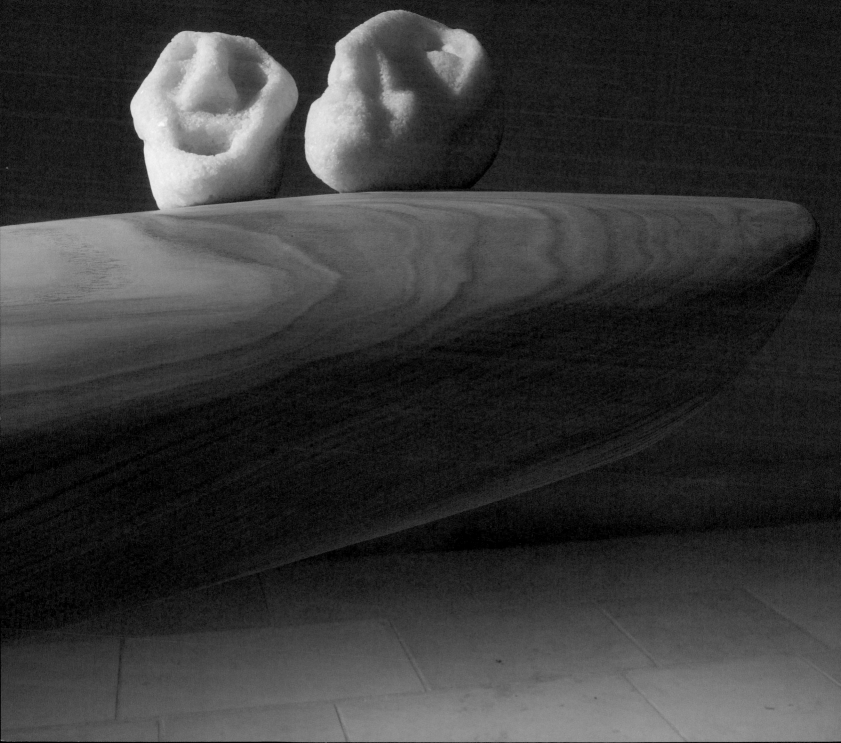

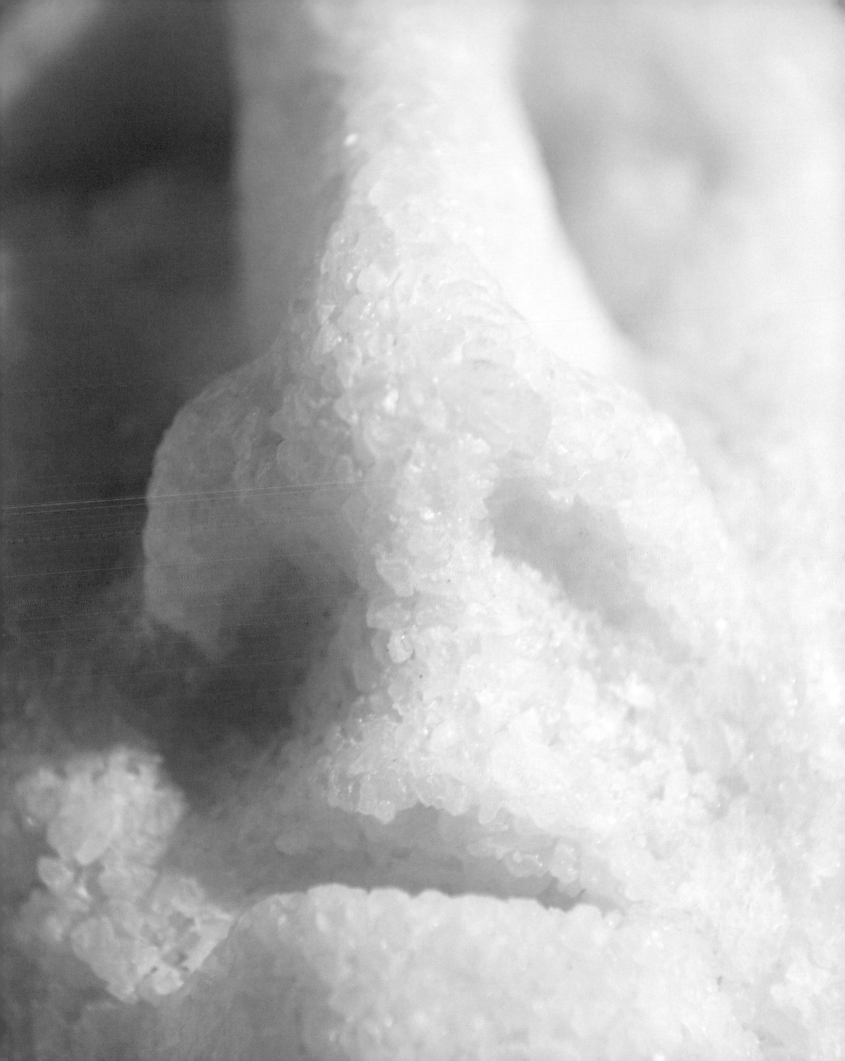

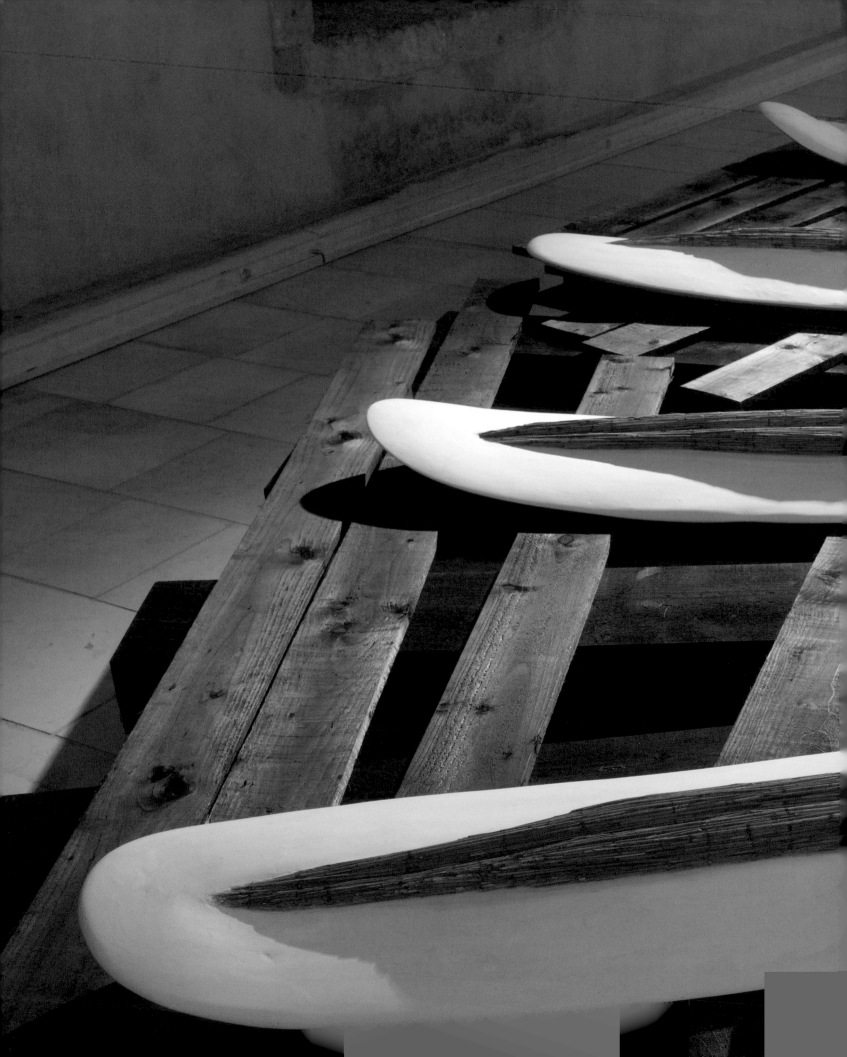

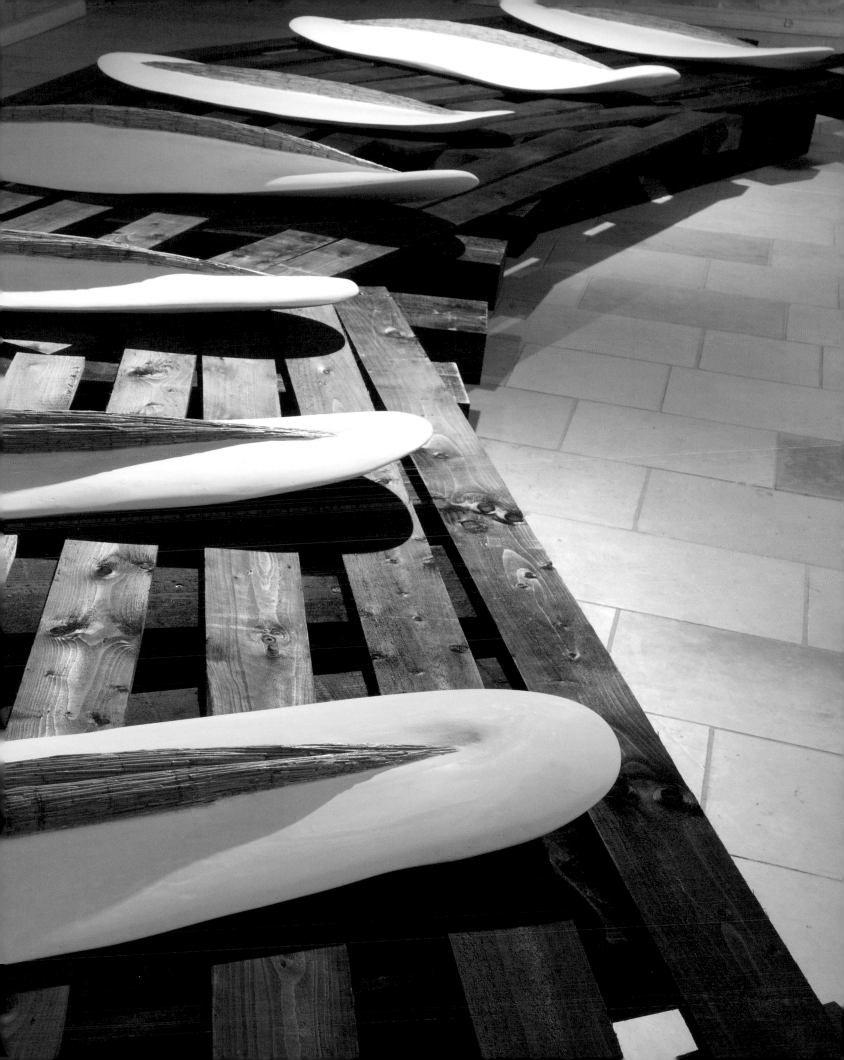

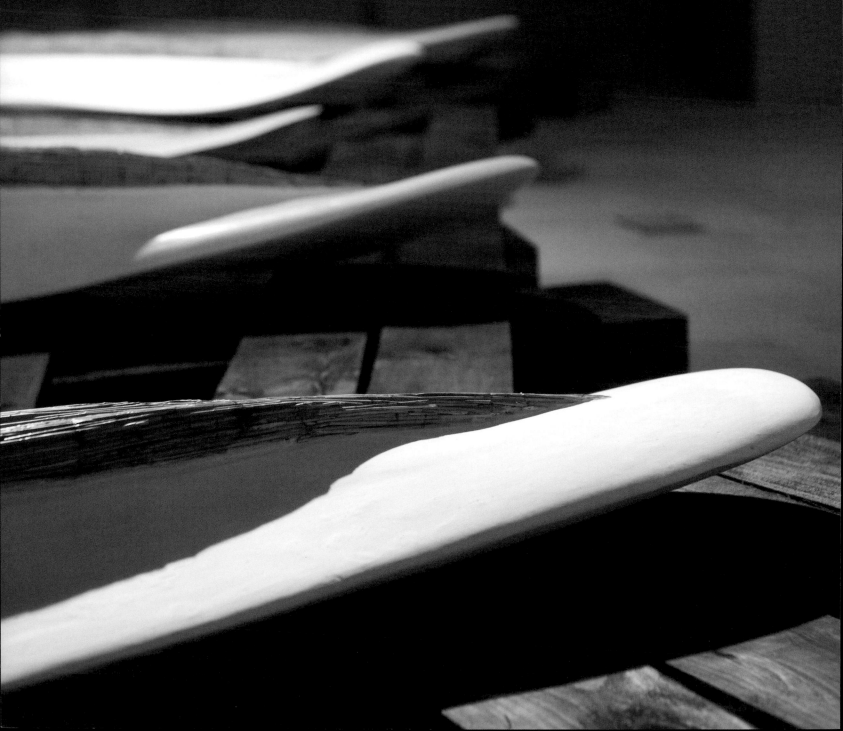

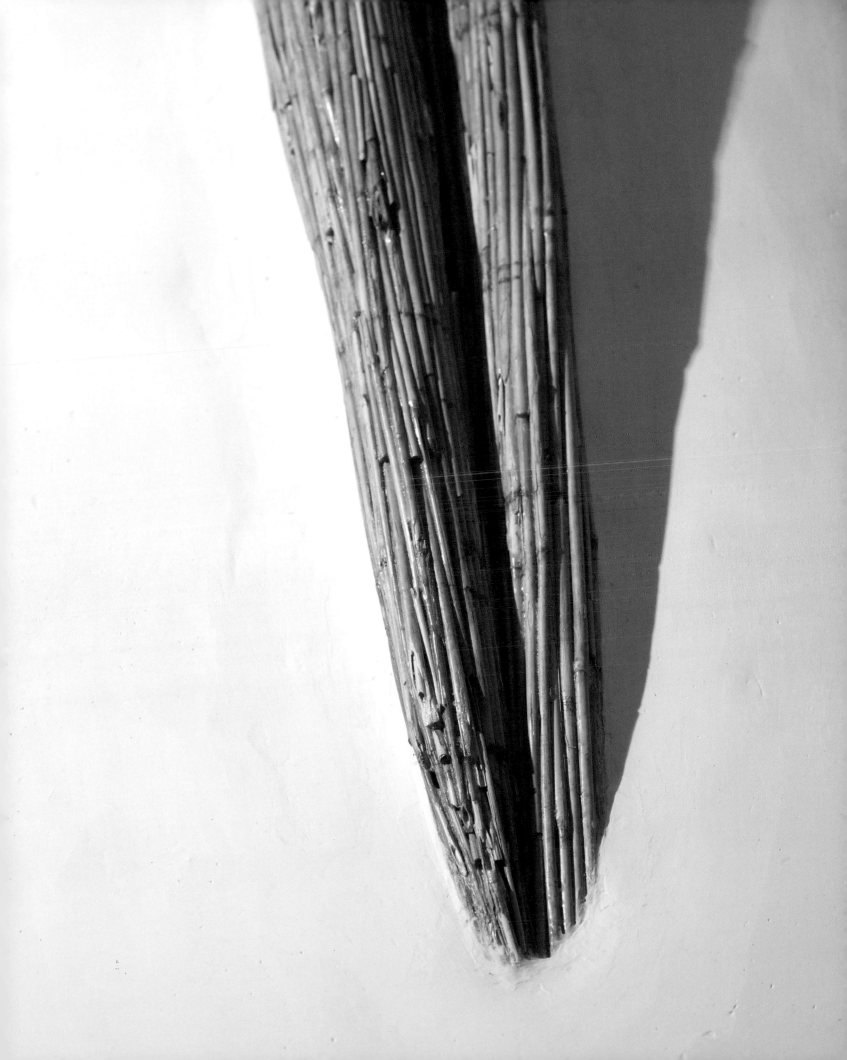

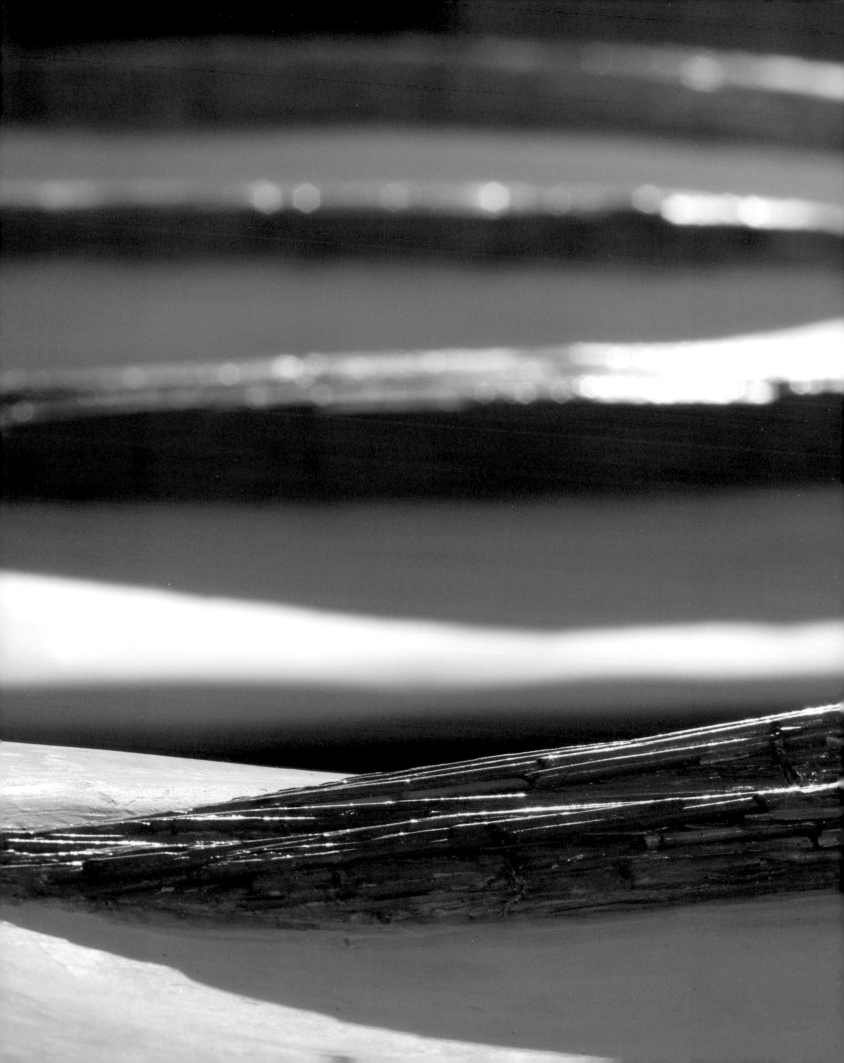

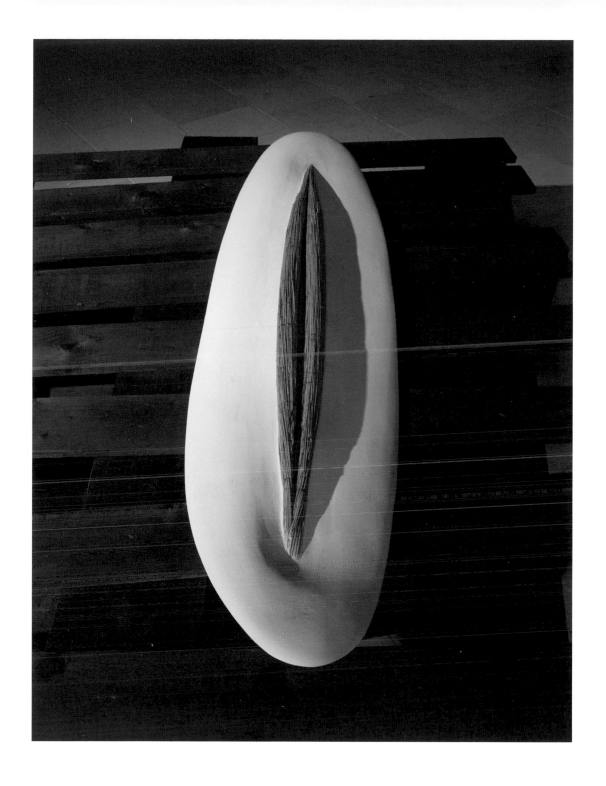

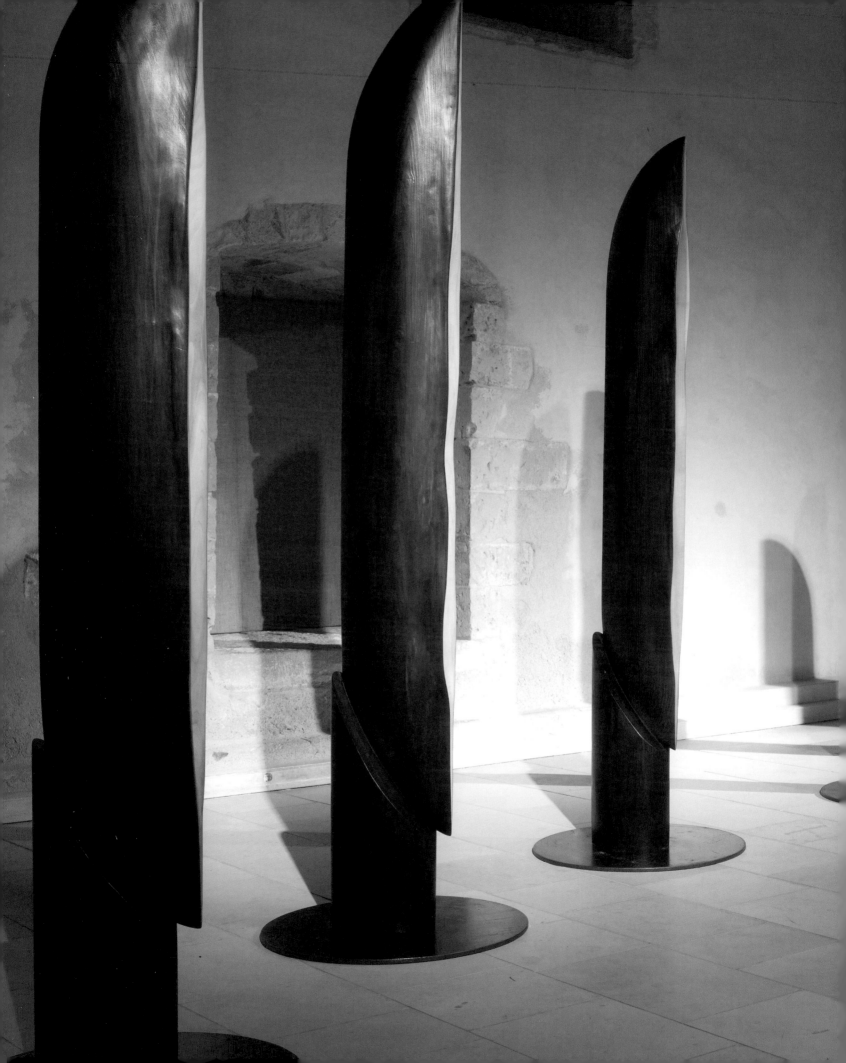

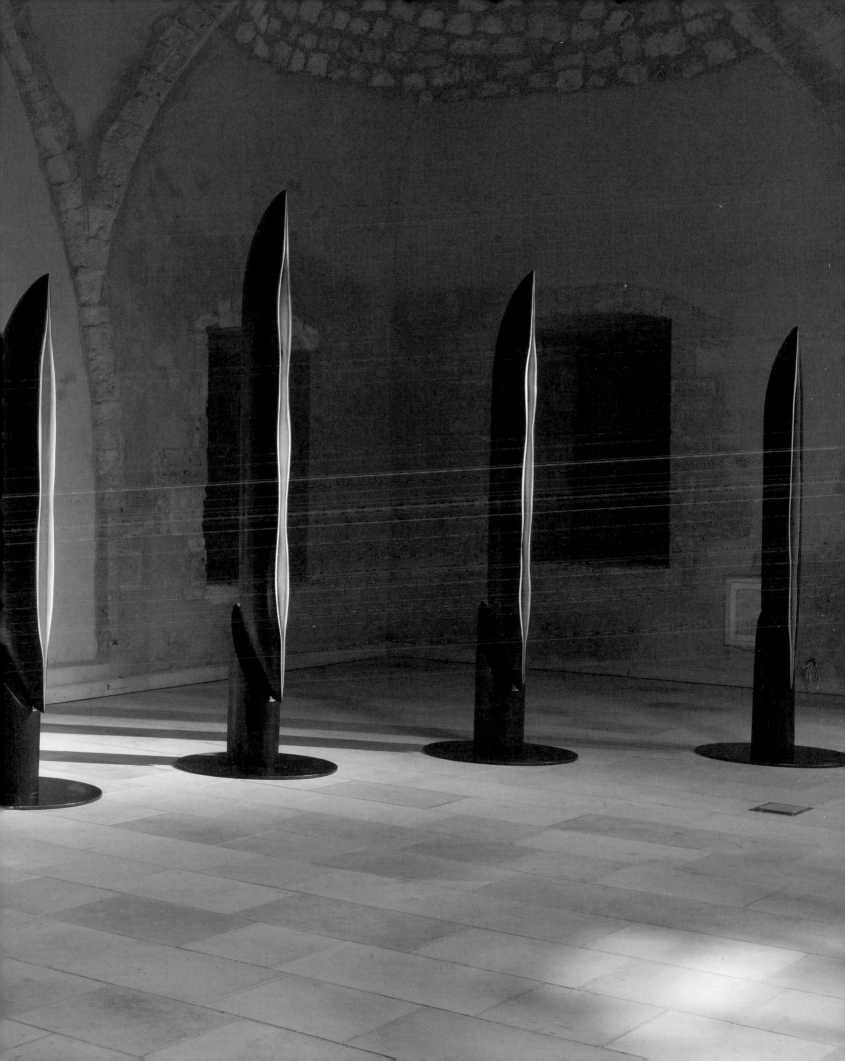

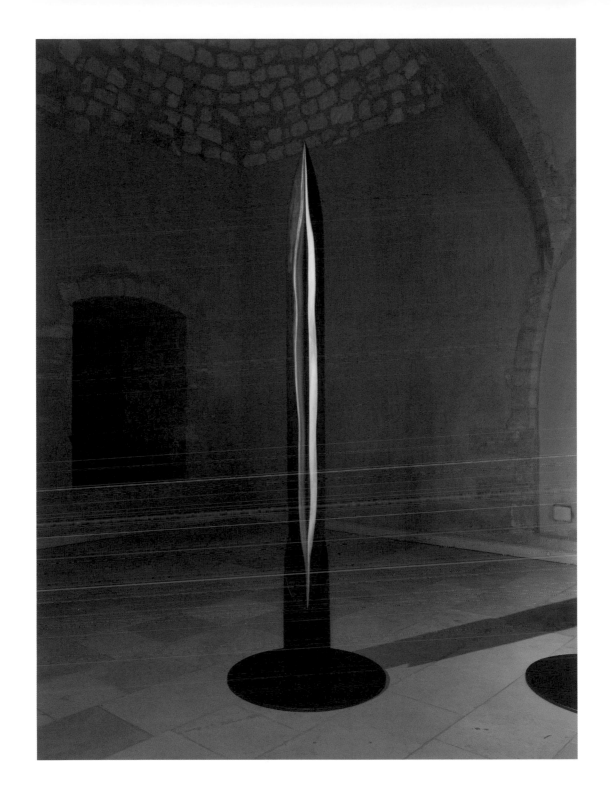

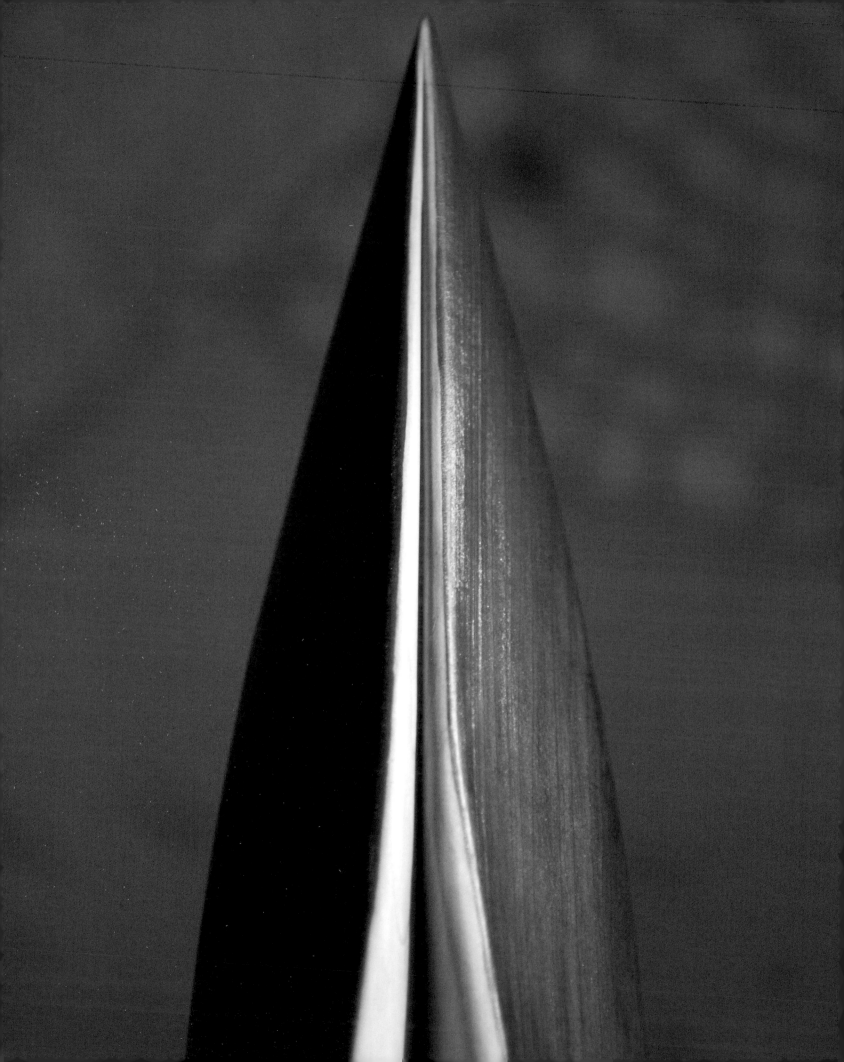

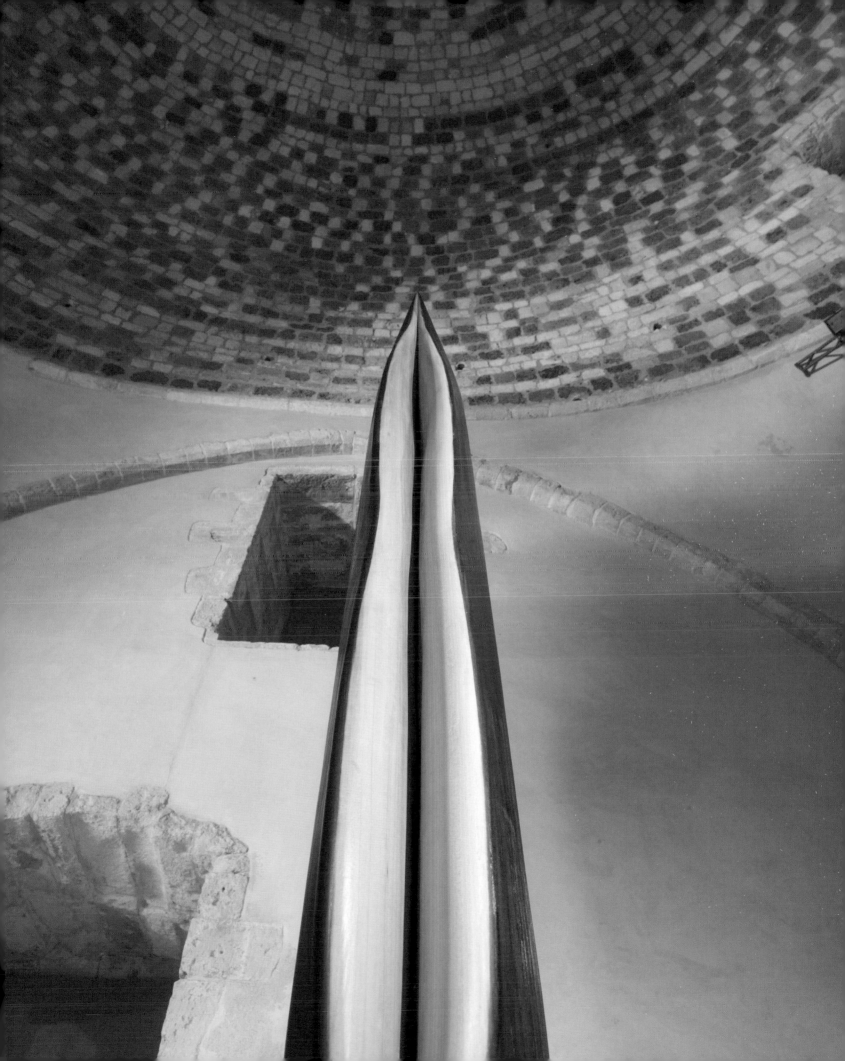

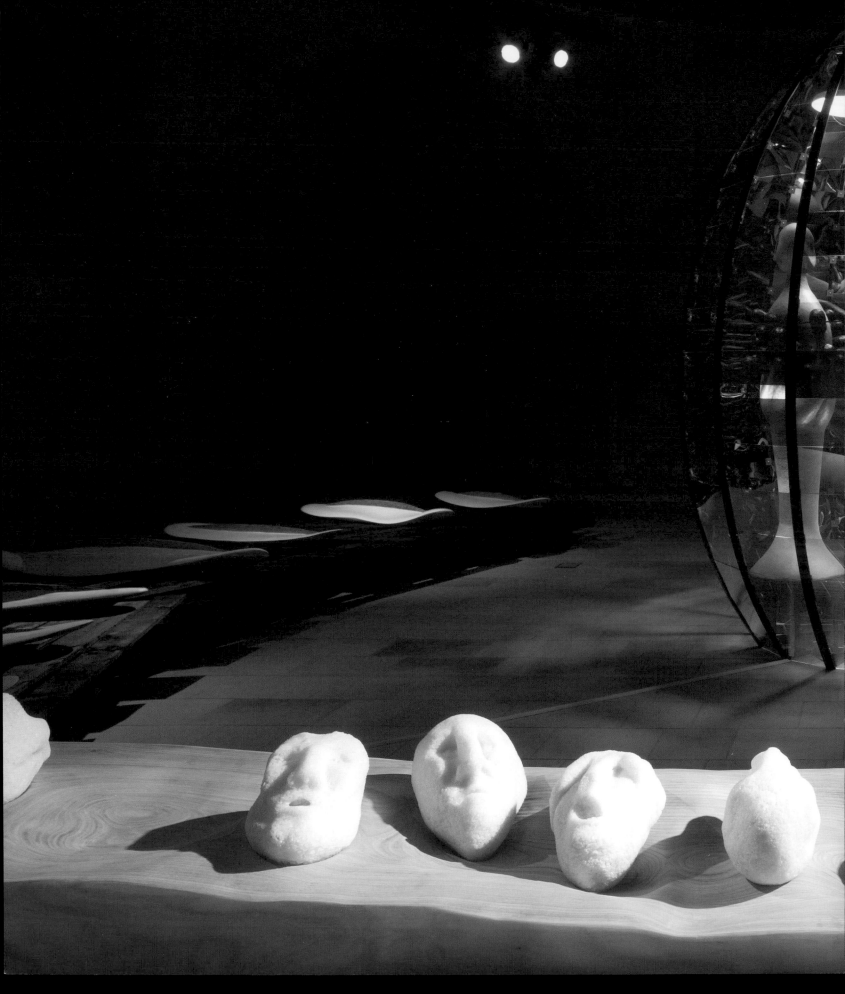

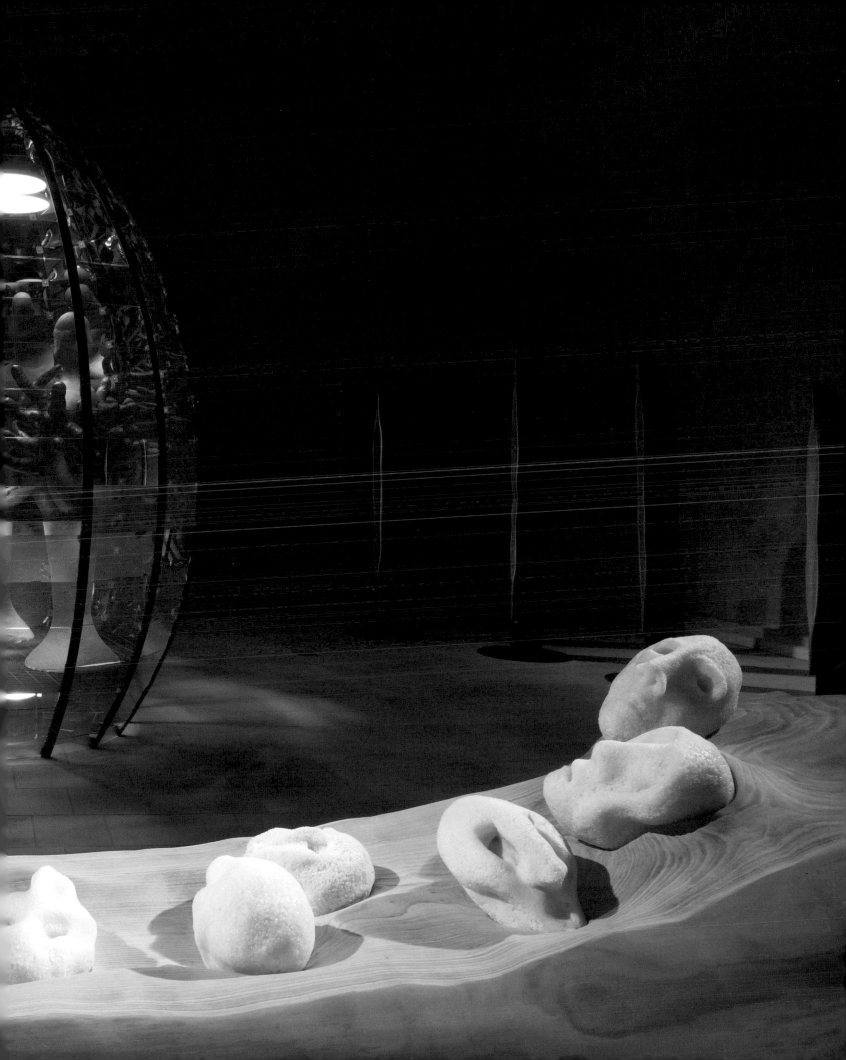

PART 3

Navigating in the dark

THE CRYPT GALLERY, ST PANCRAS, LONDON

7 October–27 November 2011

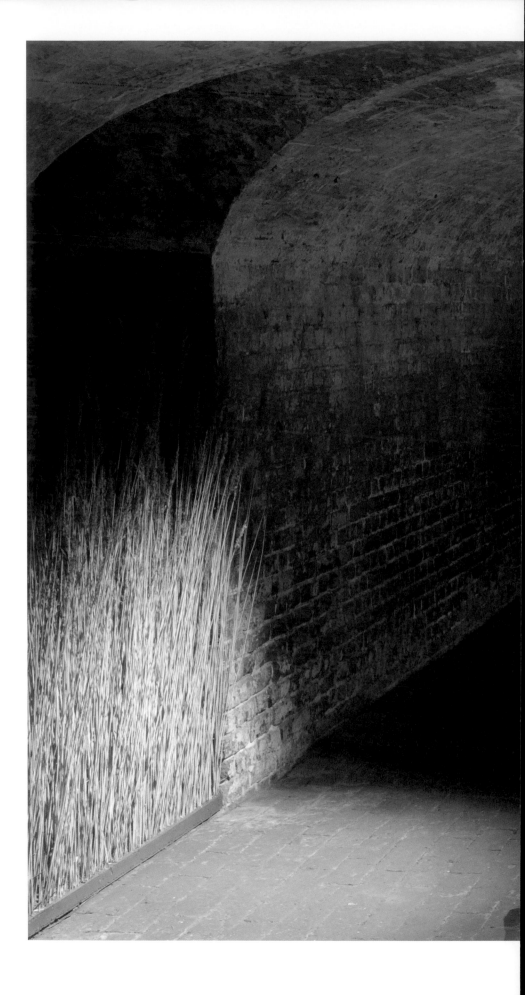

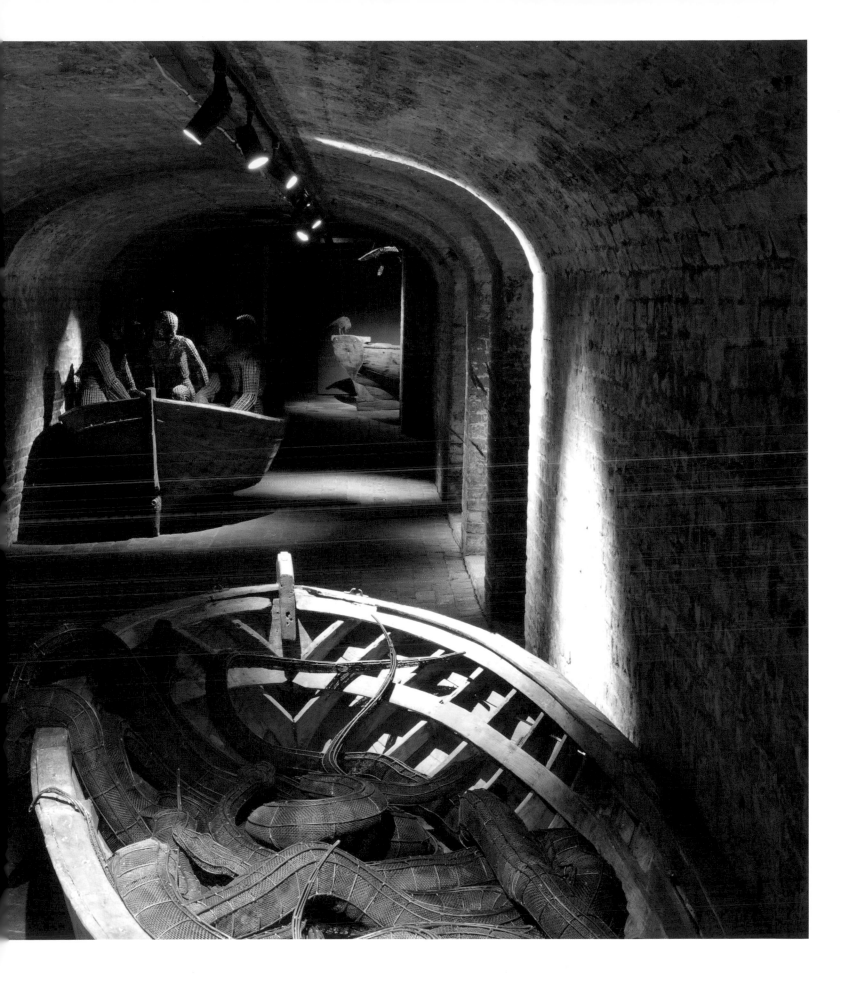

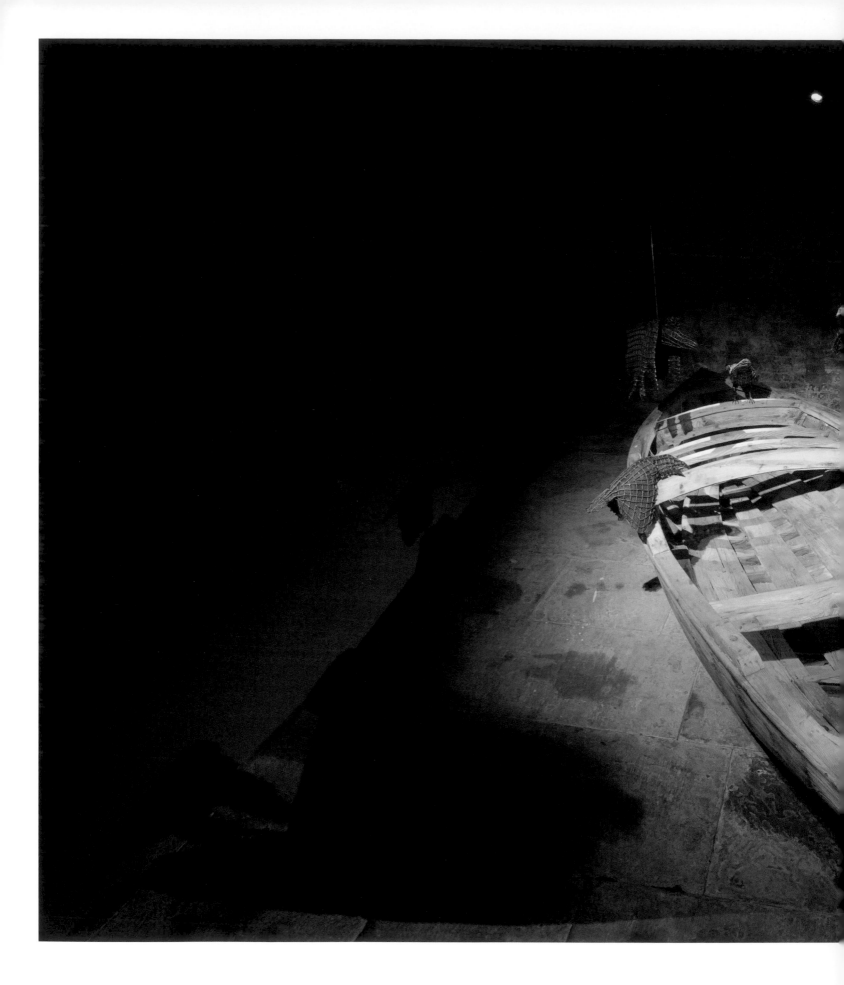

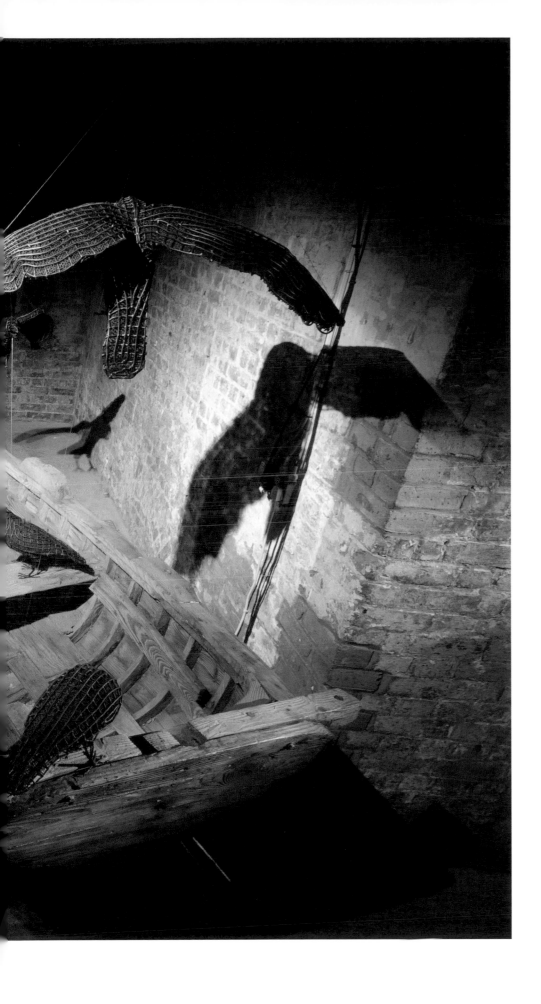

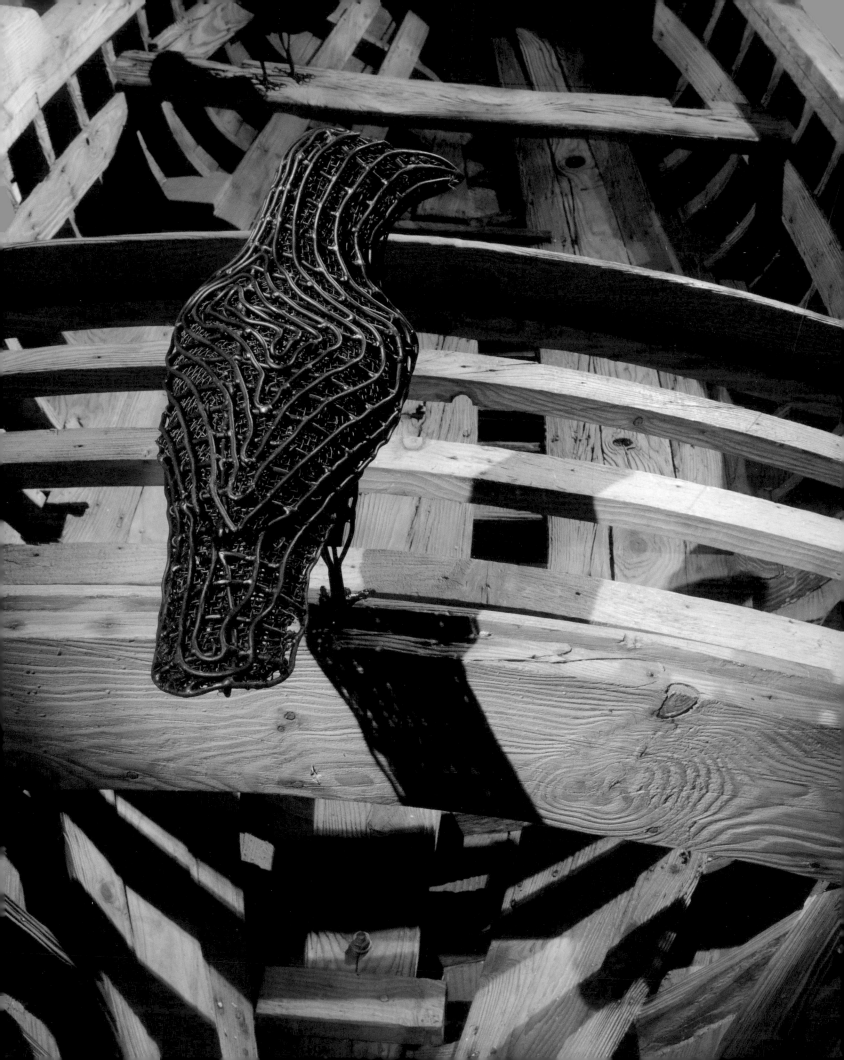

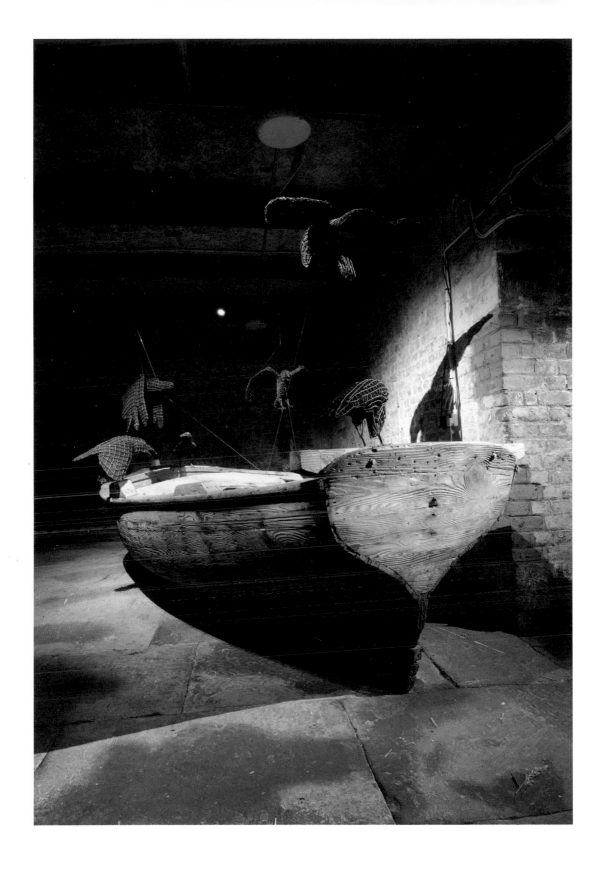

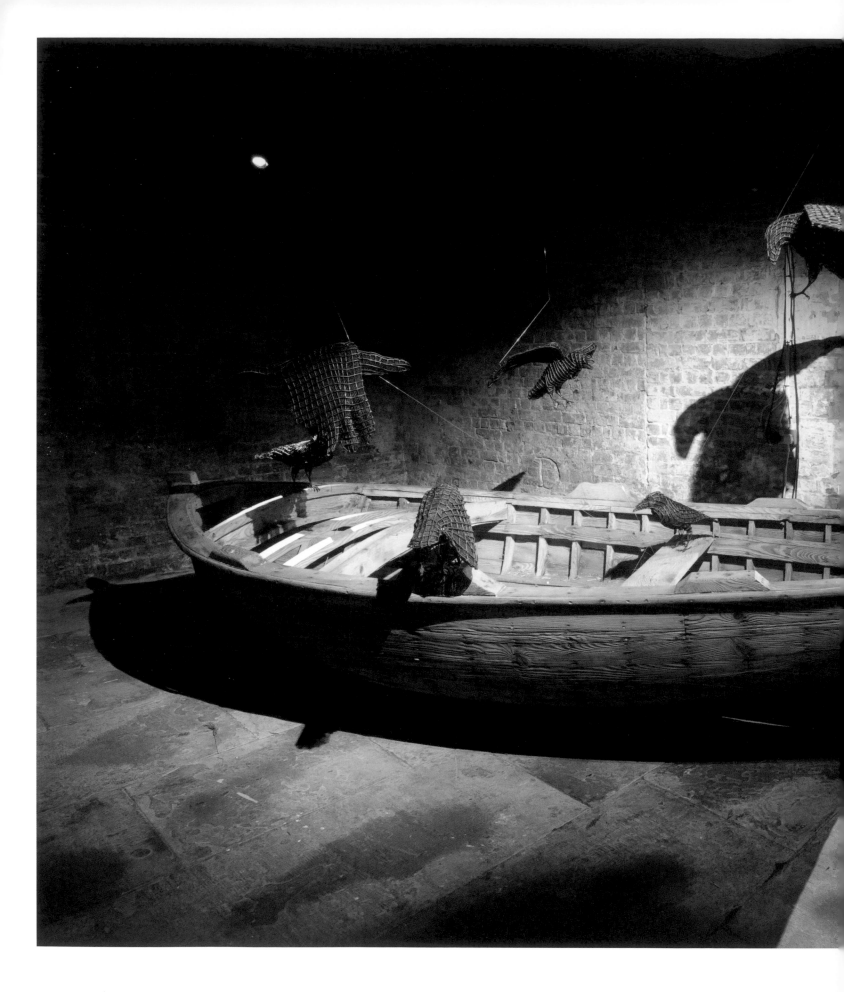

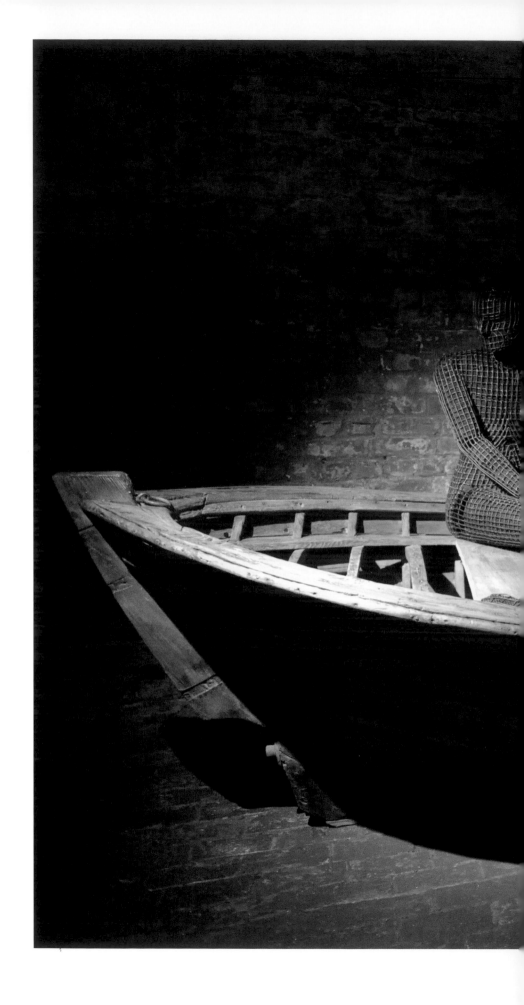

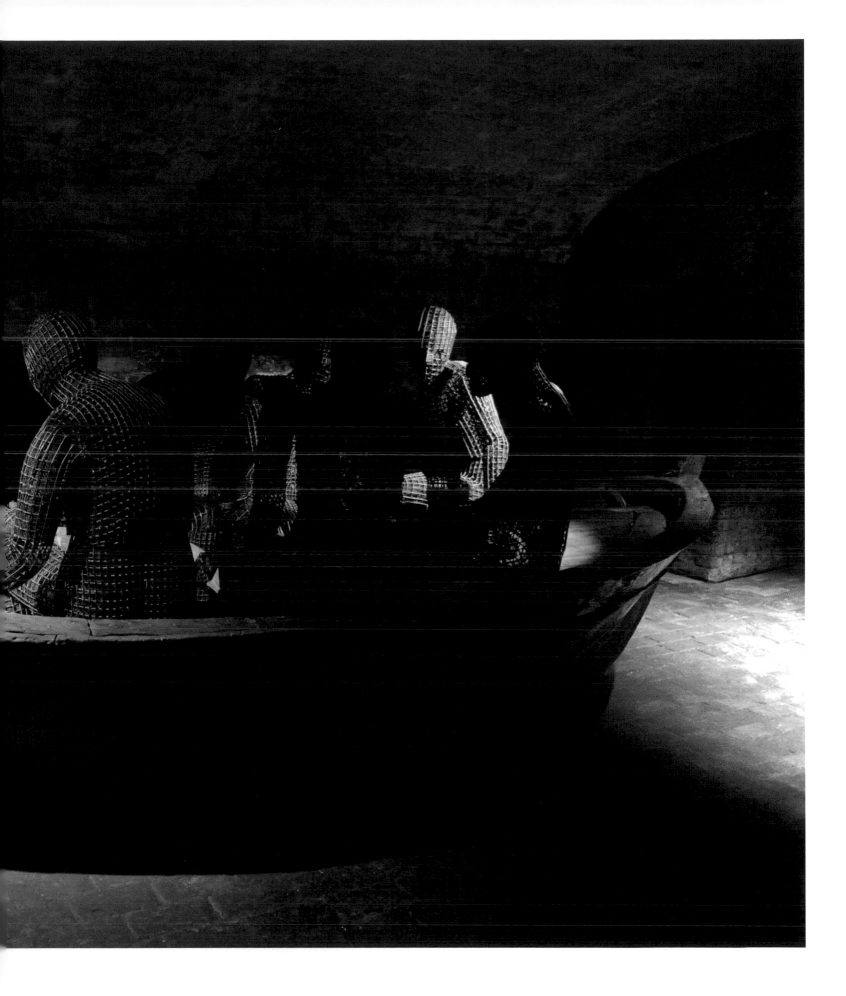

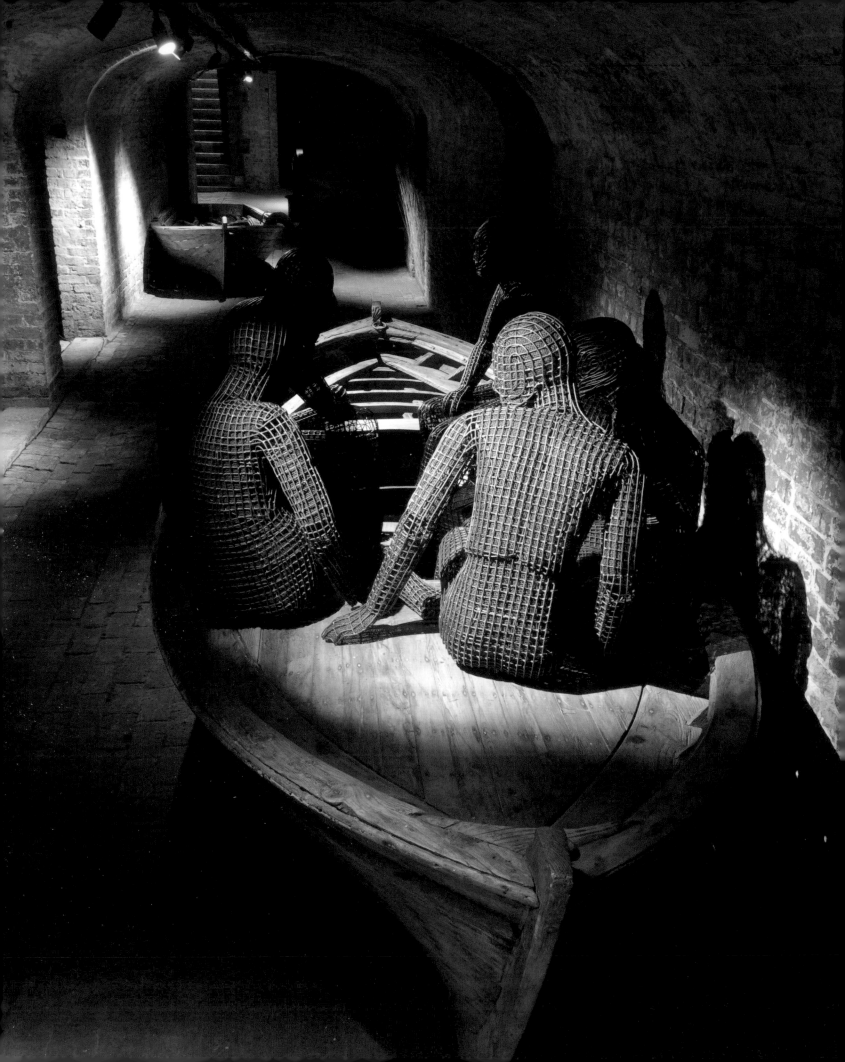

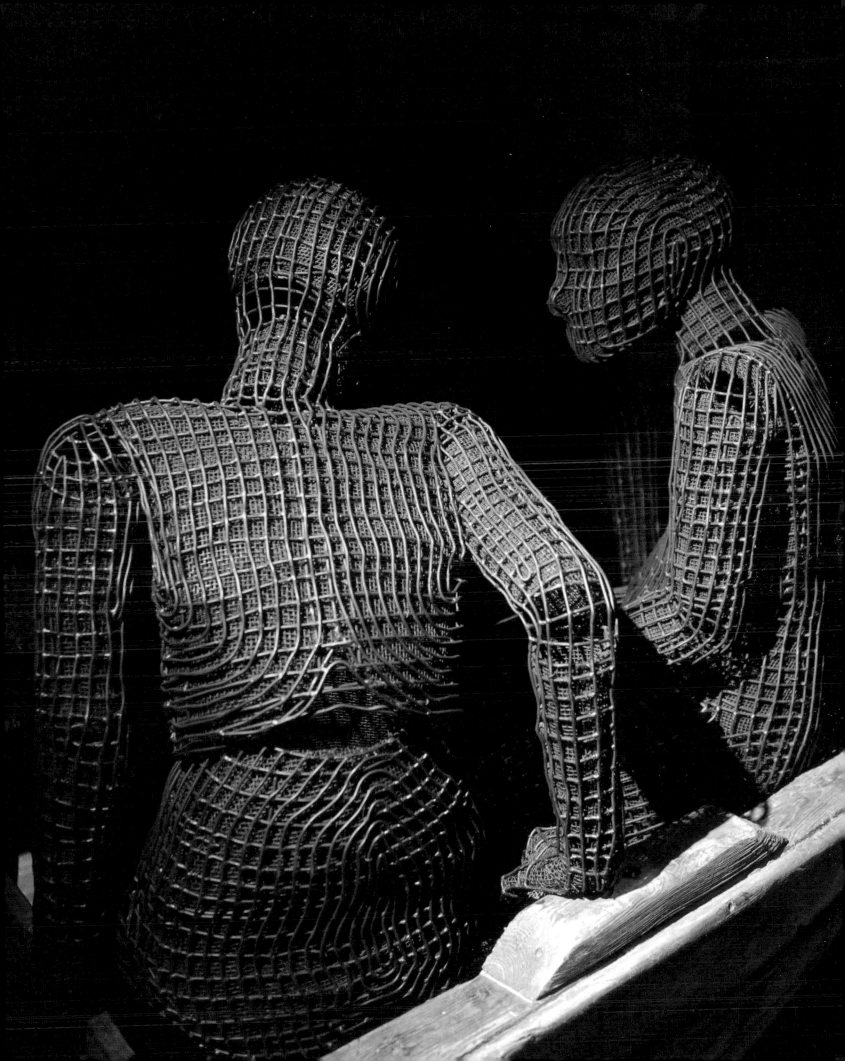

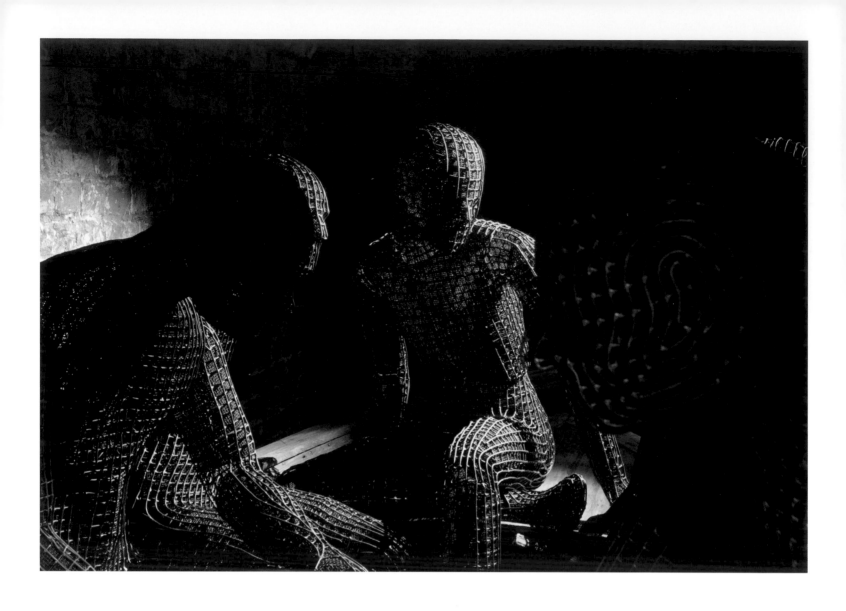

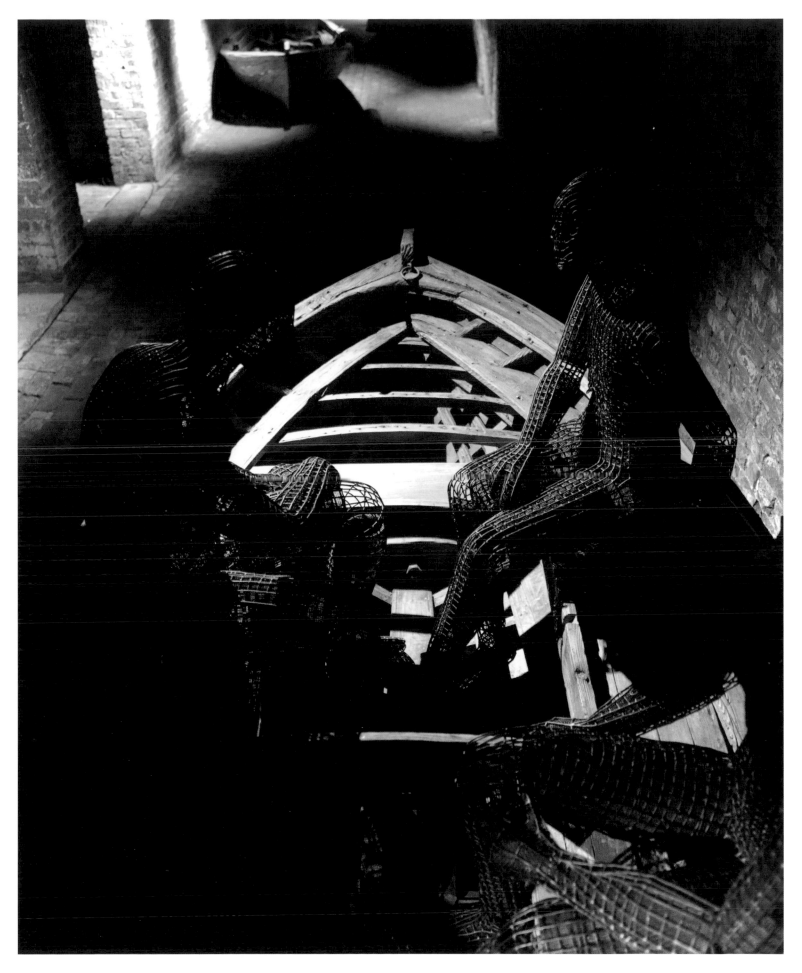

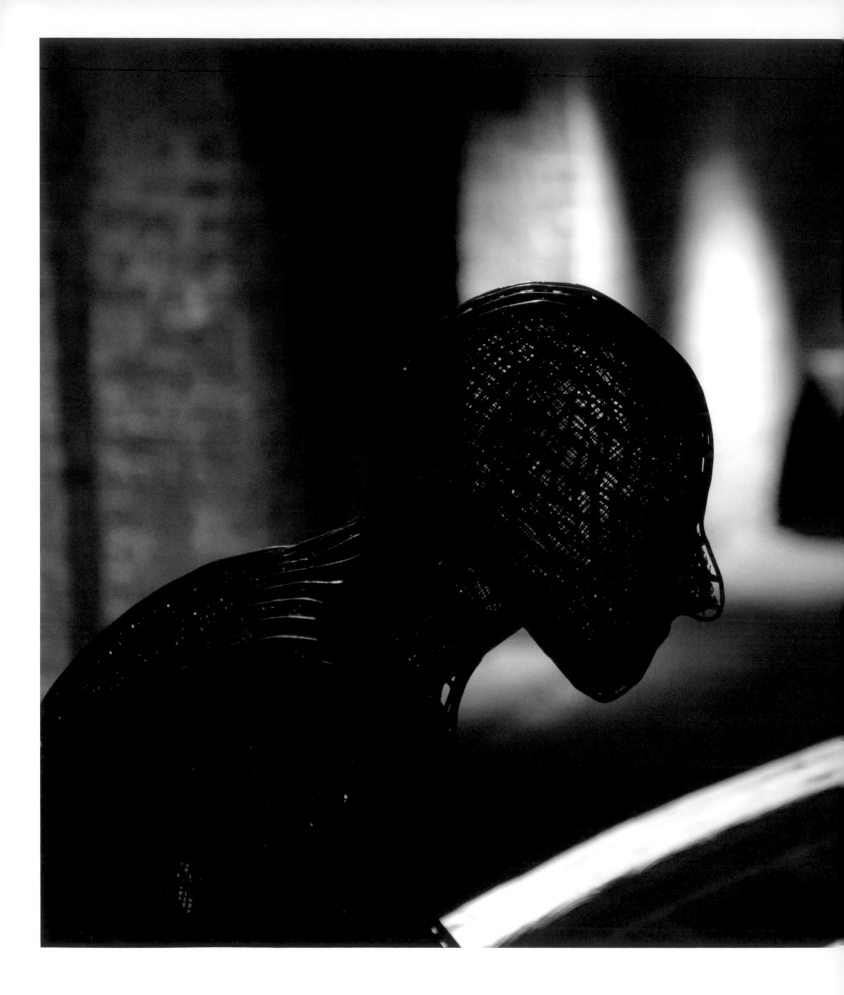

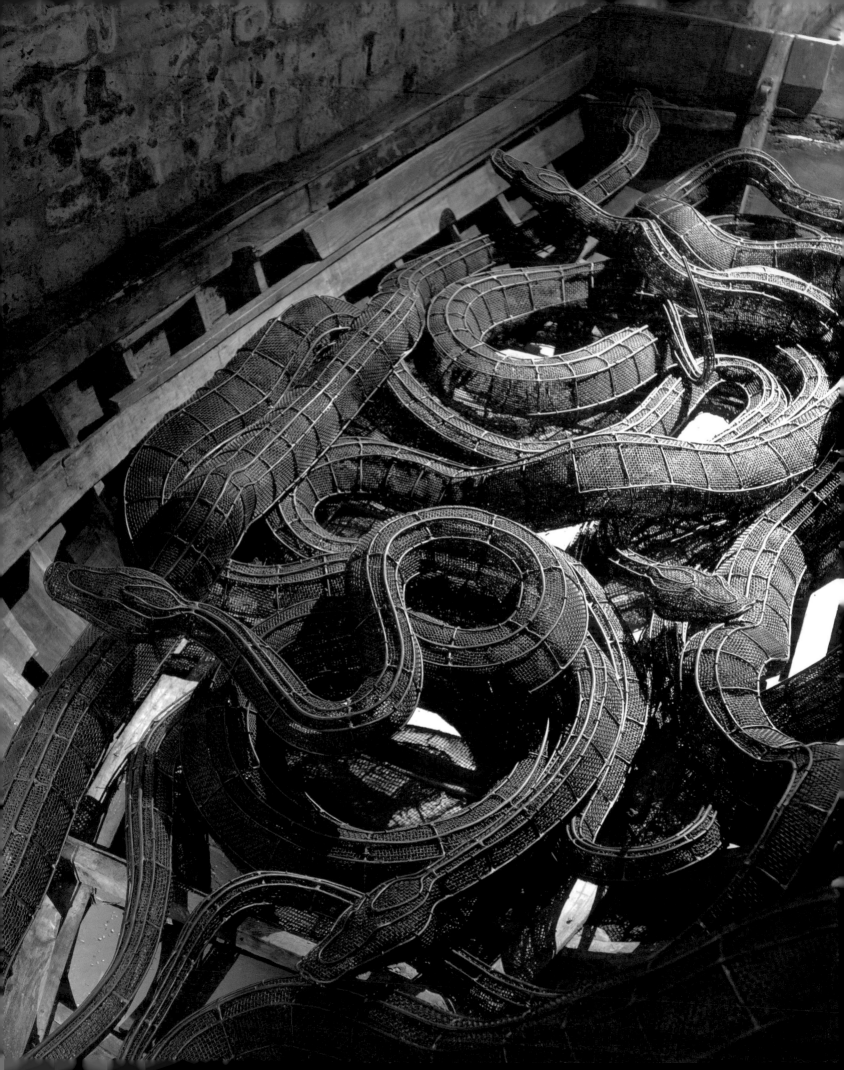

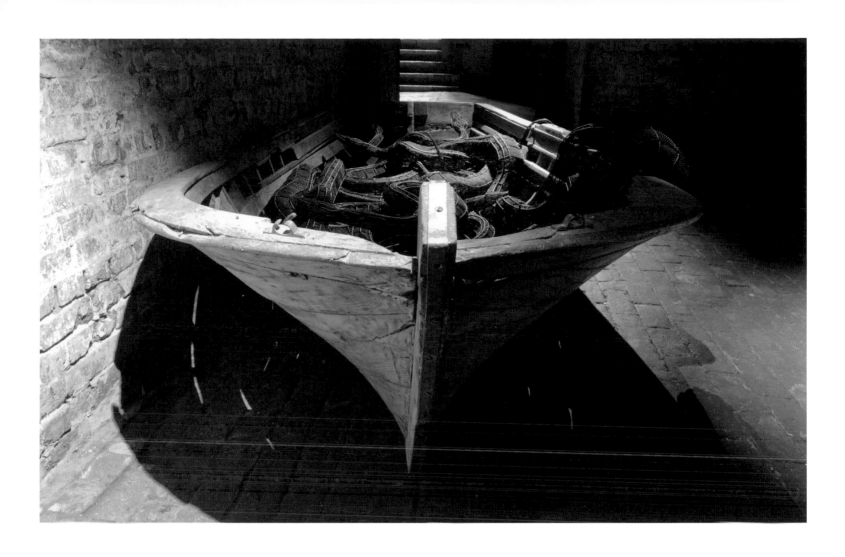

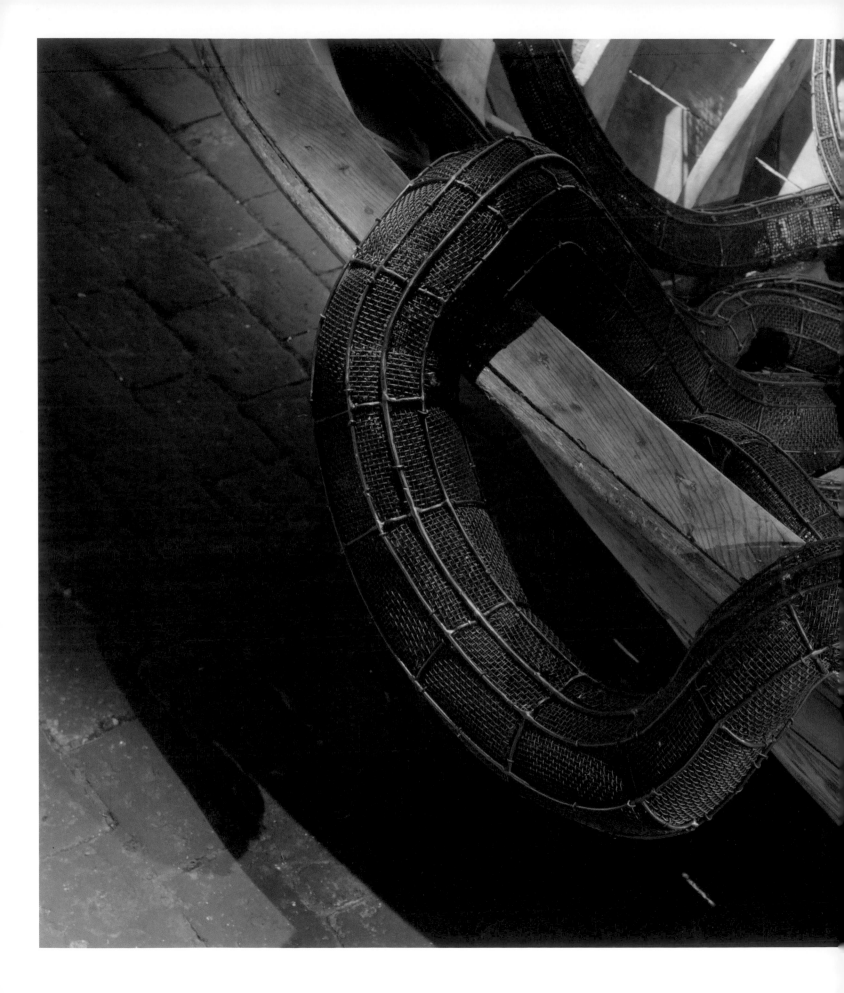

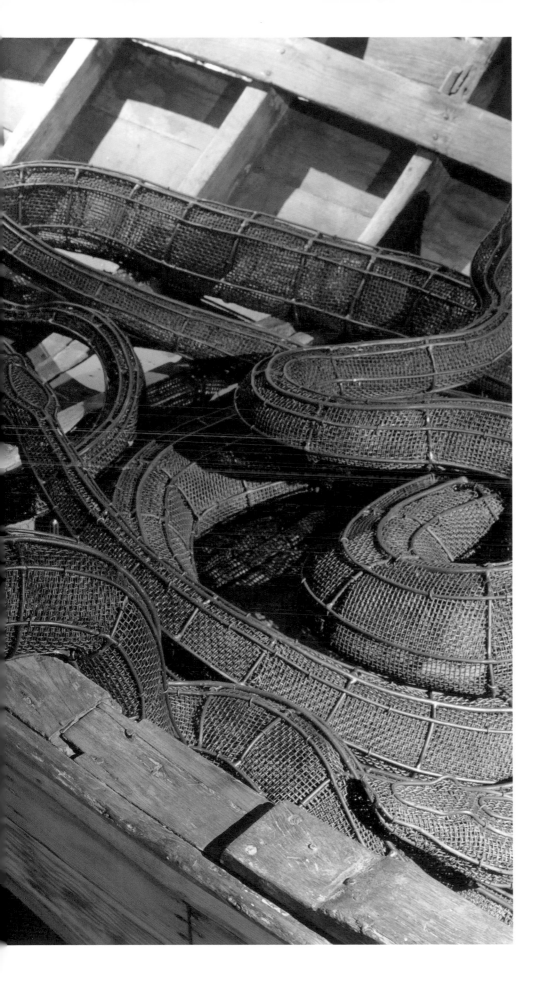

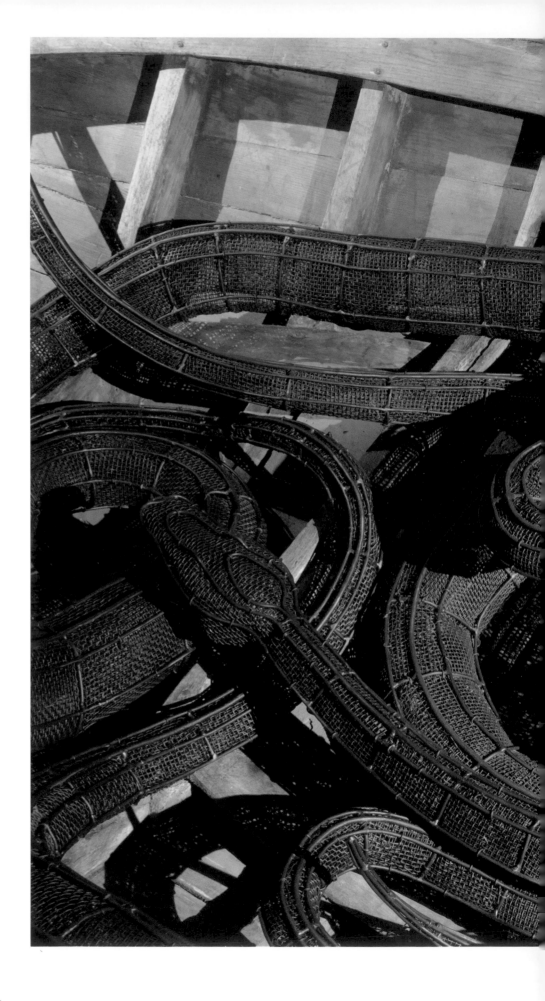

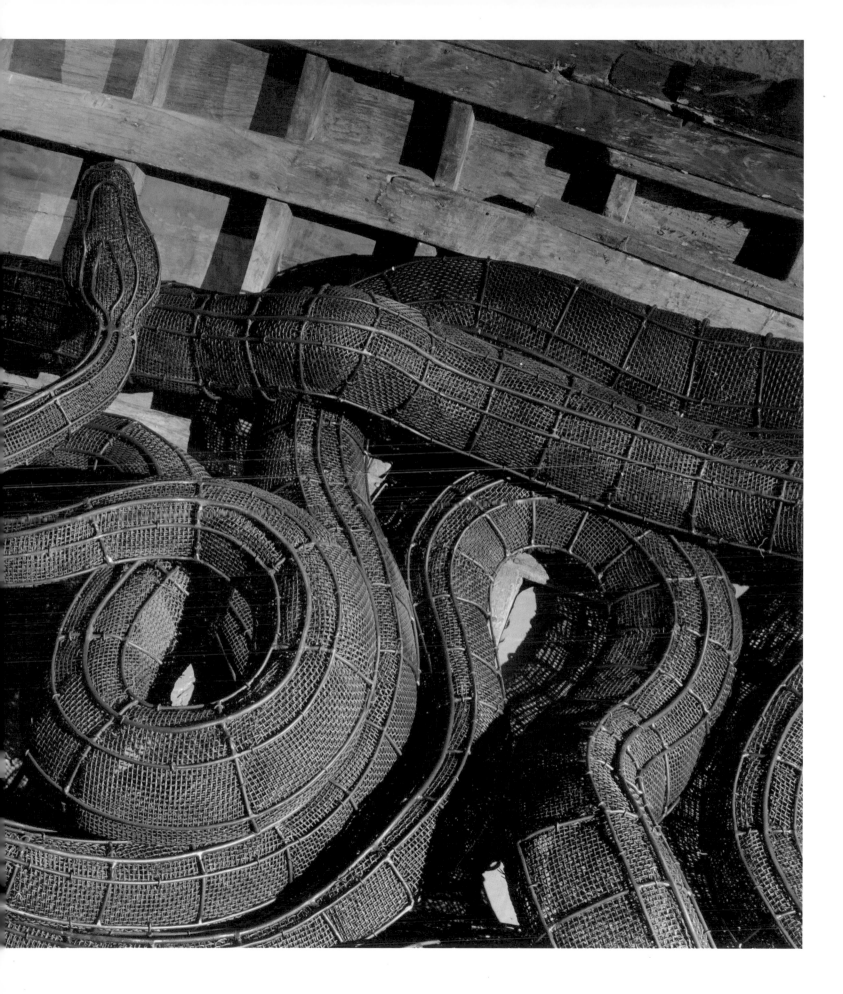

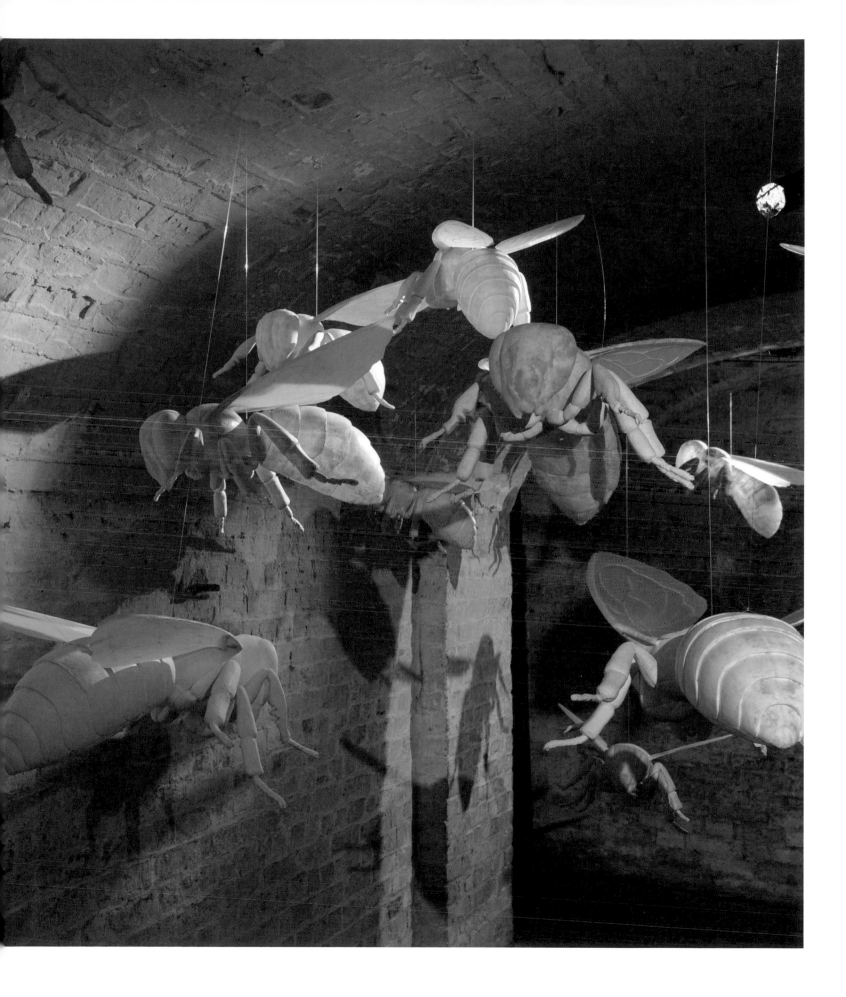

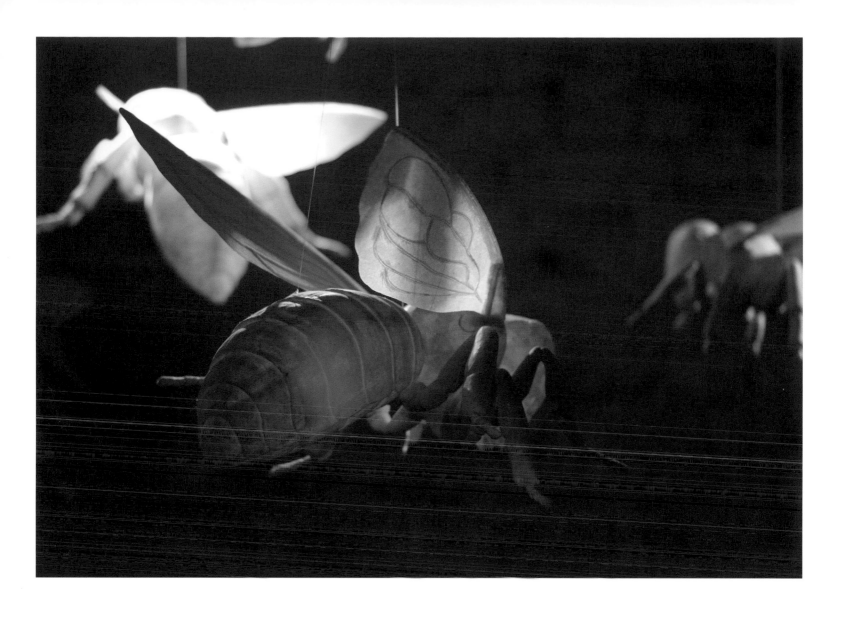

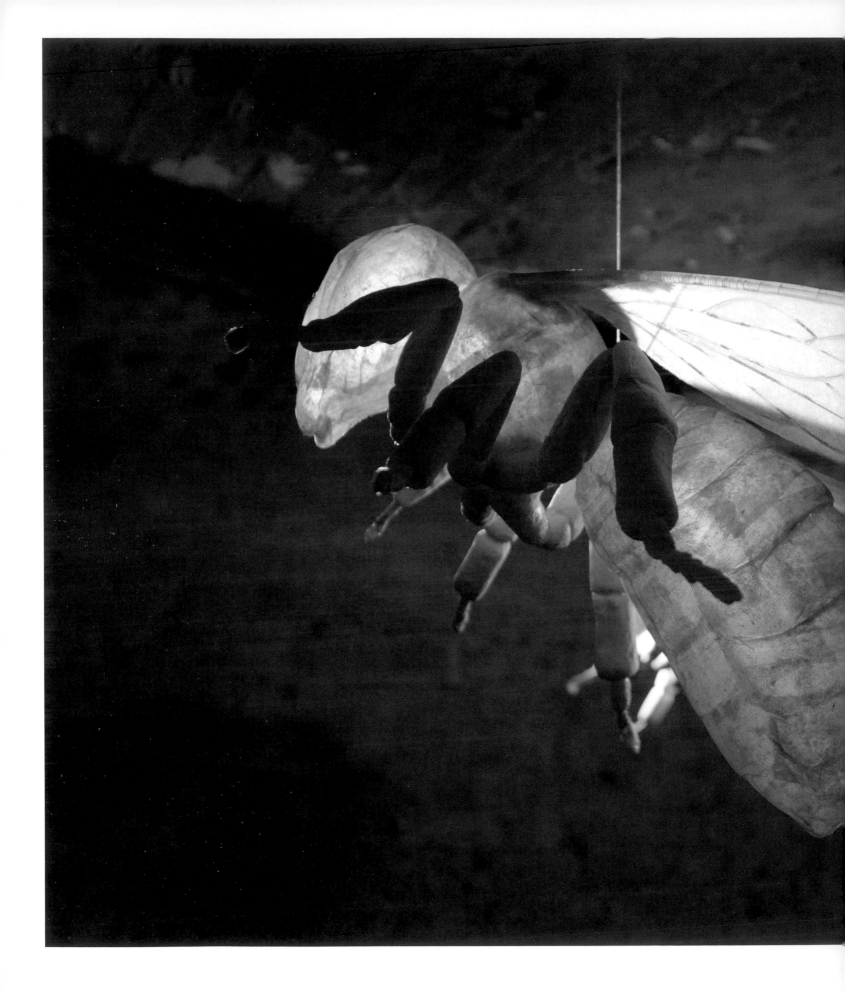

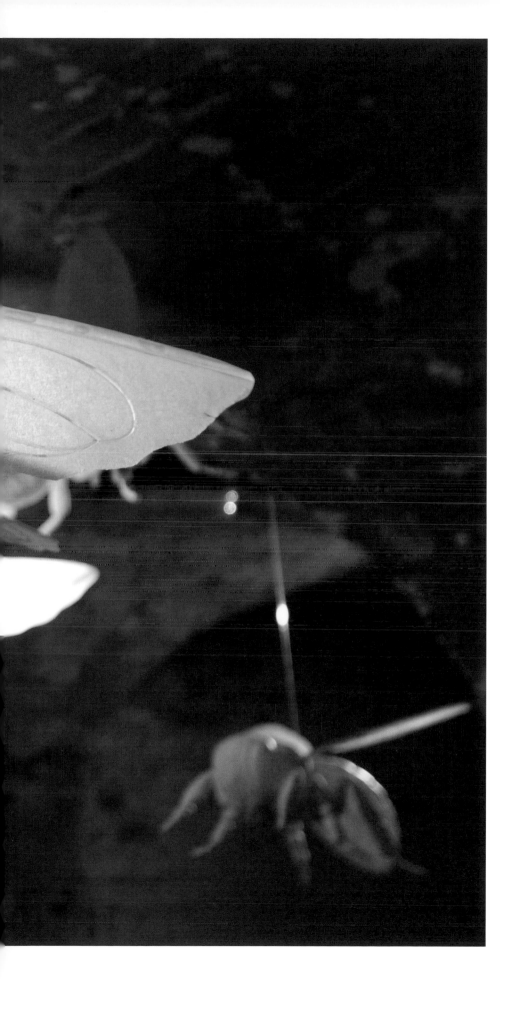

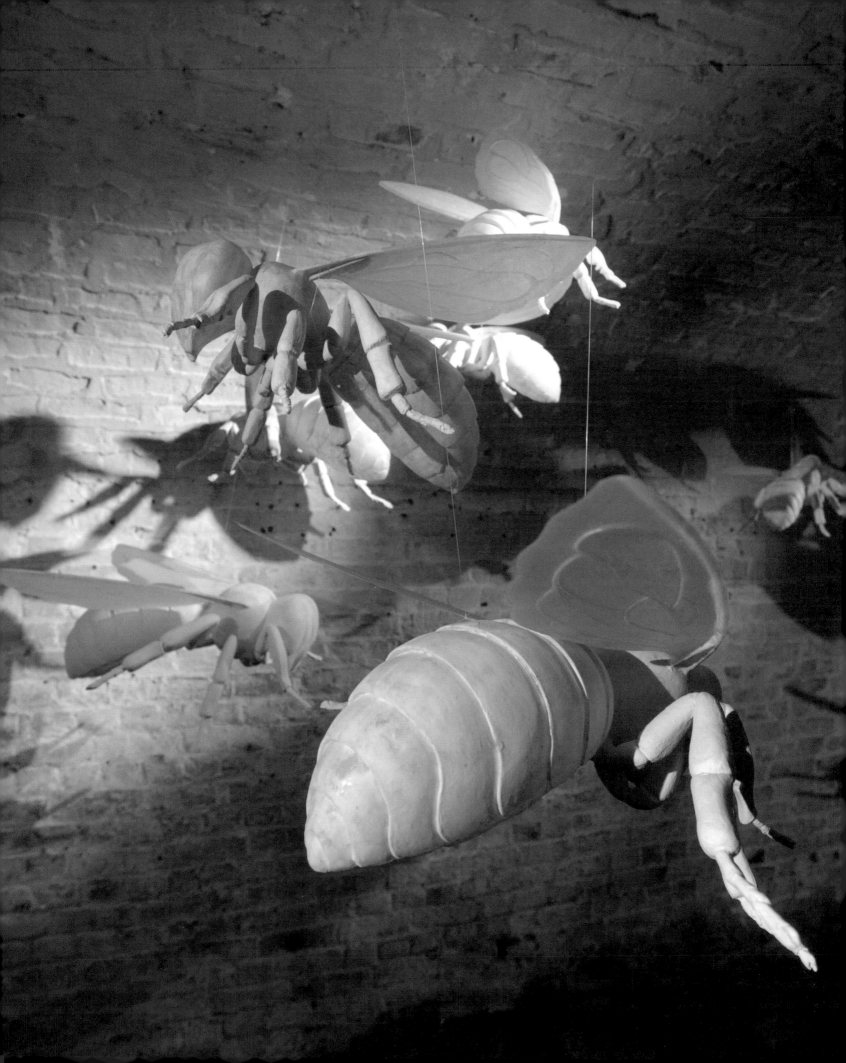

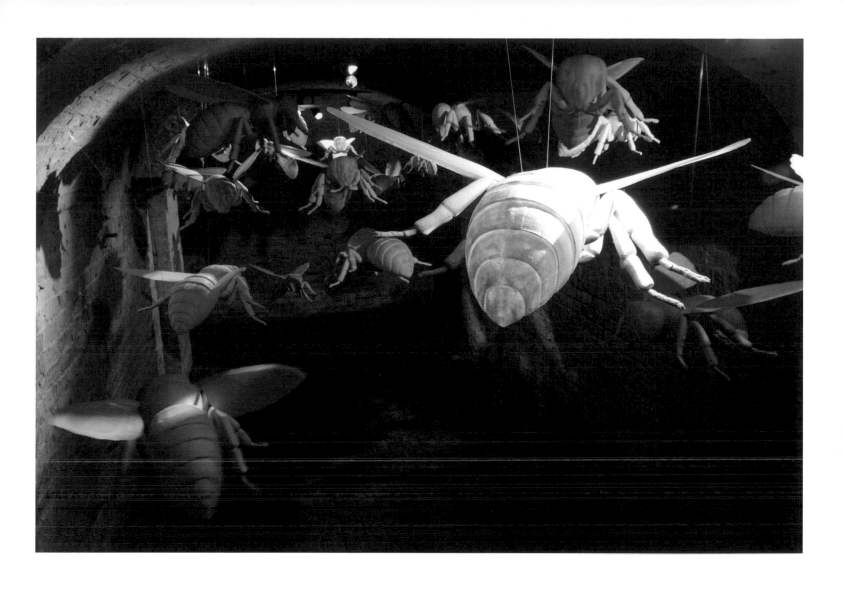

Images

INDEX

PART 1

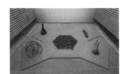

pages 44–45
Navigating in the Dark Part 1, 2011
Benaki Museum, Athens, Overall installation view

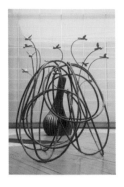

page 46
View of **The Big Egg and the Free Roaming Phalluses**, 2006, with **Space Within**, 2010 in the background

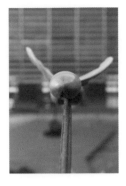

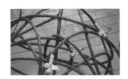

page 47
The Big Egg and the Free Roaming Phalluses (detail), 2006
Steel and bronze

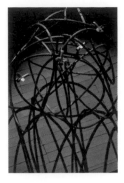

pages 48–49
The Big Egg and the Free Roaming Phalluses (detail), 2006
Steel and bronze

page 50
The Big Egg and the Free Roaming Phalluses (detail), 2006
Steel and bronze
5 x 3.5 m

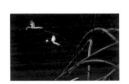

page 51
The Big Egg and the Free Roaming Phalluses (detail), 2006
Steel and bronze

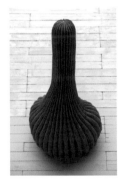

page 52
Space Within, 2010
Steel
3.7 x 1.85 m

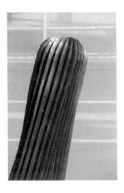

page 53
Space Within (detail), 2010
Steel

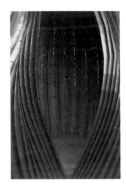

page 54
Space Within (detail), 2010
Steel

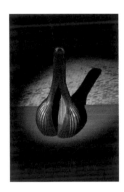

page 55
Space Within, 2010
Steel
3.7 x 1.85 m

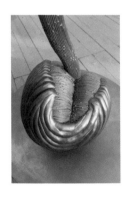

page 56
Reaching Up High (detail), 2007–2008
Steel

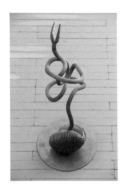

page 57
Reaching Up High, 2007–2008
Steel
3.5 x 1.5 x 1.75 m

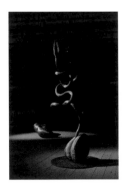

page 58
Reaching Up High, 2007–2008
Steel
3.5 x 1.5 x 1.75 m

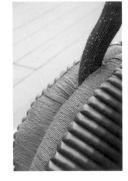

page 59
Reaching Up High (detail), 2007–2008
Steel

pages 60–61
Reaching Up High (detail), 2007–2008
Steel

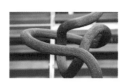
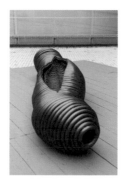
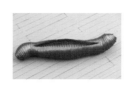

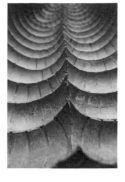

pages 62–63
Reaching Up High
(detail),
2007–2008
Steel

page 64
Bear All Crawl,
2007–2008
Steel
3.9 x 0.85 x 0.73 m

page 65
Bear All Crawl,
2007–2008
Steel
3.9 x 0.85 x 0.73 m

pages 66–67
Bear All Crawl (detail),
2007–2008
Steel

page 68
Bear All Crawl (detail),
2007–2008
Steel

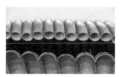

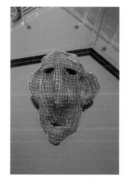
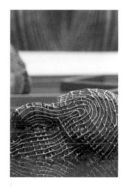

page 69
Bear All Crawl (detail),
2007–2008
Steel

pages 70–71
Twelve Steel Heads
2010–2011
Steel
Various dimensions

page 72
Twelve Steel Heads
(detail), 2010–2011
Steel

page 73
Twelve Steel Heads
(detail), 2010–2011
Steel

page 74
Twelve Steel Heads
(detail), 2010 2011
Steel

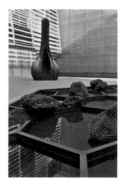
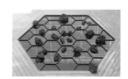

page 75
View of **Twelve Steel
Heads**, 2010–2011, with
Space Within, 2010 in
the background

pages 76–77
Twelve Steel Heads
2010–2011
Steel
Installation view

pages 78–79
**Navigating in the dark
Part 1**, Benaki Museum,
Athens, 2011
Overall installation
night view

PART 2

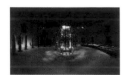

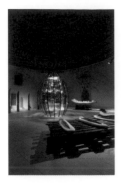

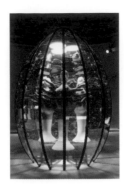

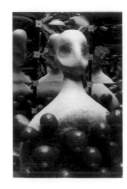

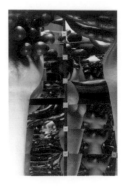

pages 82–83
Navigating in the dark Part 2, Ibrahim Khan Mosque, Rethymnon, 2011
Overall installation view

page 84
Navigating in the dark Part 2, Ibrahim Khan Mosque, Rethymnon, 2011
Overall installation view

page 85
The Big Egg and the Hairy Goddesses, 2007–2011
Mild steel and two-way acrylic mirror, papier mache, animal hair
2.7 x 4 m

page 86
The Big Egg and the Hairy Goddesses (detail), 2007–2011
Mild steel and two-way acrylic mirror, papier mache, animal hair

page 87
The Big Egg and the Hairy Goddesses (detail), 2007–2011
Mild steel and two-way acrylic mirror, papier mache, animal hair

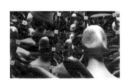

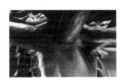

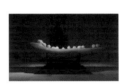

pages 88–89
The Big Egg and the Hairy Goddesses (detail), 2007–2011
Mild steel and two-way acrylic mirror, papier mache, animal hair

page 90
The Big Egg and the Hairy Goddesses (detail), 2007–2011
Mild steel and two-way acrylic mirror, papier mache, animal hair

page 91
The Big Egg and the Hairy Goddesses (detail), 2007–2011
Mild steel and two-way acrylic mirror, papier mache, animal hair

pages 92–93
Odysseus's Boat, 2011
Sweet chestnut wood
3.47 x 0.8 x 0.91 m
(height with stand: 1.34 m)

page 94
Odysseus's Boat (detail), 2011
Sweet chestnut wood and salt

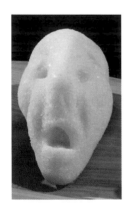

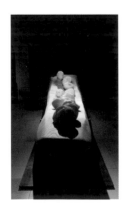

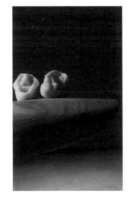

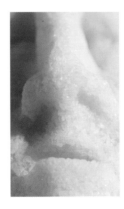

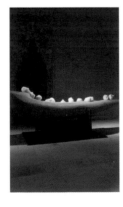

page 95
Odysseus's Boat (detail), 2011
Sweet chestnut wood and salt

page 96
Odysseus's Boat (detail), 2011
Sweet chestnut wood and salt

page 97
Odysseus's Boat, 2011
Sweet chestnut wood and salt
3.47 x 0.80 x 0.91m
(height with stand: 1.34 m)

page 98
Odysseus's Boat (detail), 2011
Sweet chestnut wood and salt

pages 99
Odysseus's Boat (detail), 2011
Sweet chestnut wood and salt

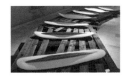

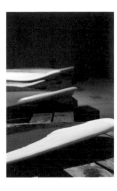

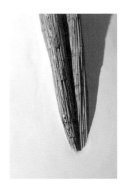

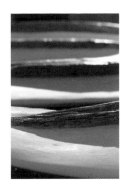

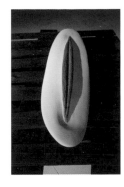

pages 100–101
Blade Boats,
2008
Plaster and reed
Length varies from:
1.52 to 1.72 m;
Width varies from:
0.42 to 0.50 m;
Height varies from
0.13 to 0.15 m

page 102
Blade Boats (detail),
2008
Plaster and reed

page 103
Blade Boats (detail),
2008
Plaster and reed

pages 104
Blade Boats (detail),
2008
Plaster and reed

page 105
Blade Boats (detail),
2008
Plaster and reed

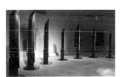

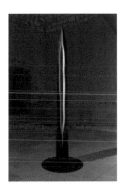

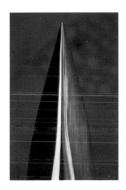

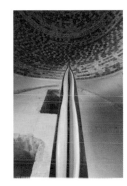

pages 106–107
Boats Full of Secrets,
2008
Tulip wood
Height varies from:
2.12 to 2.72 m;
Length varies from:
0.33 to 0.38 m;
 Width varies from:
0.17 to 0.19 m

page 108
Boats Full of Secrets
(detail), 2008
Tulip wood

page 109
Boats Full of Secrets
(detail), 2008
Tulip wood

page 110
Boats Full of Secrets
(detail), 2008
Tulip wood

page 111
Boats Full of Secrets
(detail), 2008
Tulip wood

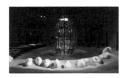

pages 112–113
**Navigating in the dark
Part 2**, Ibrahim Khan
Mosque, Rethymnon,
2011
Overall installation view

PART 3

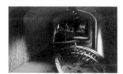

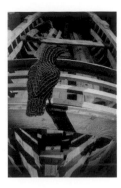

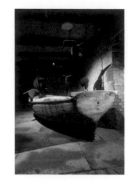

pages 116–117
**Navigating in the dark
Part 3**, Crypt Gallery, St
Pancras, London, 2011
Overall installation view

pages 118–119
**Wooden Boat with
Seven Crows**, 2011
Wood and steel
Boat dimensions:
3.50 x 1.41 x 0.88 m

page 120
**Wooden Boat with
Seven Crows** (detail),
2011
Wood and steel

page 121
**Wooden Boat with
Seven Crows**, 2011
Wood and steel
Boat dimensions:
3.50 x 1.41 x 0.88 m

pages 122–123
**Wooden Boat with
Seven Crows**, 2011
Wood and steel
Boat dimensions:
3.50 x 1.41 x 0.88 m

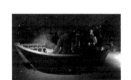

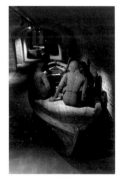

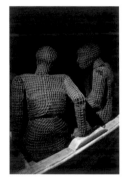

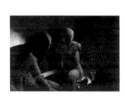

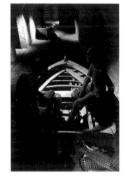

pages 124–125
**Wooden Boat with
Seven People**, 2011
Wood and steel
Boat dimensions:
4.33 x 1.71 x 1.10 m

page 126
**Wooden Boat with
Seven People**, 2011
Wood and steel
Boat dimensions:
4.33 x 1.71 x 1.10 m

page 127
**Wooden Boat with
Seven People** (detail),
2011
Wood and steel

pages 128
**Wooden Boat with
Seven People** (detail),
2011
Wood and steel

page 129
**Wooden Boat with
Seven People** (detail),
2011
Wood and steel

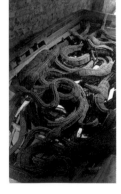

pages 130–131
**Wooden Boat with
Seven People** (detail),
2011
Wood and steel

page 132
**Wooden Boat with
Seven Snakes,** 2011
Wood and steel
Boat dimensions:
3.51 x 1.46 x 0.85 m

page 133
**Wooden Boat with
Seven Snakes,** 2011
Wood and steel
Boat dimensions:
3.51 x 1.46 x 0.85 m

pages 134–135
**Wooden Boat with
Seven Snakes** (detail),
2011
Wood and steel

pages 136–137
**Wooden Boat with
Seven Snakes** (detail),
2011
Wood and steel

 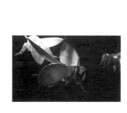 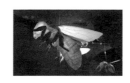 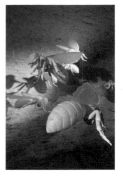

pages 138–139
White Bees, 2011
Japanese paper
Various dimensions

page 140
White Bees, (detail)
2011
Japanese paper

page 141
White Bees, (detail)
2011
Japanese paper

pages 142–143
White Bees, (detail)
2011
Japanese paper

page 144
White Bees, (detail)
2011
Japanese paper

page 145
White Bees (detail),
2011
Japanese paper

pages 146–147
Field of Reeds 2011,
Reeds

Biographies

KALLIOPI LEMOS

Kalliopi Lemos is a sculptor, painter and installation artist. She studied painting and printing at Byam Shaw School of Art, University of the Arts London, Central Saint Martins, where she also pursued post-graduate studies. Previous to this she studied the art of *Ikebana* for 15 years. She lives and works in London.

Lemos' recent work has explored the narrative of existential journeys, displacement and the politics of forced migration. In 2012 she realised a solo exhibition at a.antonopoulou.art gallery in Athens and participated in the Third International Biennial of Canakkale, Turkey with her installation *Pledges for a Safe Passage*. In 2011, Lemos collaborated with acclaimed director Theodoros Terzopoulos, in Greece and the UK and she participated in the group exhibition Polyglossia at the Onassis Cultural Centre Athens.

From 2006 to 2009 she presented a series of public art installations, comprising *Crossing* (Eleusis, Greece, 2006/2009), *Round Voyage*, (Istanbul, 2007 (permanent installation)), and *At Crossroads*, (Brandenburg Gate, Berlin 2009). A book about the trilogy was published by Steidl and the Akademie der Künste in January 2011.

Selected solo exhibitions include Kalliopi Lemos in BM Suma Contemporary Art Centre, Istanbul (2008), Rites of Passage, Art Gallery of Cyclades, Syros (2006), and Angela Flowers Gallery, London (1999). Group exhibitions include Artists Books, ICA, London (2004), Redfern Gallery, London (2002), and Julian Machin Gallery, London, (2002).

Her sculptural installation *Perpetual Transitions* is on permanent display at the Onassis Cultural Centre in New York.

SIMON CRITCHLEY

Simon Critchley is Hans Jonas Professor of Philosophy at the New School for Social Research. He also teaches at Tilburg University and the European Graduate School. His many books include *Very Little… Almost Nothing*, *Infinitely Demanding*, *The Book of Dead Philosophers*, *The Faith of the Faithless*, and, most recently with Tom McCarthy, *The Mattering of Matter: Documents from the Archive of the International Necronautical Society*. A new work on *Hamlet* called *Stay, Illusion!* is published in 2013 by Pantheon Books, co-authored with Jamieson Webster. He is series moderator of "The Stone", a philosophy column in *The New York Times*, to which he is a frequent contributor.

ARTHUR C DANTO

Arthur C Danto is Johnsonian Professor Emeritus of Philosophy at Columbia University. He was art critic for *The Nation* for 25 years, and has been developing a systematic philosophy of art, beginning with *The Transfiguration of the Commonplace*, in 1981.

JIM FITZGERALD

Jim Fitzgerald is a Jungian analyst with a private practice in London. His background is in Ancient Classics and Byzantine Greek. Fitzgerald specialised in Drama, and has studied at the Central School of Speech and Drama in London. He holds a Diploma from the C G Jung Institute in Zurich, and is a member of The Independent Group of Analytical Psychologists and of The Guild of Analytical Psychologists. He has lectured widely, and is the author of two pamphlets published by the Guild of Pastoral Psychology, London: *The Father's Shadow and the Source of the Masculine*, and *Vision of Light: The Healing Power of the Numinous*.

MARIA MARANGOU

Maria Marangou is a journalist, art critic and curator. She is the Director of the Museum of Contemporary Art, Crete. She has organised more than 20 solo and group exhibitions in various institutions in Athens, Thessaloniki, Crete, Venice and Sao Paolo. She was Commissioner of the Greek national participation at the Sao Paolo Biennale (1991) and at the Venice Biennale (1995), and curated the participation of the Greek Pavillion at the 54th Venice Biennale. She has also organised a number of education and residency programs in collaboration with European institutions and artists, as well as with the Athens School of Fine Arts. Her curatorial practice focuses on issues of migration, social groups and the problems of minorities, advocating a firm belief in the role of art as a catalyst for social change. She is a member of the Athens Daily Press Editors Union [ESIEA] and was President of the Greek chapter of AICA—The International Association of Art Critics.

THEODOROS TERZOPOULOS

Theodoros Terzopoulos was born in the village of Makrygialos, Crete. He attended K Michailidis' Drama School (1965–1967) in Athens and studied at the Berliner Ensemble, Berlin, as Hospitant and assistant from 1972 to 1976.

Terzopoulos was Director of the Drama School of the State Theatre of Northern Greece from 1981 to 1983 and Artistic Director of the International Meeting of Ancient Drama in Delphi from 1985 to 1988. In 1985 he created the ATTIS theatre group and has produced 1900 performances internationally since.

Since 1990 he has been a founding member of the International Institute of Mediterranean Theatre comprising 22 Mediterranean countries, and President of the International Institute of Mediterranean Theatre in Greece since 1991. He has been the Chairman of the International Committee of Theatre Olympics.

In 2005 he founded the International Meeting of Ancient Drama in Municipality of Sykion. The first edition was titled *Skotos emon faos* (2005), the second *Descent* (2006) and the third *Revenge* (2011)

Theodoros Terzopoulos has been awarded theatre prizes in Greece and abroad and has published internationally.

Kalliopi Lemos
would like to thank especially:

Curator:
Maria Marangou

Assistant Curators:
Elina Kountouri
Artemis Manolopoulou

Venues organisation:

BENAKI MUSEUM, ATHENS:
Aggelos Delivorias
Polina Kosmadaki

MUSEUM OF CONTEMPORARY ART, CRETE:
Maria Marangou
Katerina Kougioumoutzi
Municipality of Rethymno

CRYPT GALLERY, LONDON:
Claire Pinney

Studio technicians:
Rebecca Ackroyd
Simon Brundret
Paolo Carraro
Abby Clark
Rowan Durrant
Naomi Edwards
Tim Peacock
Polly Phipps-Holland

Exhibition design:
William Hodgson

Benaki Museum Construction:
A&T Kontodimas Architects

Filming:
Filippos Koutsaftis

Photography:
Rowan Durrant

Sound installation:
Tom Joyce

Performance:
Theodoros Terzopoulos
Paolo Musio

PR and Communication:
Maria Panayidou
Colman Getty

Resources:
Stavros Tsesmeloglou

And her husband Christos P Lemos for his everlasting invaluable support.

Black Dog Publishing
10A Acton Street
London
WC1X 9NG

t. +44 (0)207 713 5097
f. +44 (0)207 713 8682
sales@blackdogonline.com
www.blackdogonline.com

All opinions expressed within this publication are those of
the authors and not necessarily of the publisher.

Designed by Leonardo Collina at Black Dog Publishing.

British Library Cataloguing-in-Publication Data.
A CIP record for this book is available from the British Library.

ISBN 978 1 908966 31 5

Black Dog Publishing is an environmentally responsible company.
Navigating in the dark is printed on FSC accredited paper.

art design fashion
history photography
theory and things

www.blackdogonline.com